Out of Tibet

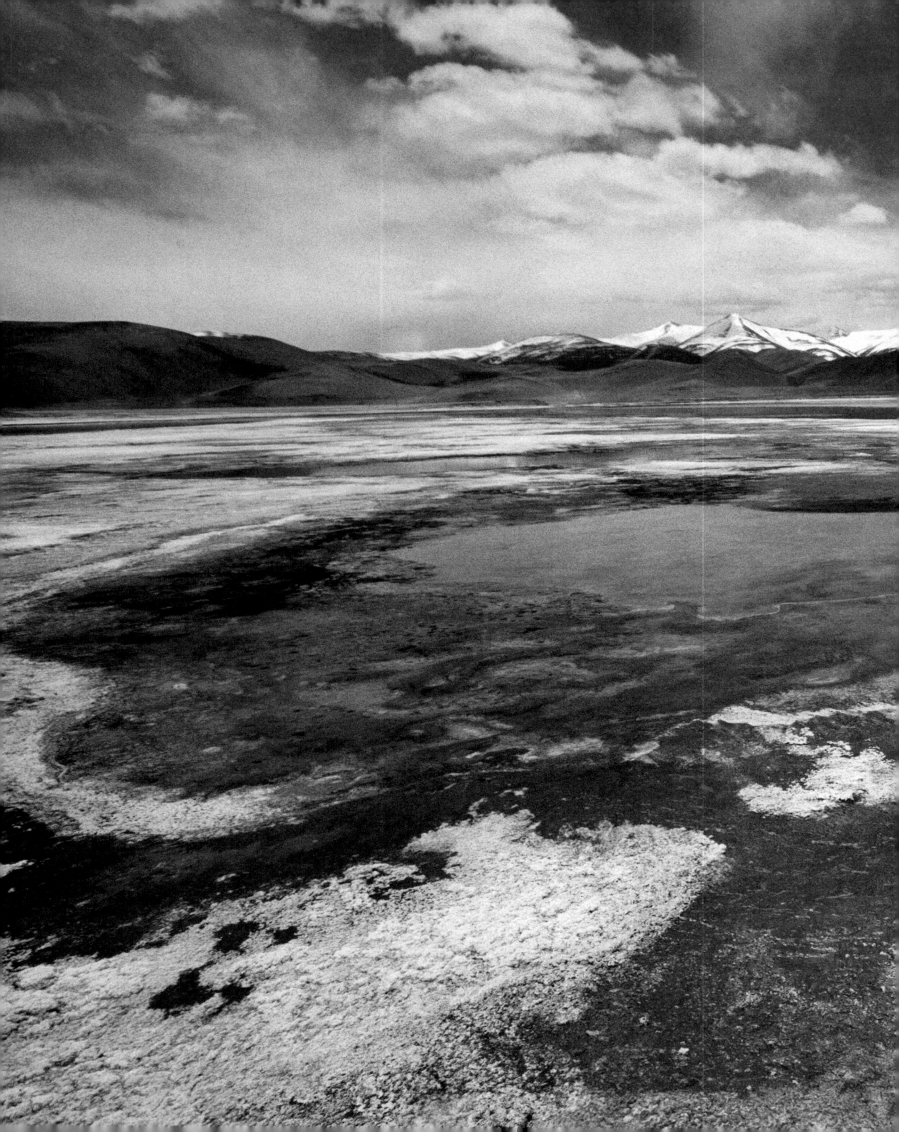

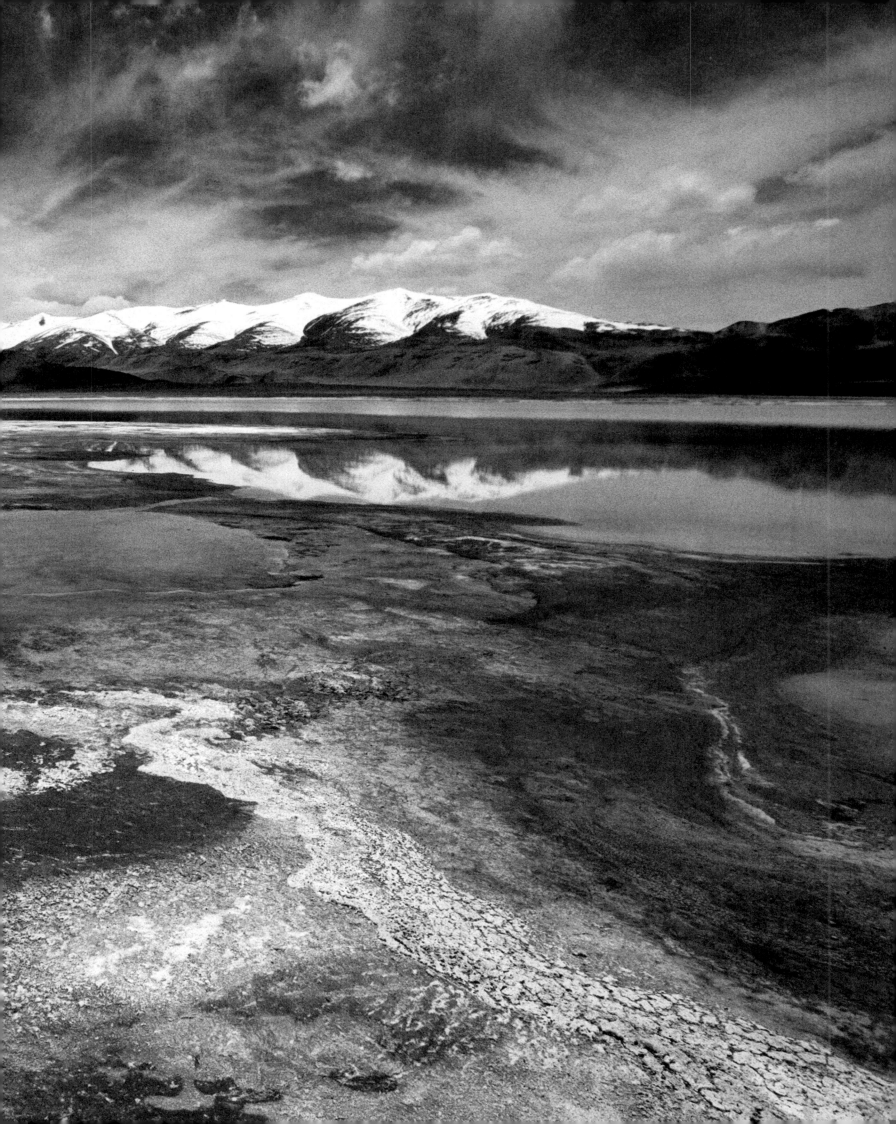

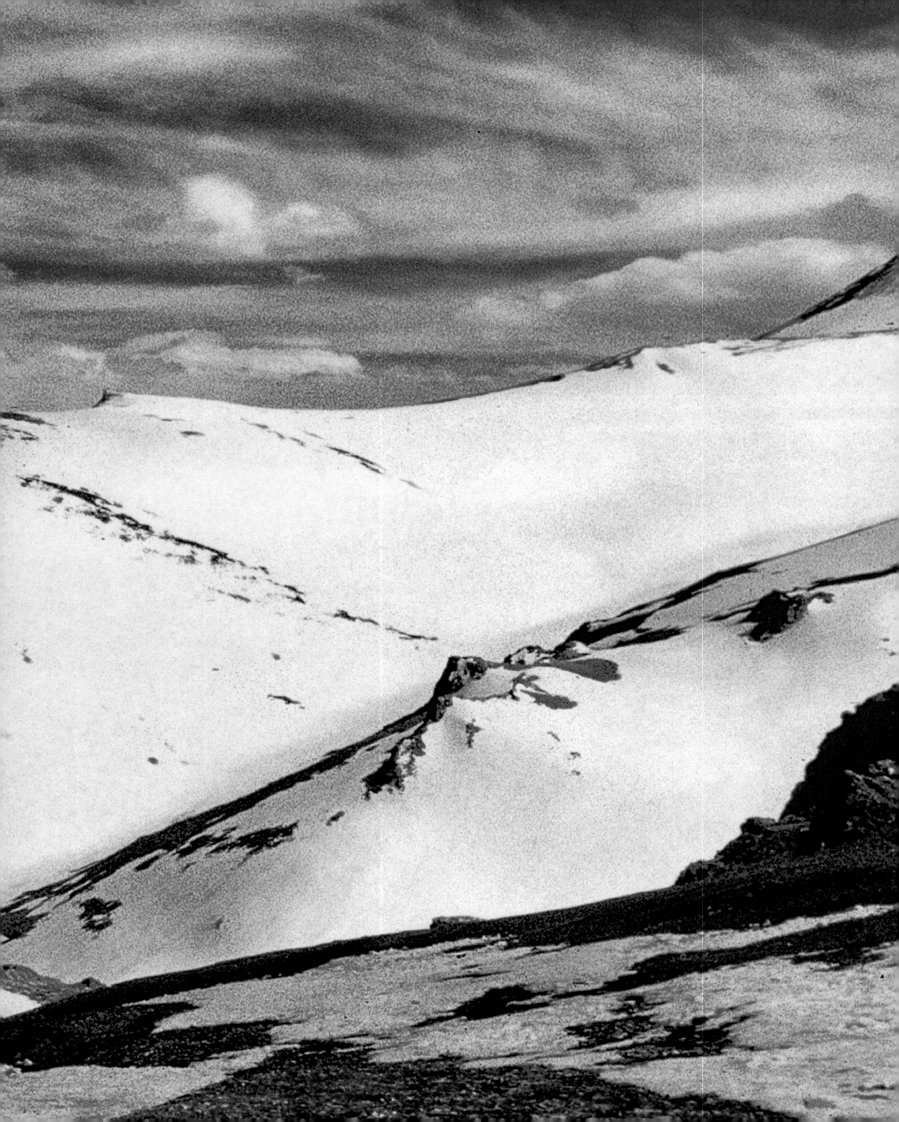

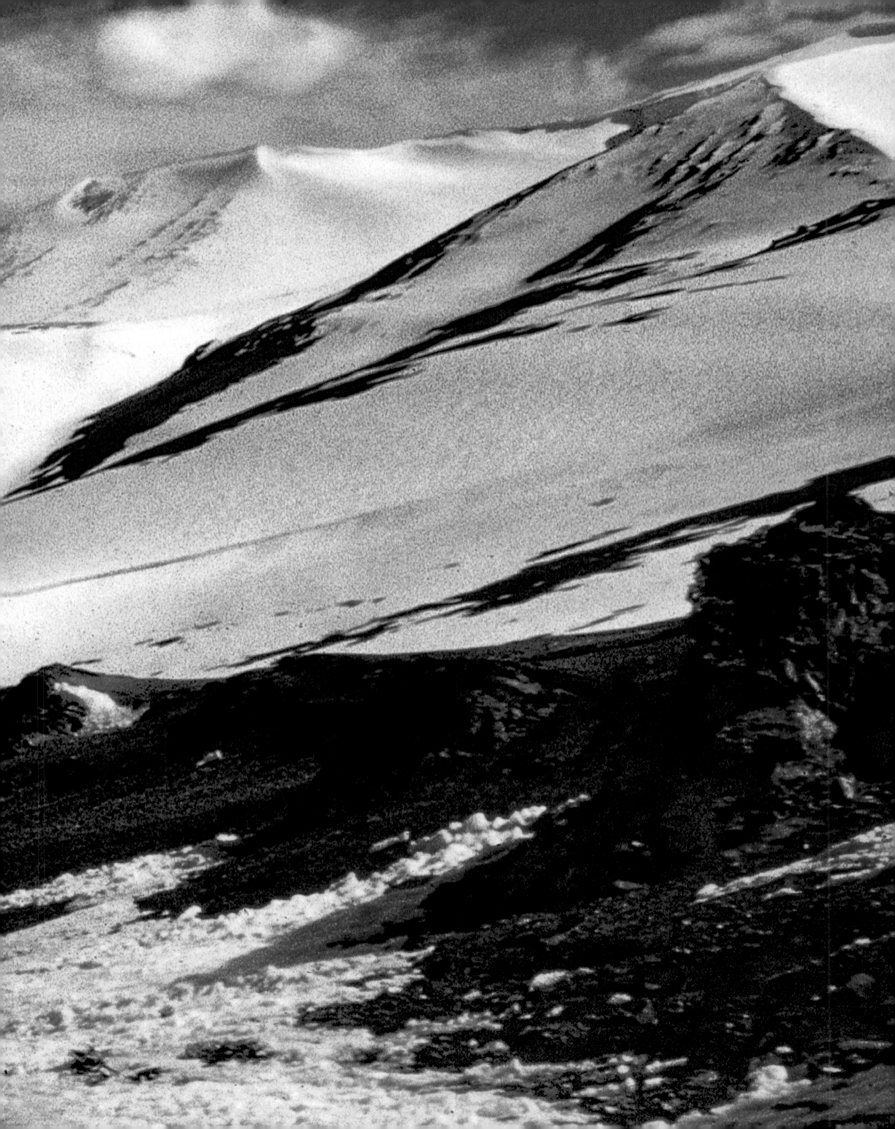

When I was escaping from Tibet I walked mainly at night. During the journey I didn't eat for four days. For seven days I just longed for a cup of tea. As well as that, the snow had blinded me. For three days I couldn't find anyone to travel with and I thought I would die. That was very hard for me. After losing my sight I was stranded without food for days. That, and the blindness,

made me feel very isolated – the thought of committing suicide crossed my mind. Then I heard the sound of bells on a horse and people talking. I shouted for help. It was some Nepalese and Tibetan traders passing by, though I wasn't sure that they were Tibetan until they began speaking about His Holiness the Dalai Lama.

Tsering Phuntsok, Dharamsala, India

THE DALAI LAMA

FOREWORD

It is now more than fifty-four years since I left my homeland for exile in India followed by a steady flow of Tibetan compatriots ready to embrace the life of a refugee. For many of us, the trauma of the upheavals that had already taken place in Tibet was sufficient to make the freedom of exile, with all its hardships, attractive.

However, I believe that the purpose of our coming into exile concerned much more than mere physical survival. In Tibet we were faced with a concerted threat to our identity. Our unique, rich and ancient cultural heritage was faced with imminent, actual destruction, and our social structure and our monastic institutions, the repositories of our education and culture, were turned upside down. The task of those of us in exile was not only to alert the world to what was going on in Tibet, appealing for help to stop it, but equally important to set about preserving our traditions as best as we could.

This attractive book of photographs by Albertina d'Urso reveals much that has taken place in the Tibetan community in exile. We have achieved much that we can be proud of and much that we can look forward to contributing positively to life in Tibet one day. We have not done this alone, but have received tremendous support from many quarters, and I hope we will continue to do so until our ultimate goal is realised.

September 7, 2013

Out of Tibet

Albertina d'Urso

Dewi Lewis Publishing

They say pictures speak louder then a thousand words. This photo book 'Out of Tibet' by Albertina d'Urso is an eloquent depiction of the rich cultural landscape of Tibetan refugees in India and elsewhere.

The exile Tibetan population of about 150,000 is scattered all over the globe. However, under the enlightened leadership and guidance of His Holiness the Dalai Lama, the Tibetan Diaspora has for over half a century continued to remain a highly coherent, democratic community that has successfully preserved and advanced its rich cultural and religious heritage.

In Tibet, the Chinese government has undermined the unique religious, cultural and linguistic identity of the Tibetan people. Many therefore say that today the real Tibet survives but only in exile, with Dharamsala in India, where the headquarters of exile Tibetan polity is located, as the 'Little Lhasa' of the Tibetan Diaspora.

This book serves as a further testament to the fact that you can take Tibetans out of Tibet, but you can never take Tibet out of Tibetan hearts and minds.

As the first democratically elected political successor of His Holiness the Dalai Lama, it is my great pleasure to write this introduction to a photo book that will greatly enhance global awareness and understanding about the trials and tribulations in the life of Tibetan refugees in exile.

Dr. Lobsang Sangay
Sikyong (Prime Minister) of the Central Tibetan Administration

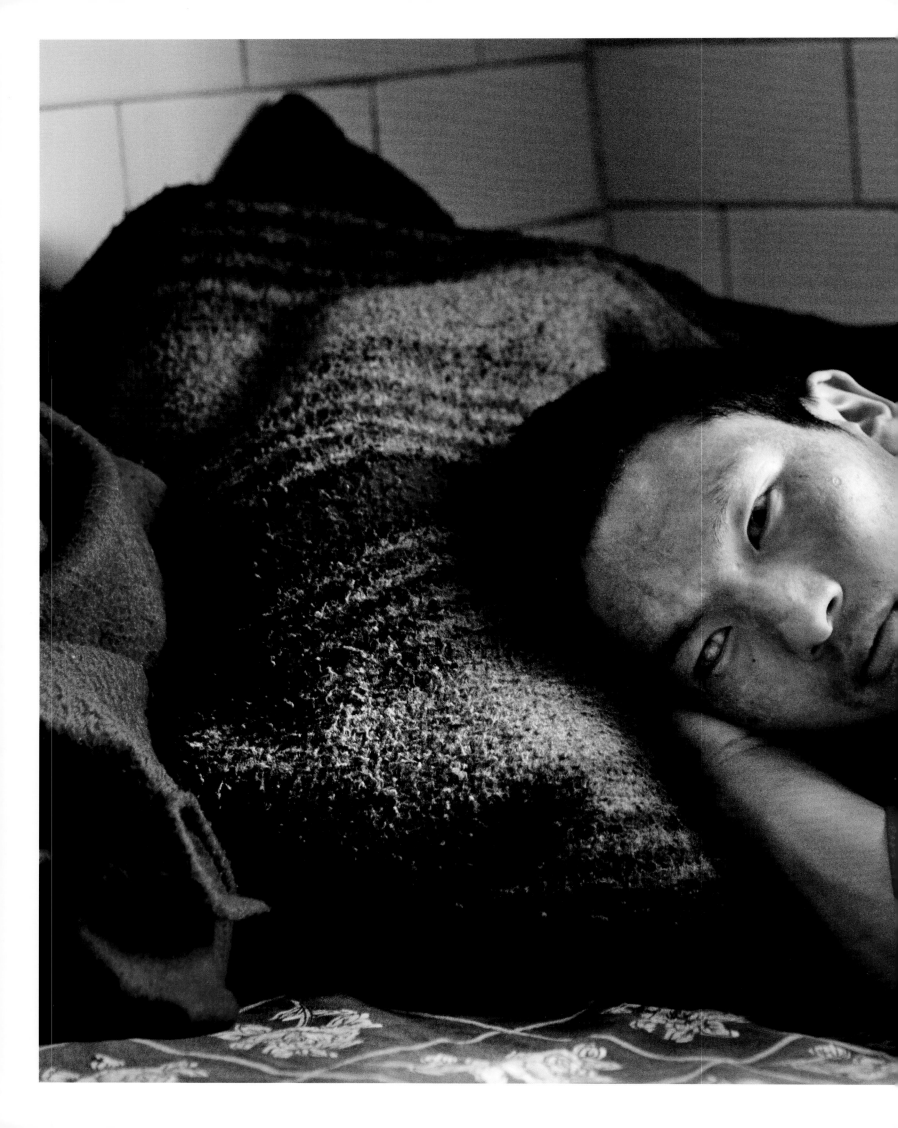

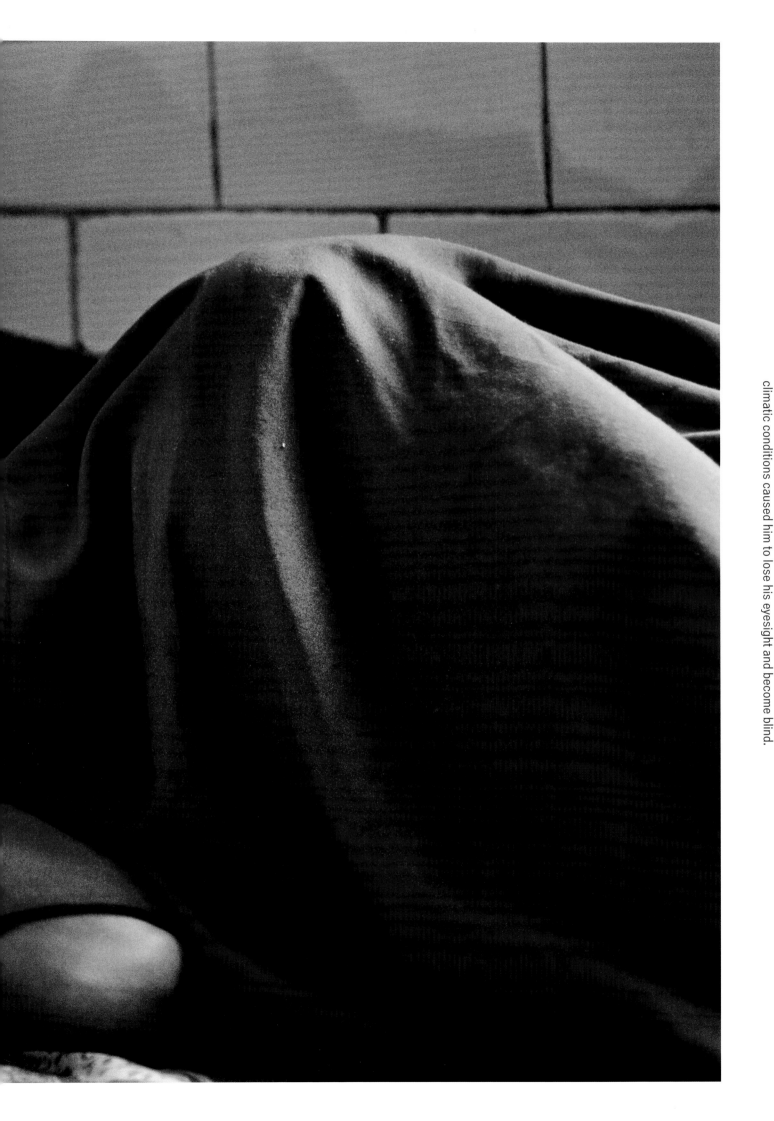

DHARAMSALA, HIMACHAL PRADESH, INDIA - Tsering Phuntsok, a Tibetan monk who escaped from Tibet after the 2008 uprising, rests at McLeod Ganj reception centre for exiled Tibetans, the first place of refuge for new arrivals from Tibet. Like most of the refugees who escaped from their homeland, 19 year old Phuntsok, crossed the hazardous terrain of the Himalayas, mainly at night and slept in caves. During the journey the extreme climatic conditions caused him to lose his eyesight and become blind.

TORONTO, CANADA - Exiled Tibetans outside the Rogers Centre, after attending a public talk given by His Holiness the Dalai Lama. 22 October 2010.

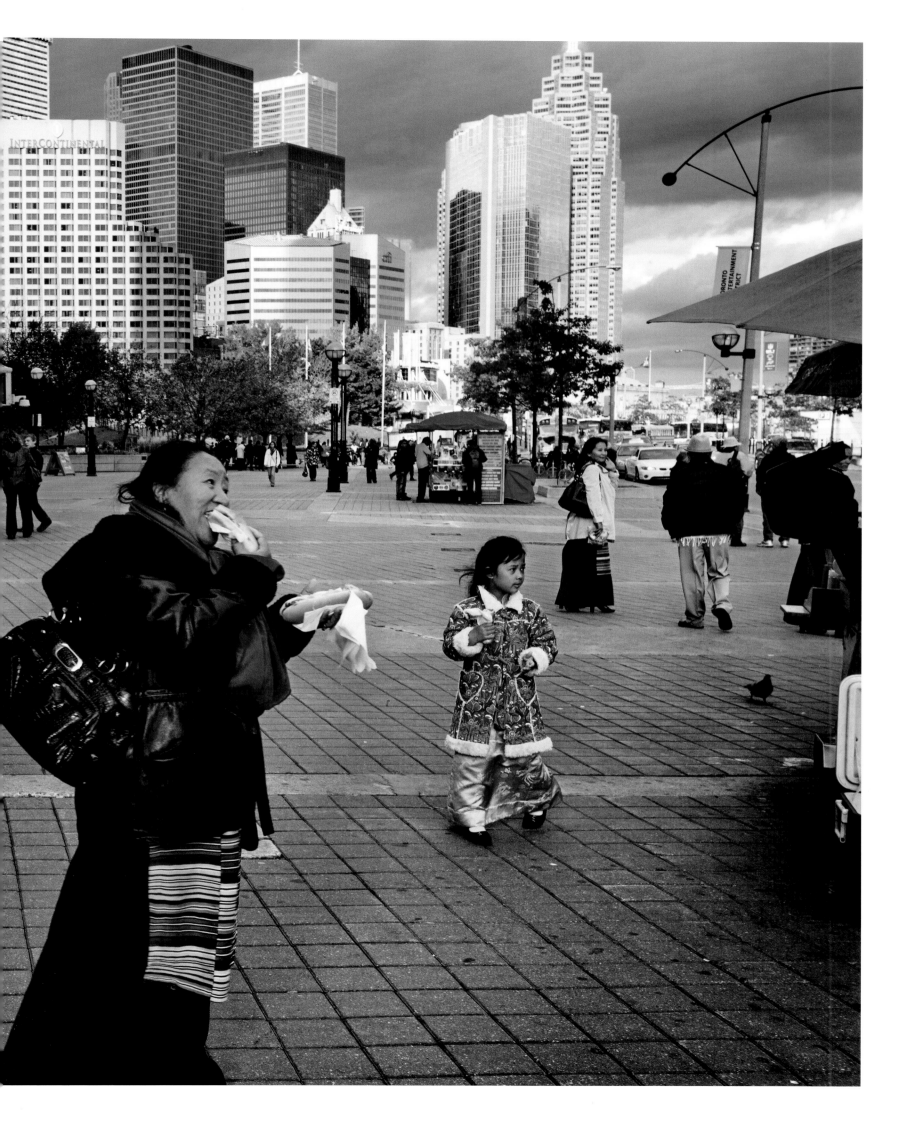

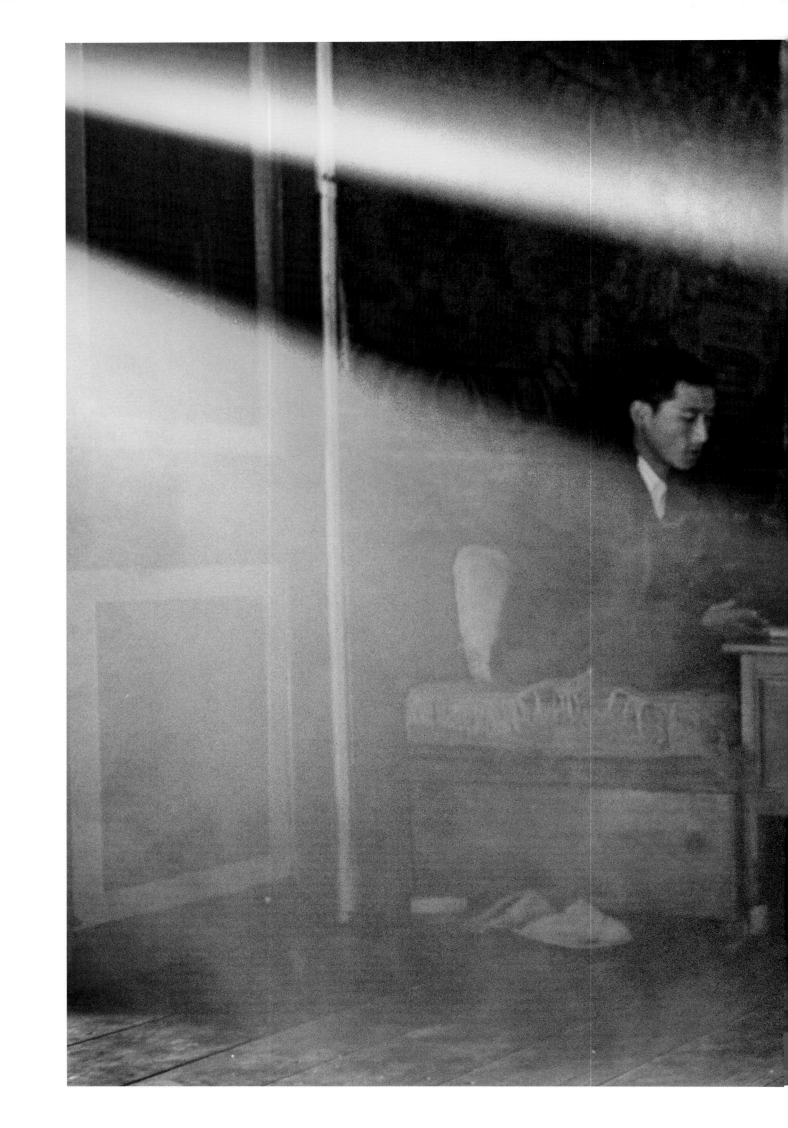

DARJEELING, INDIA - Light pouring in through a door at Sakya Choling Gompa frames a Rinpoche (reincarnated lama) while he holds early morning Puja (prayers). This is a daily ritual in most Tibetan monasteries.

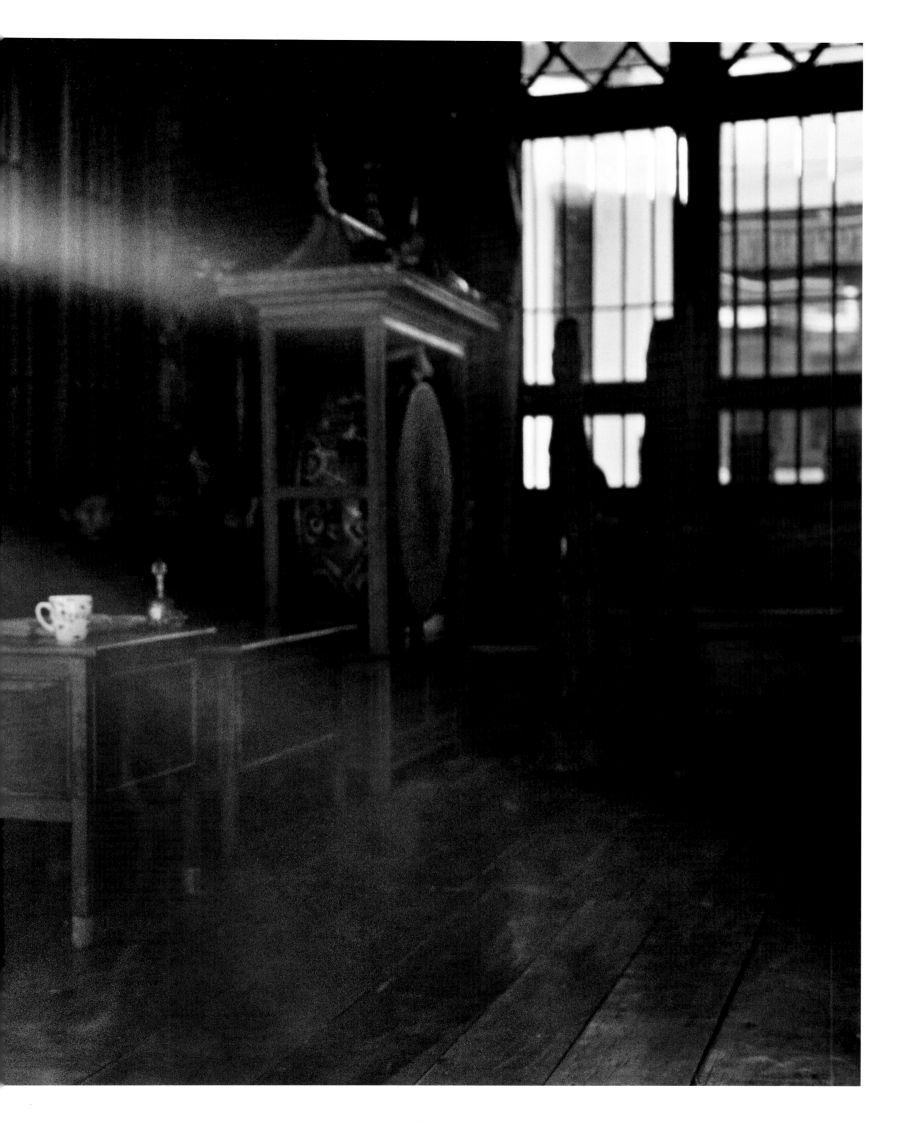

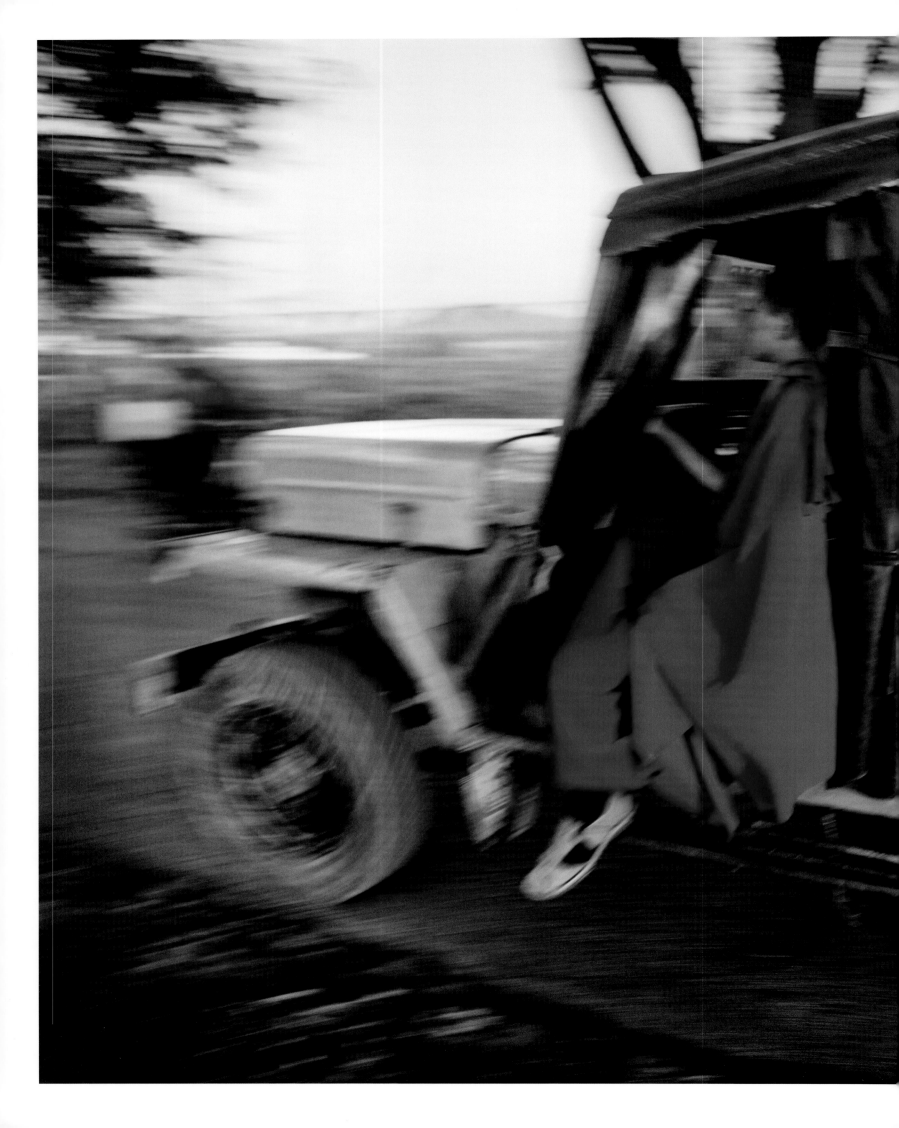

MUNDGOD, KARNATAKA, INDIA - Tibetan monks take an early morning 'Jeep' ride to attend a teaching by His Holiness the Dalai Lama at Mundgod, one of the largest Tibetan refugee settlements.

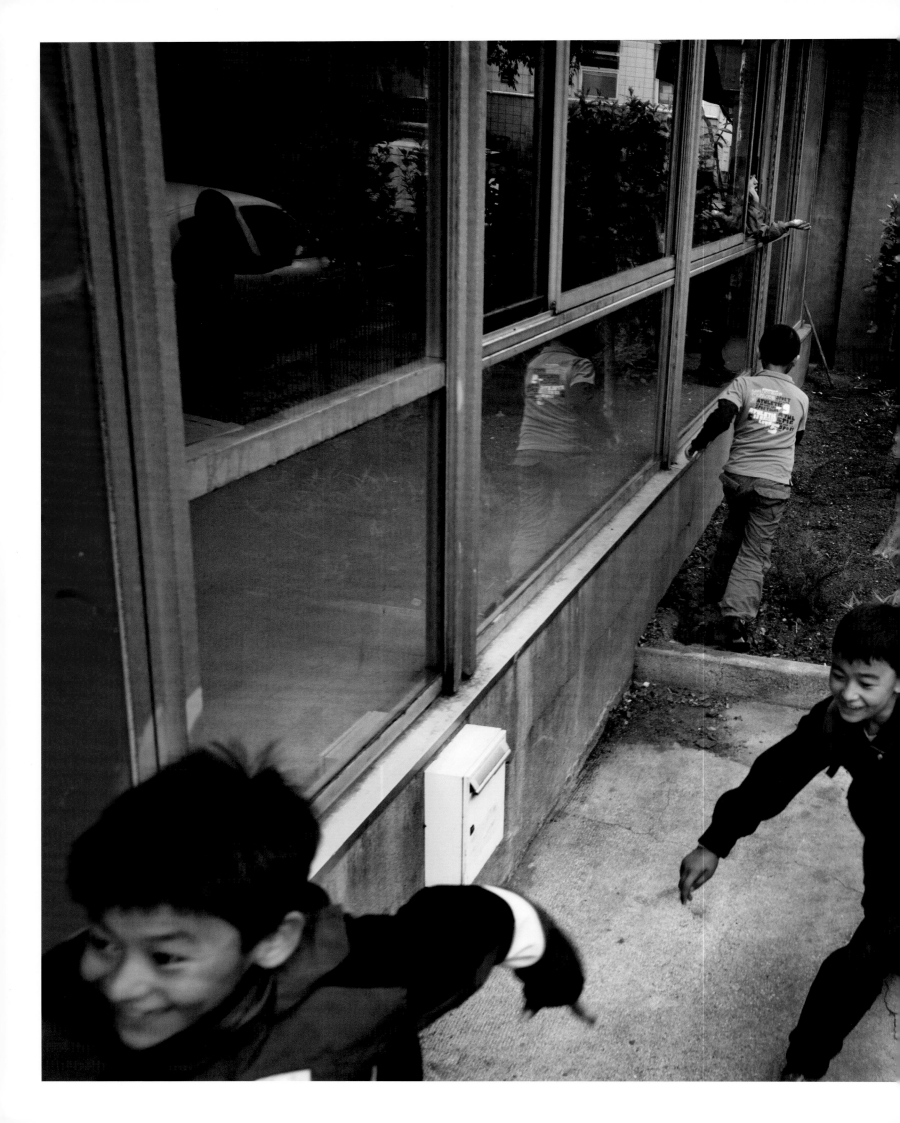

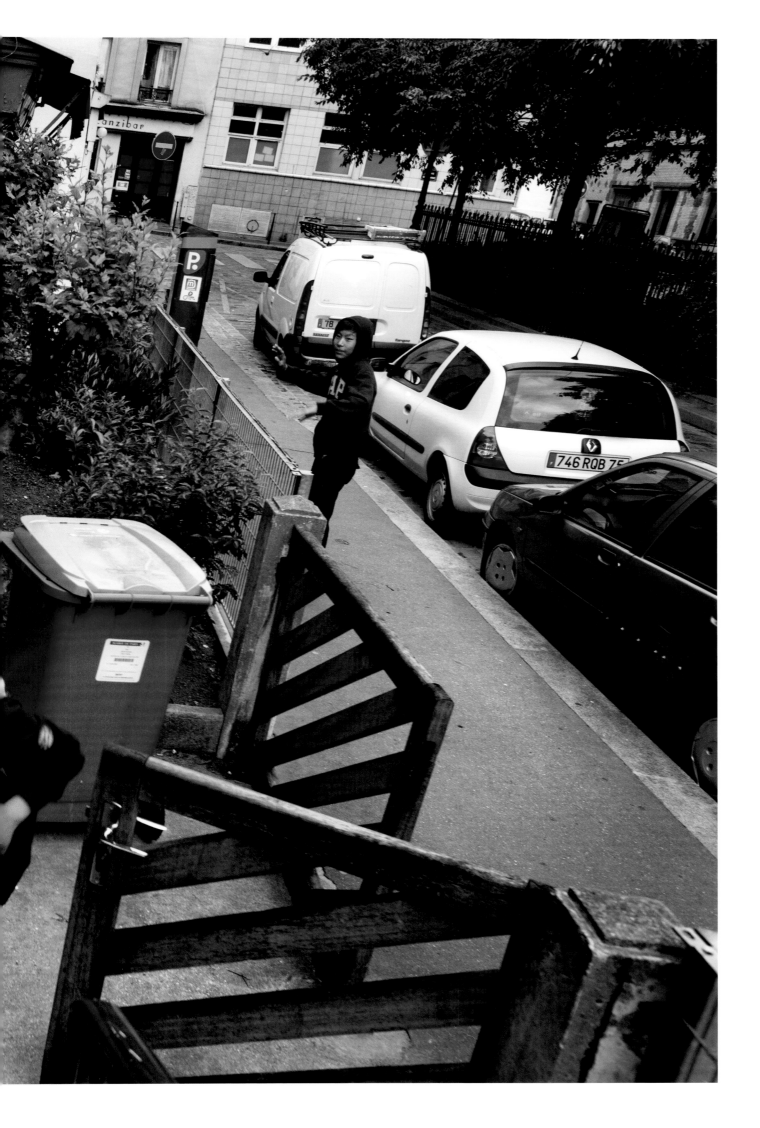

PARIS, FRANCE - Tibetan children outside a 'Sunday school', run at the Jean Aicard Hall. Provided for Tibetans by the city authorities, Tibetan culture, language, music, and songs are taught to children of Tibetan refugees who register for weekend classes.

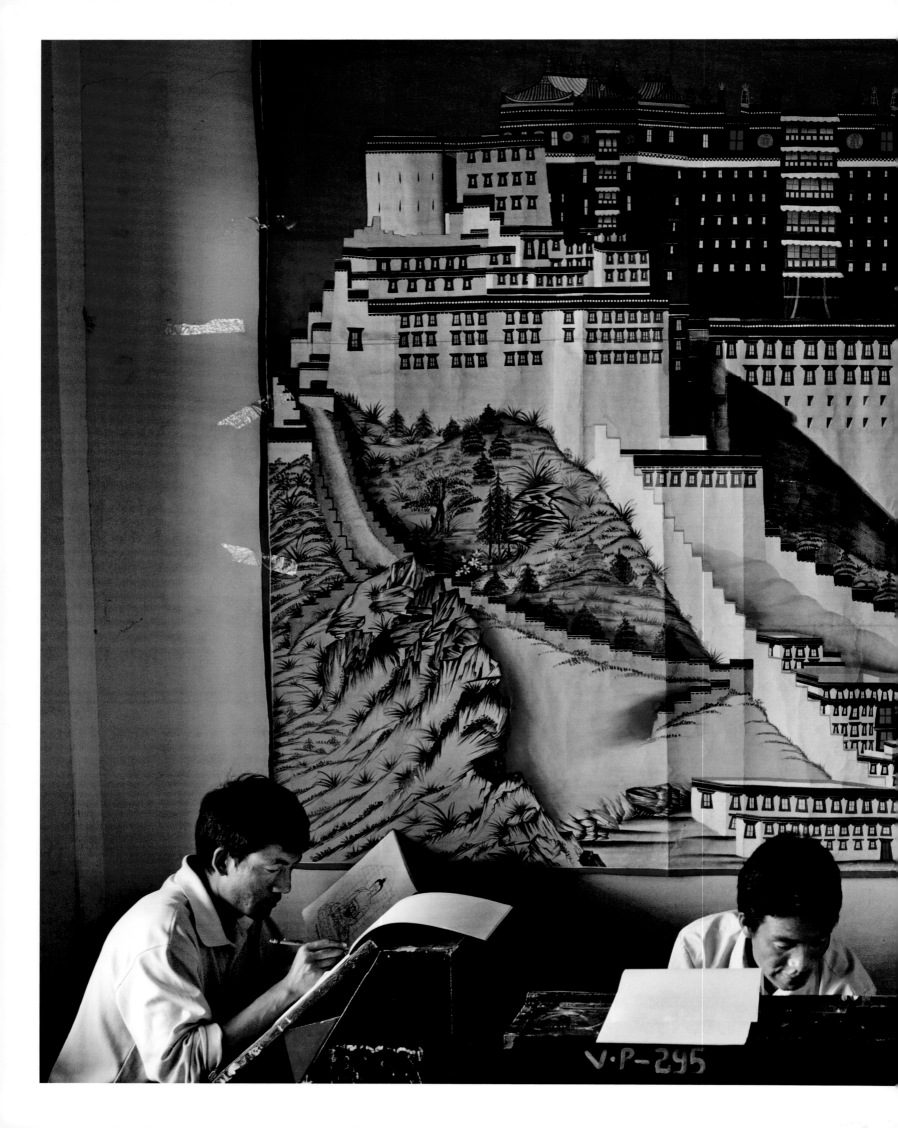

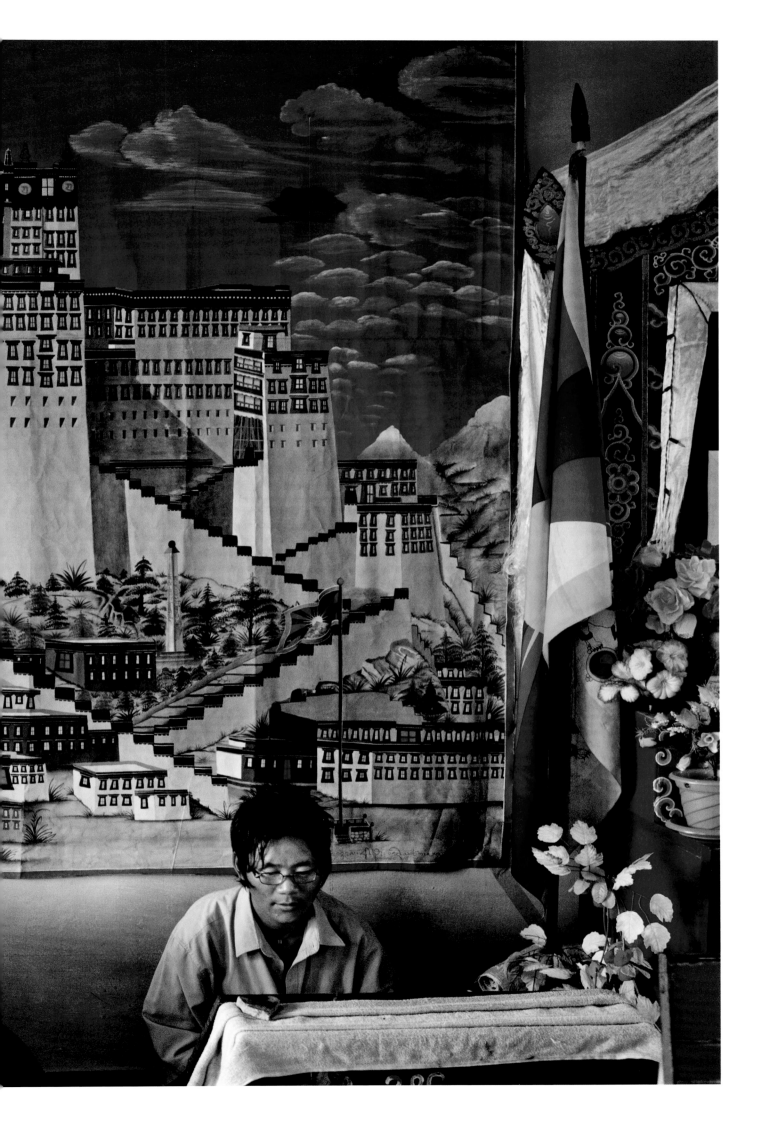

DHARAMSALA, HIMACHAL PRADESH, INDIA - Three Tibetan refugees practise the art of Thangka painting at the Tibetan Transit School (TTS). The school educates often illiterate new arrivals from Tibet aged between 18 to 30. They learn basic conversational skills to adapt to the new environment of a foreign country and to help them get work.

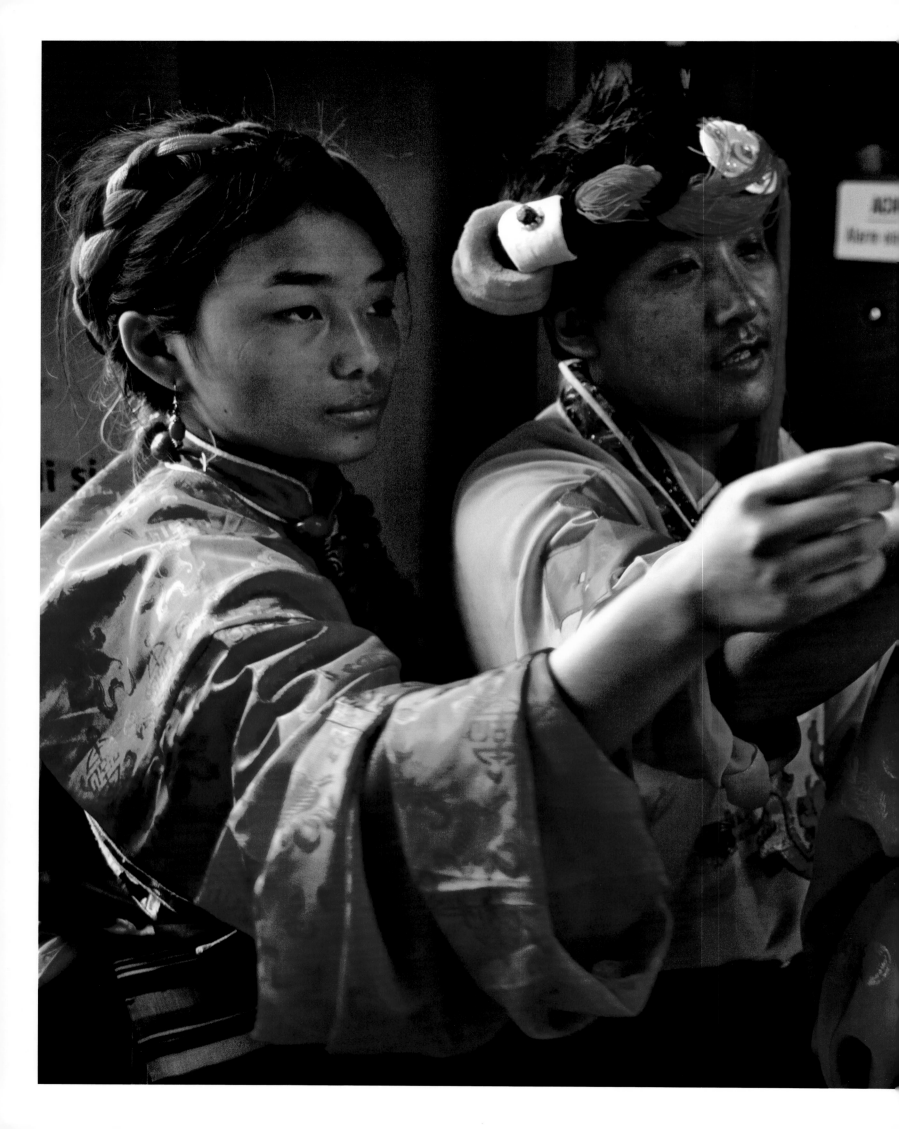

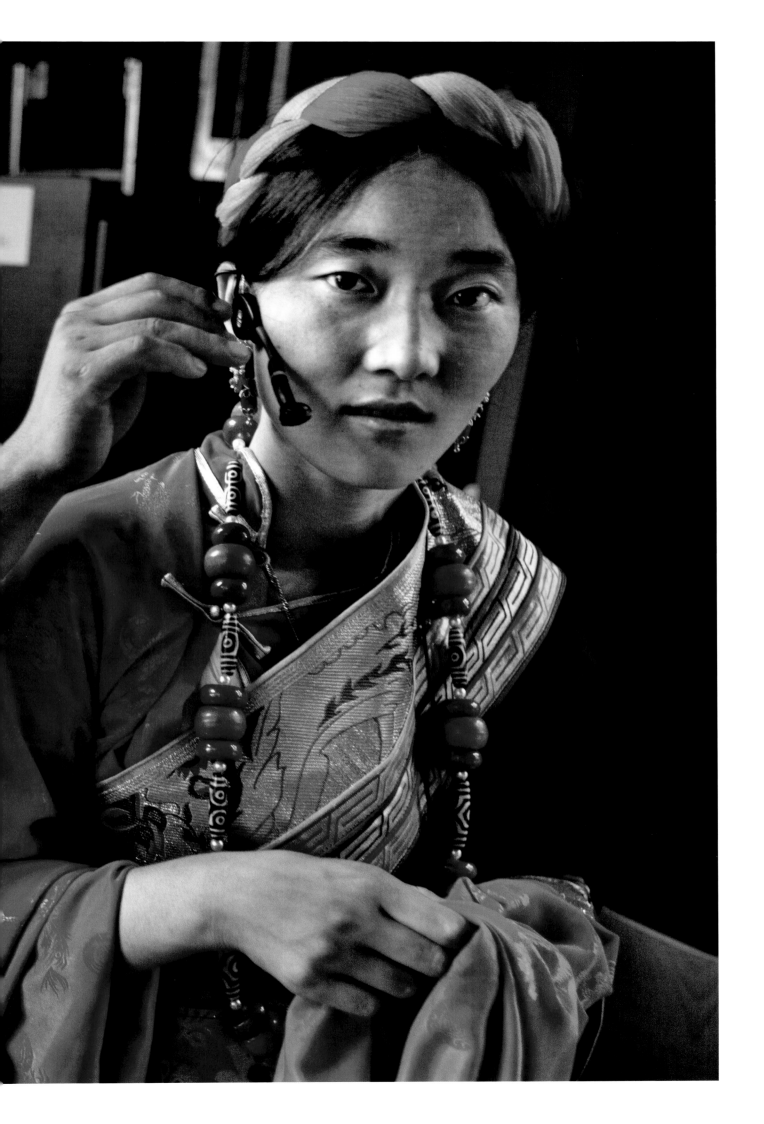

ZURICH, SWITZERLAND - Tibetan performing artists in traditional costume, backstage in Bulach Stadthalle at an event to celebrate the 75th birthday of His Holiness the Dalai Lama.

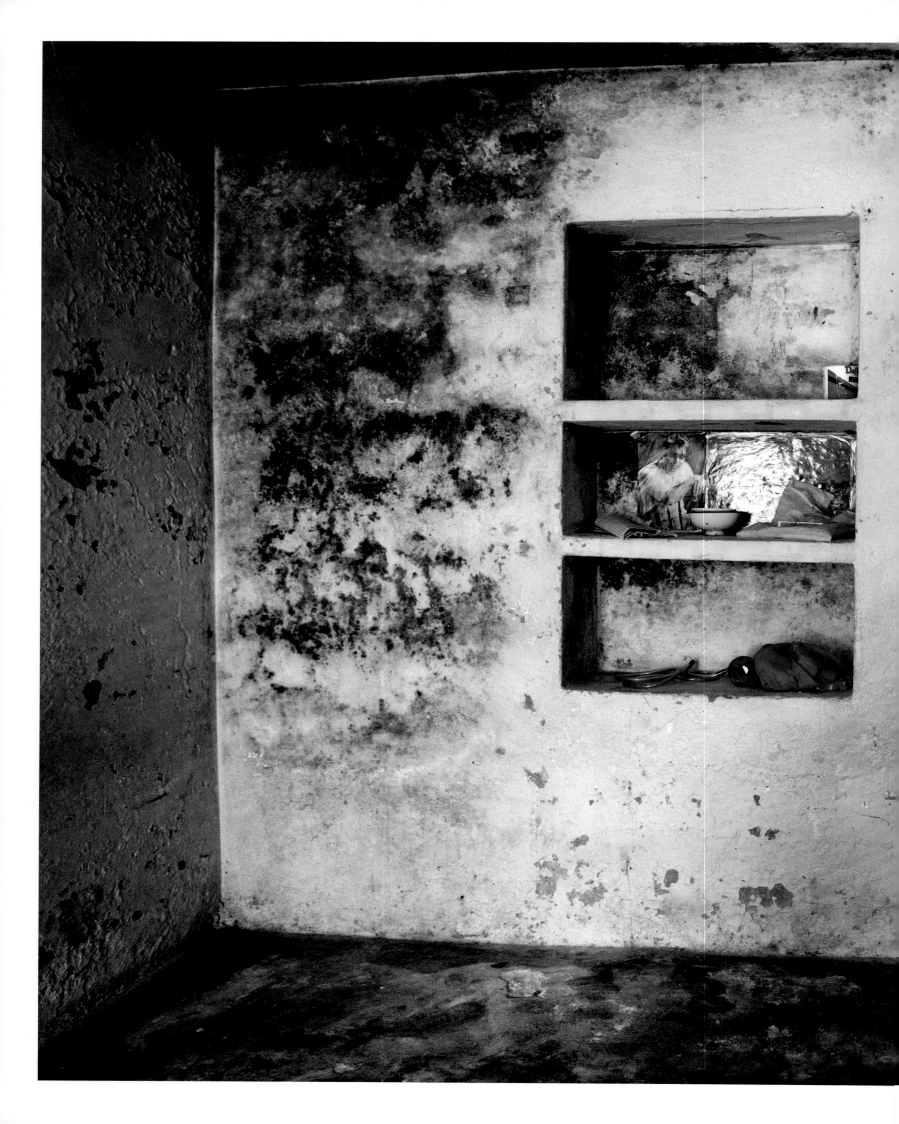

DHARAMSALA, HIMACHAL PRADESH, INDIA - Piled in the corner of the room are all the belongings of Choezom, a nun recently escaped from Tibet.

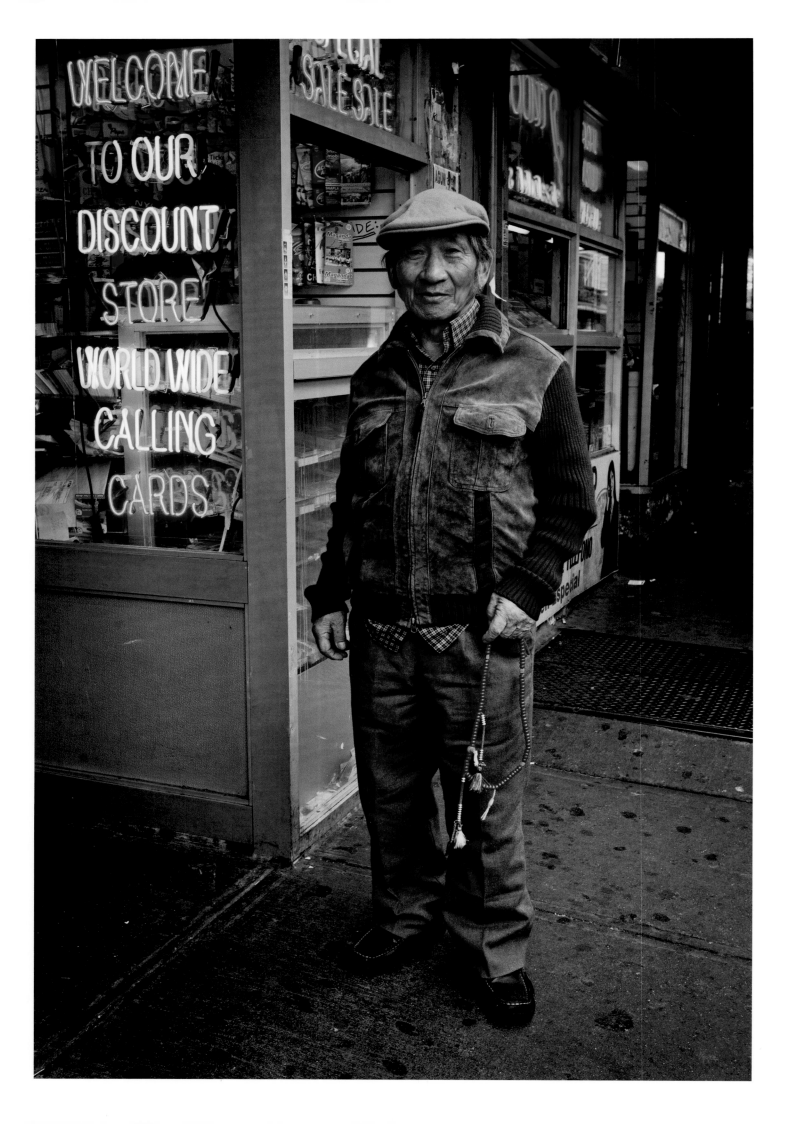

I haven't been able to see my family for twenty years and to make things worse, my mother died while I was in India. Being separated from your loved ones and the place you call home isn't a good experience but I didn't want to continue living in a colonial and oppressive environment, where neither individual or collective freedom nor human dignity have any place. It's a great sadness to me that I was unable to live in my own country and that I've been forced to spend a great deal of my life abroad.

Seeking exile in India with His Holiness the Dalai Lama meant that I could enjoy freedom. This, in turn, gave me the chance to develop my intellectual faculties in my quest for knowledge about the world and my own identity. I feel privileged to be amongst those who are working to build a new Tibet under the aegis of the Dalai Lama. What's more,

I am delighted that Tibetans the world over have taken it upon themselves to make

people aware of Tibet's culture and its fight for freedom.

For the time being, we have lost control of Tibet, but we have gained a democratic political culture in exile without any periods of revolutionary unrest. I am absolutely convinced that sooner or later Tibet will regain its freedom and be restored to its people. One day, the people of Tibet will be able to hold their heads up high and link hands with the rest of the world to make it a better place. We will be proud to welcome our friends from around the world and to offer them a place where they can recharge their batteries and enjoy our hospitality.

Thupten Gyatso, (President of Tibetan community in France), Paris, France

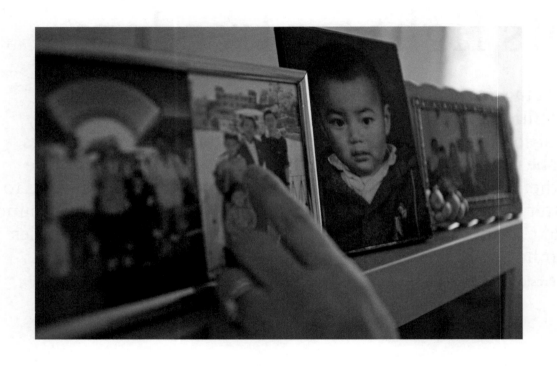

NEW YORK, U.S.A - An elderly Tibetan man with his 'mala', a rosary which has 108 beads and is used during the chanting of prayers and mantras.

DHARAMSALA, HIMACHAL PRADESH, INDIA - A young Tibetan mother and her child marching in McLeod Ganj to demand the release of Tibet's second most important spiritual leader, the Panchen Lama, on the occasion of his 19th birthday. At the age of five, Gedhun Chokyi Nyima was recognised as the 11th reincarnation of the Panchen Lama. Detained by Chinese authorities five days later, he is considered to be the youngest political prisoner and his whereabouts remain unknown. 25 April 2008.

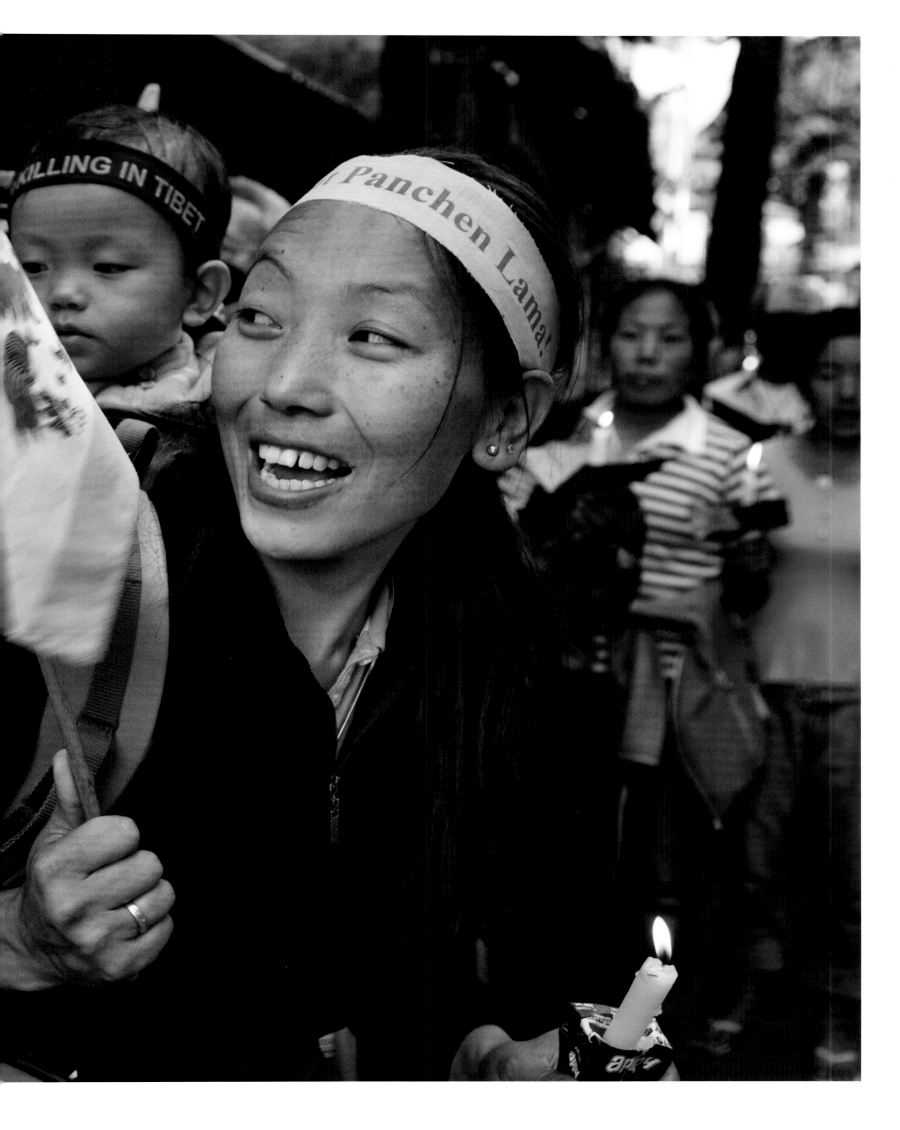

AMSTERDAM, HOLLAND - Dhondup sleeps on the metro after work. He escaped from Tibet in 2002 and crossed over to Nepal by walking for 25 days through the Himalayas. He was in transit in Nepal for two weeks before being able to emigrate to Holland where he got a job as a housekeeper in a hotel.

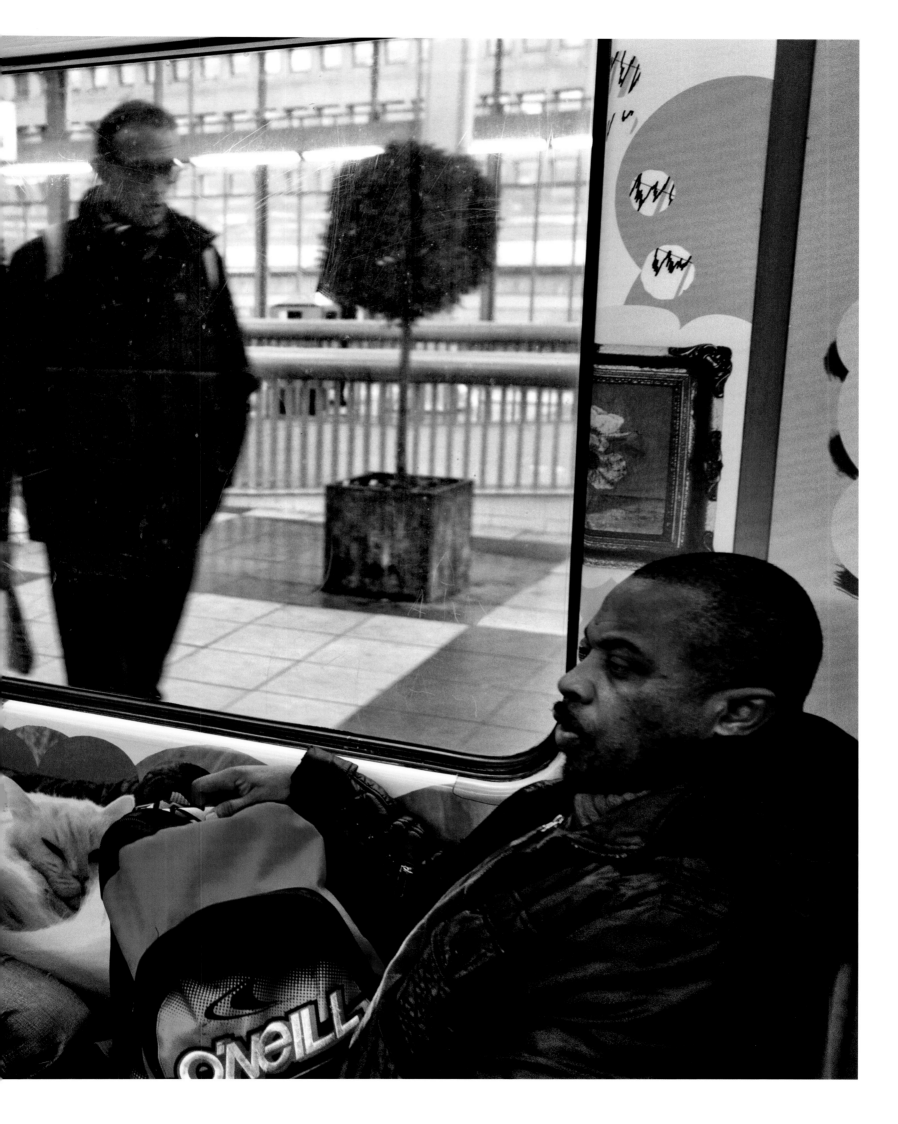

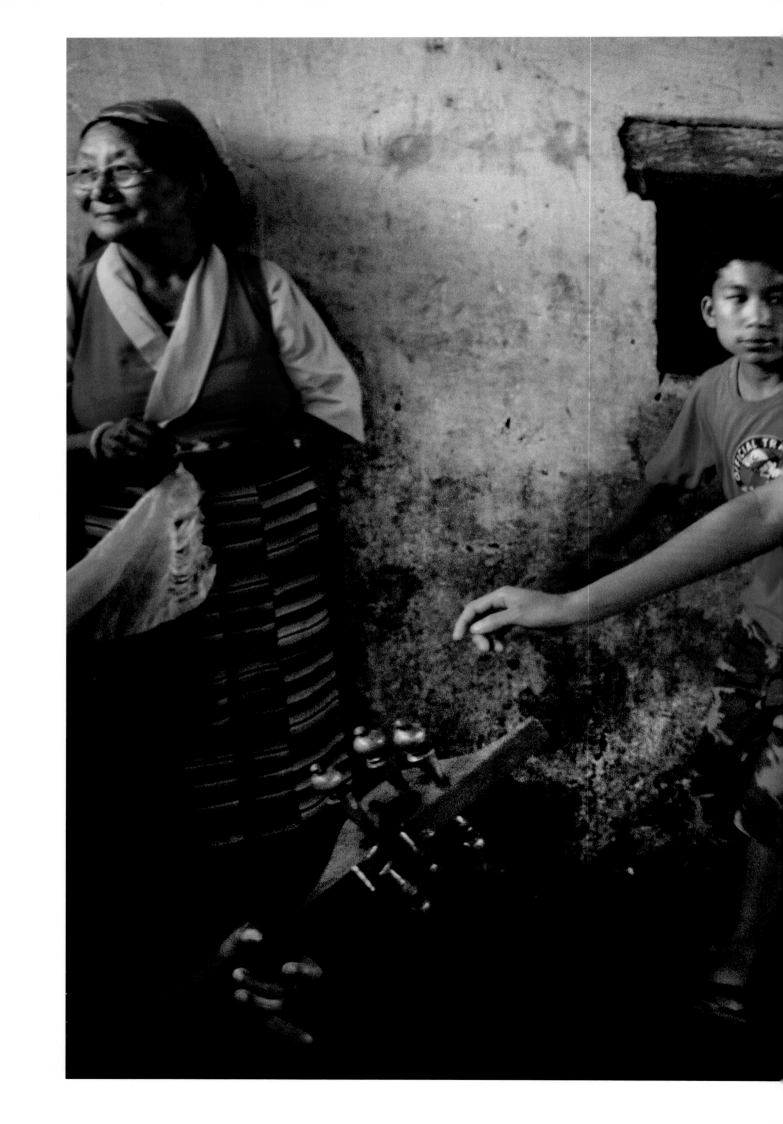

BYLAKUPPE, KARNATAKA, INDIA - Young exiled Tibetans practise Tibetan traditional dance in Bylakuppe, the first and largest Tibetan settlement in the southern state of Karnataka.

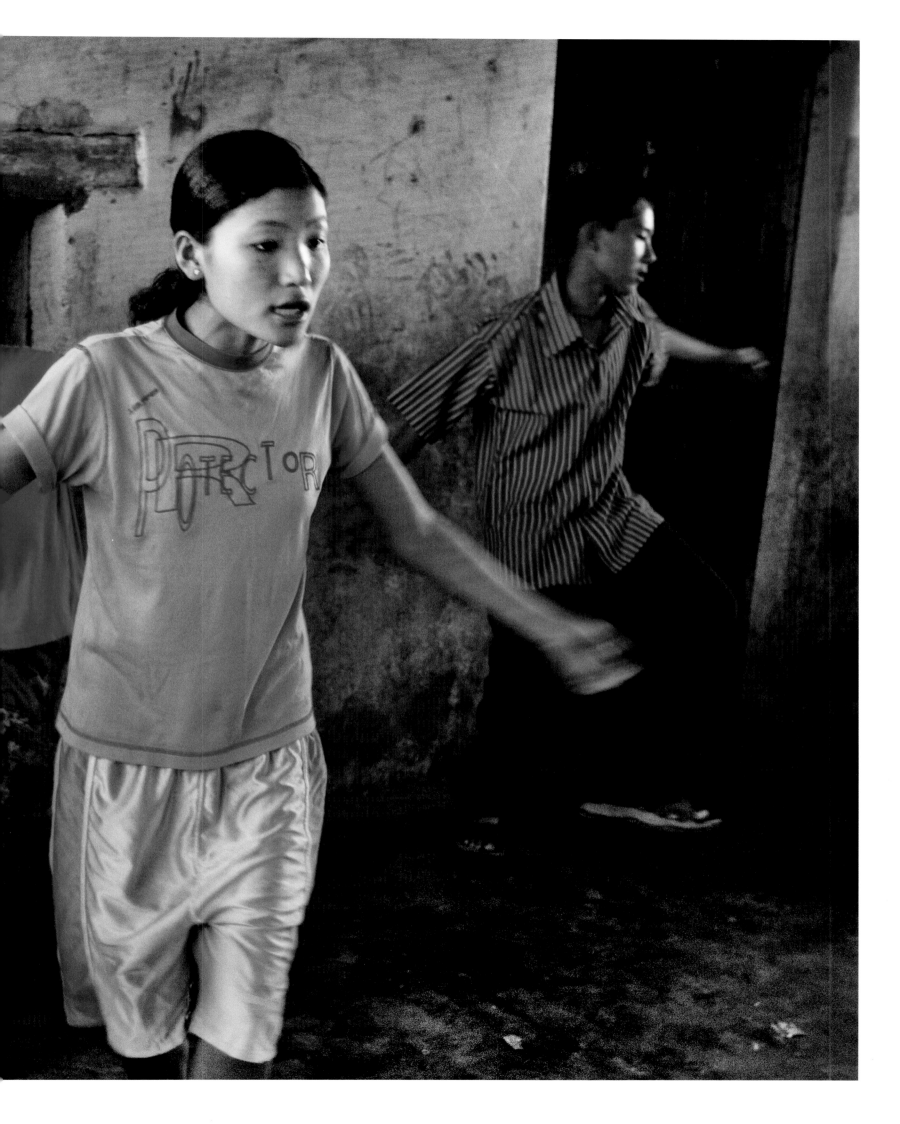

RUPSU VALLEY, LADAKH, INDIA - Tibetan mother and son outside their tent.

I want to marry a Tibetan because I want to continue our race and increase our population in order to keep the Tibetan identity. If I marry someone else I'm afraid my children are going to lose that. Yeshay, New York, USA

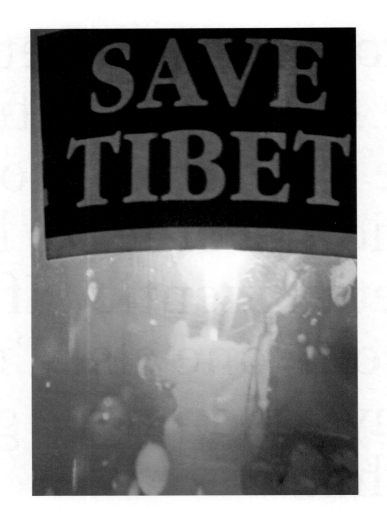

The only positive side of the Tibetan diaspora is that, today, our culture and the teachings of His Holiness the Dalai Lama are not just for our people but are shared with all the world.

Pempa, Alessandria, Italy

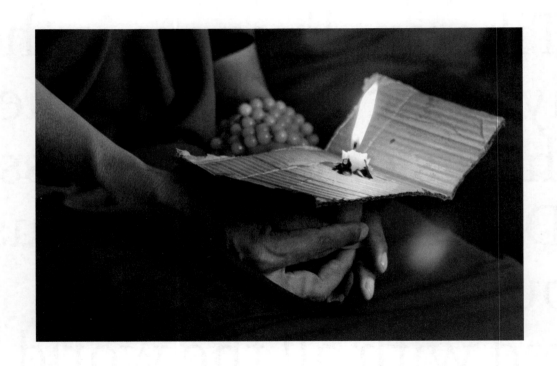

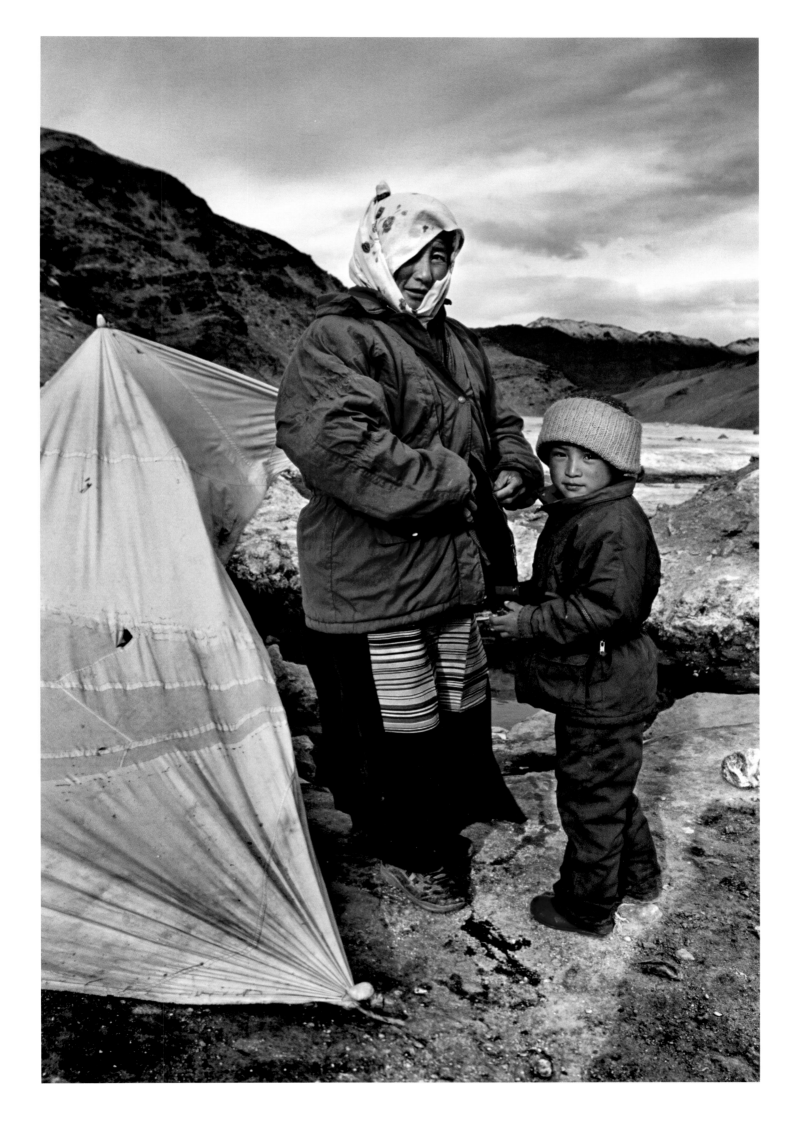

LONDON, UK - Young Tibetans take a smoking break during a solidarity event organised for 'Free Tibet'.

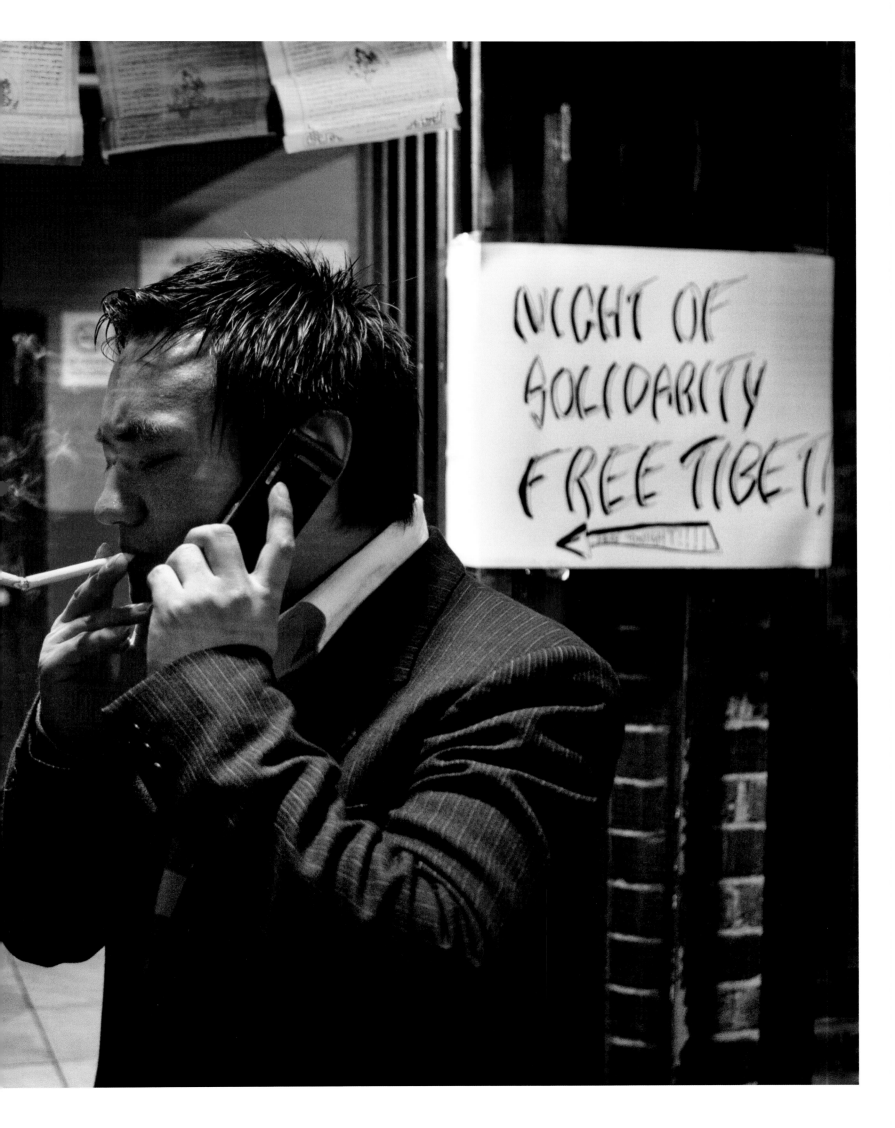

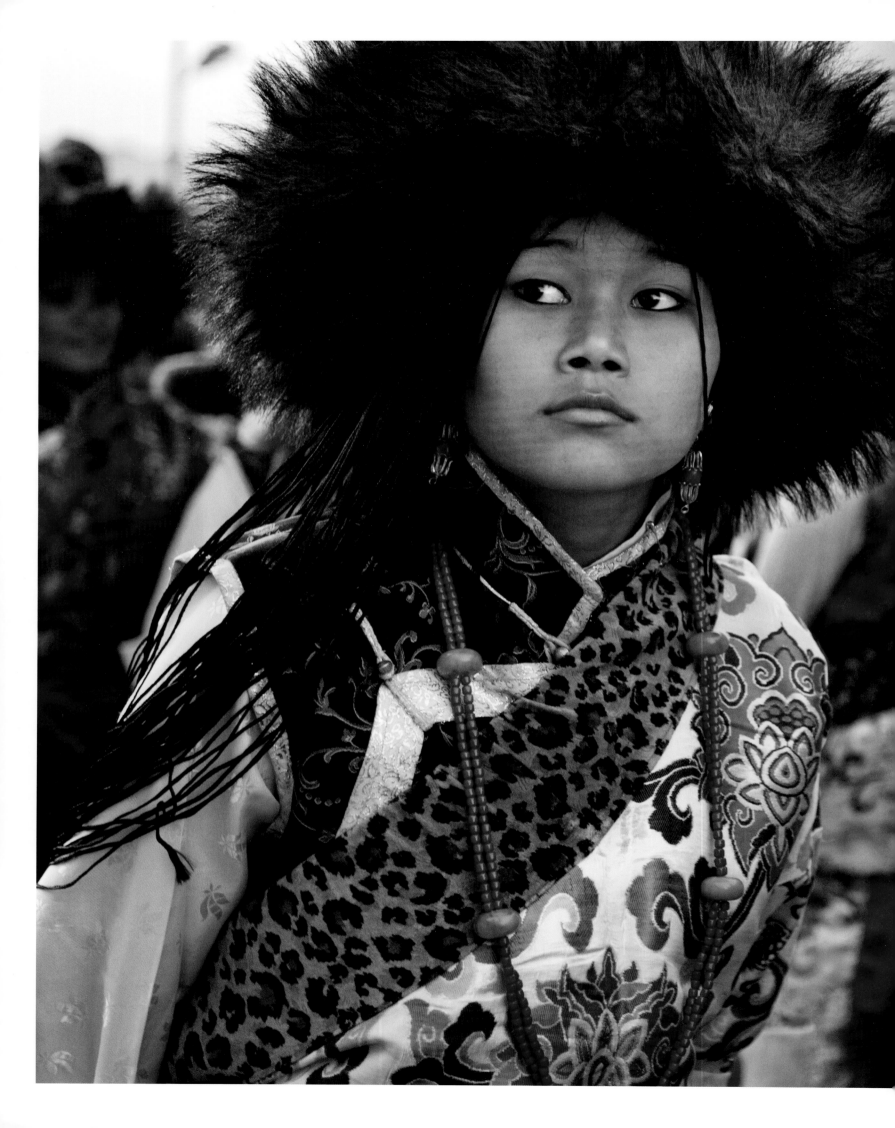

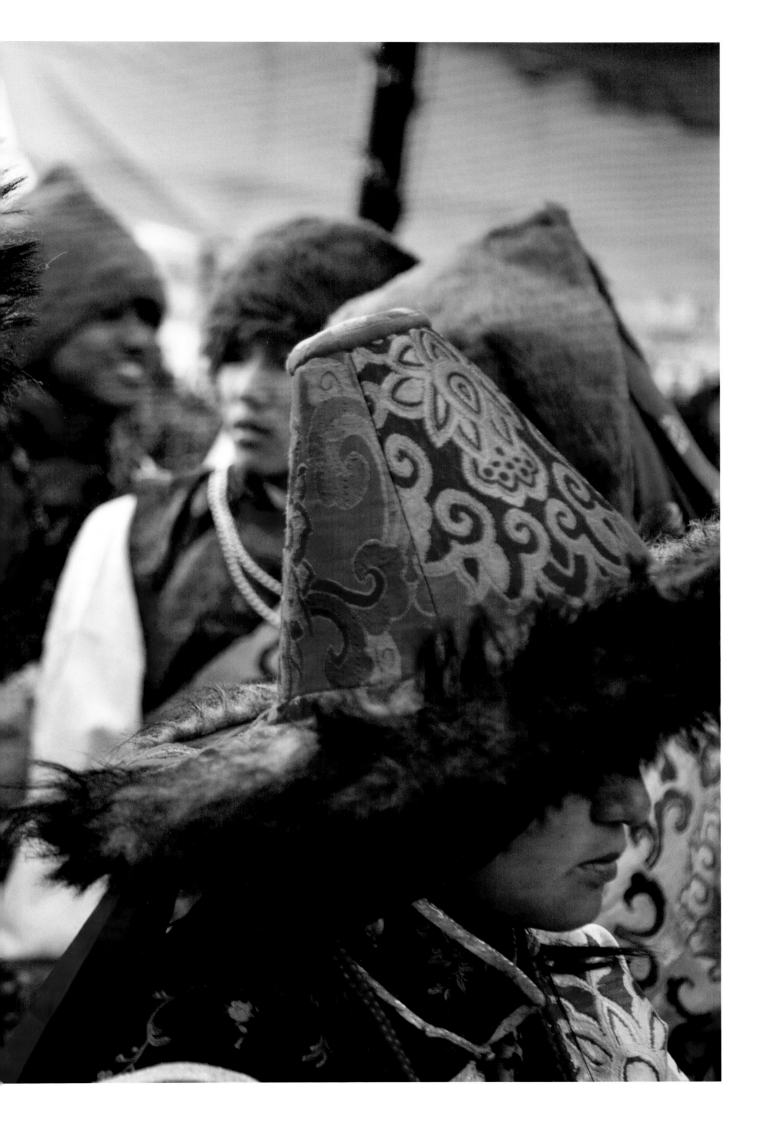

MUNDGOD, KARNATAKA, INDIA - Young Tibetan girls dressed in traditional Khampa and Amdo attire get ready to perform their traditional dances during the teachings imparted by their spiritual leader the Dalai Lama in Mundgod refugee camp.

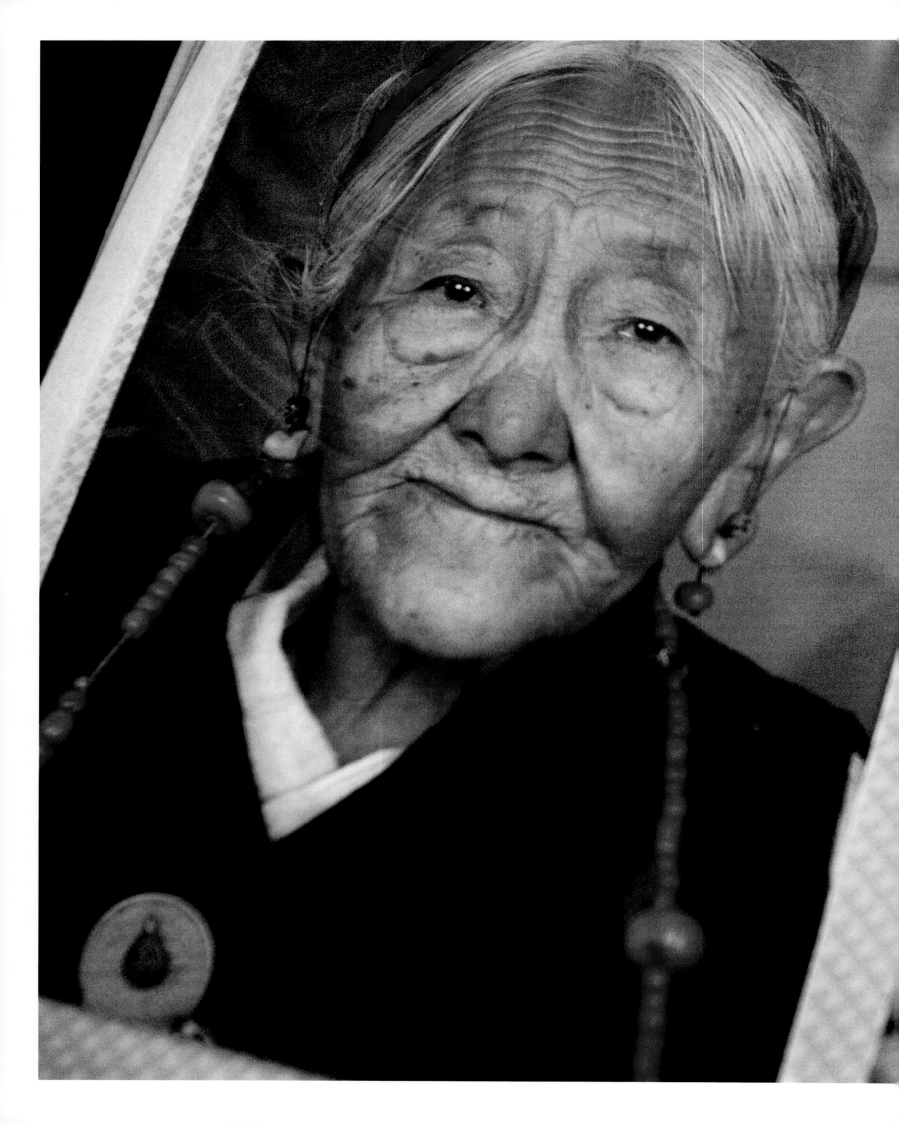

NEW YORK. U.S.A - An exiled family now settled in Brooklyn show an album of photographs shot in Tibet.

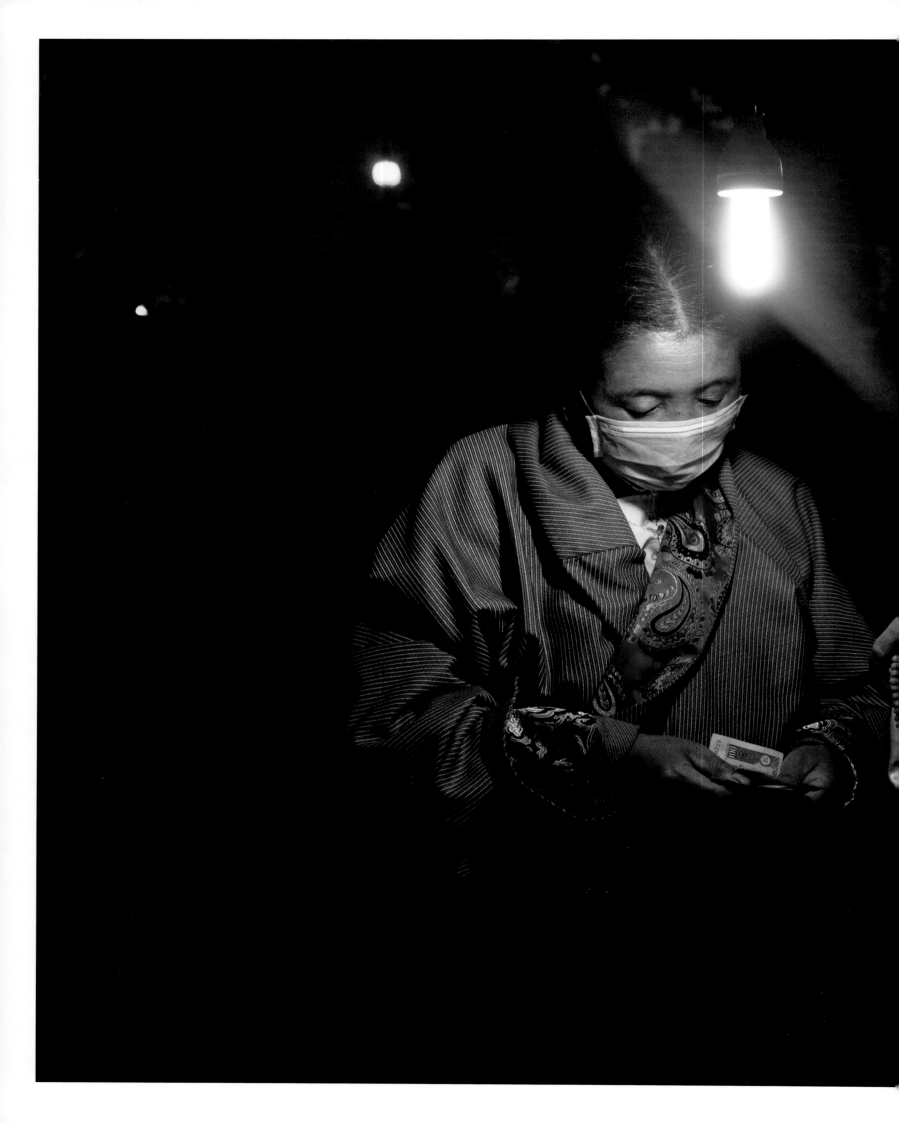

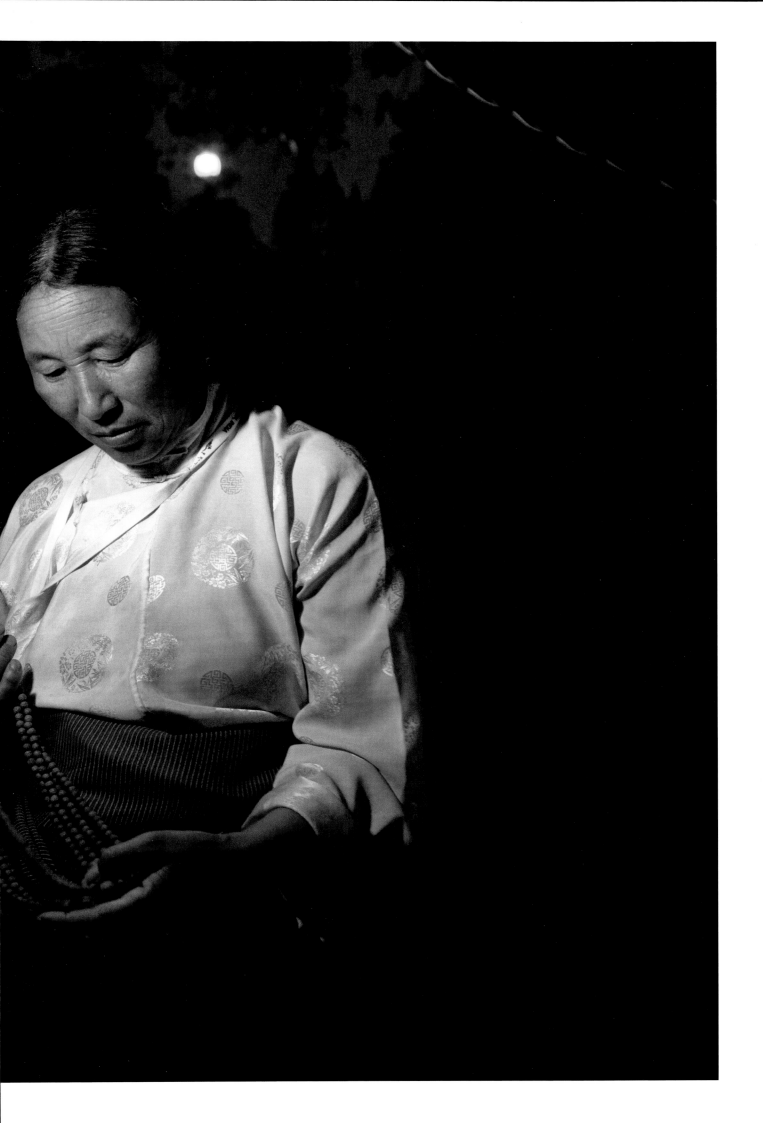

BODH GAYA, BIHAR, INDIA - Tibetan women look at prayer beads (mala) on sale at a street vendors. While chanting mantras Tibetans rotate the mala between their fingers. Most Tibetans carry one at all times.

NEW YORK, U.S.A - Jackson Heights, Queens, is a suburb of New York, and the area where most of the Tibetan refugees live.

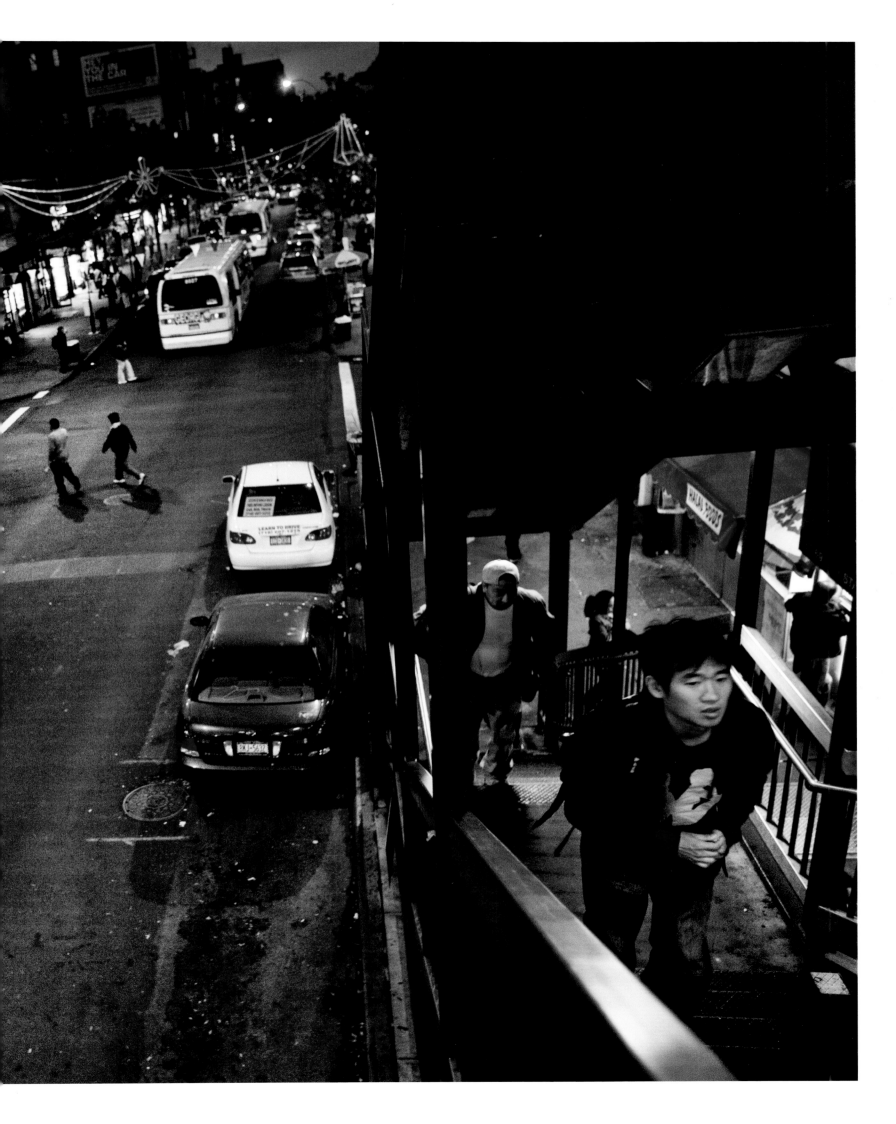

DHARAMSALA, HIMACHAL PRADESH, INDIA - Exiled Tibetan youths play basketball on a court where many young Tibetans gather each evening.

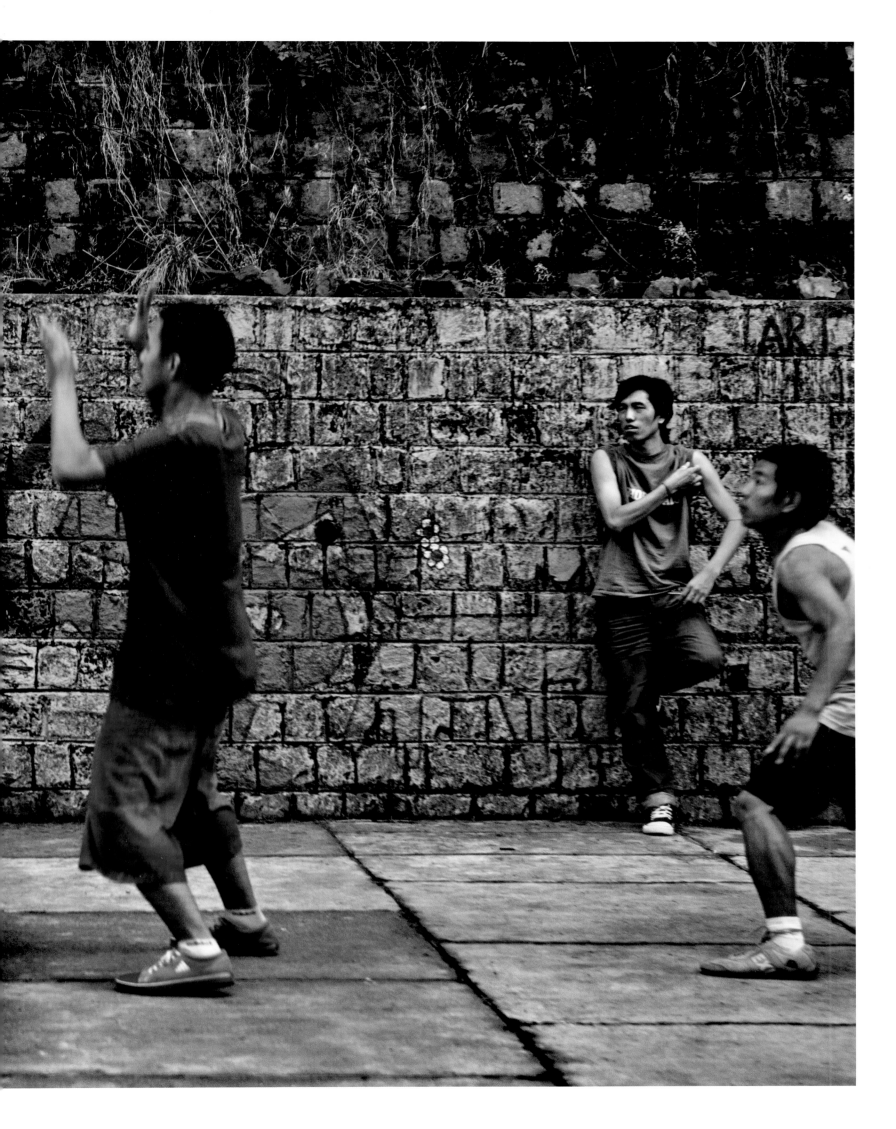

BULACH, STADTHALLE, ZURICH, SWITZERLAND - Displaced young Tibetan women in their best traditional costumes perform a traditional dance from the Kham region of eastern Tibet in celebration of the 75th birthday of their spiritual leader, the Dalai Lama.

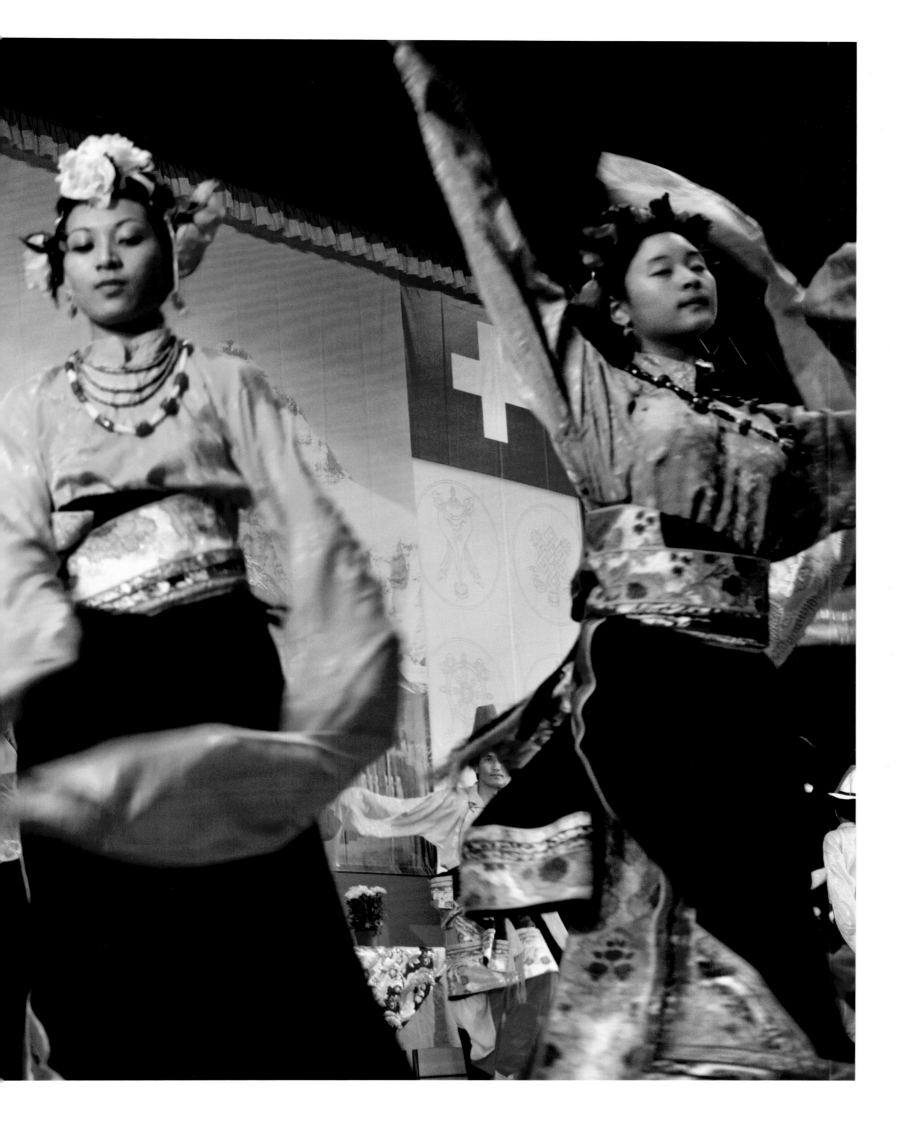

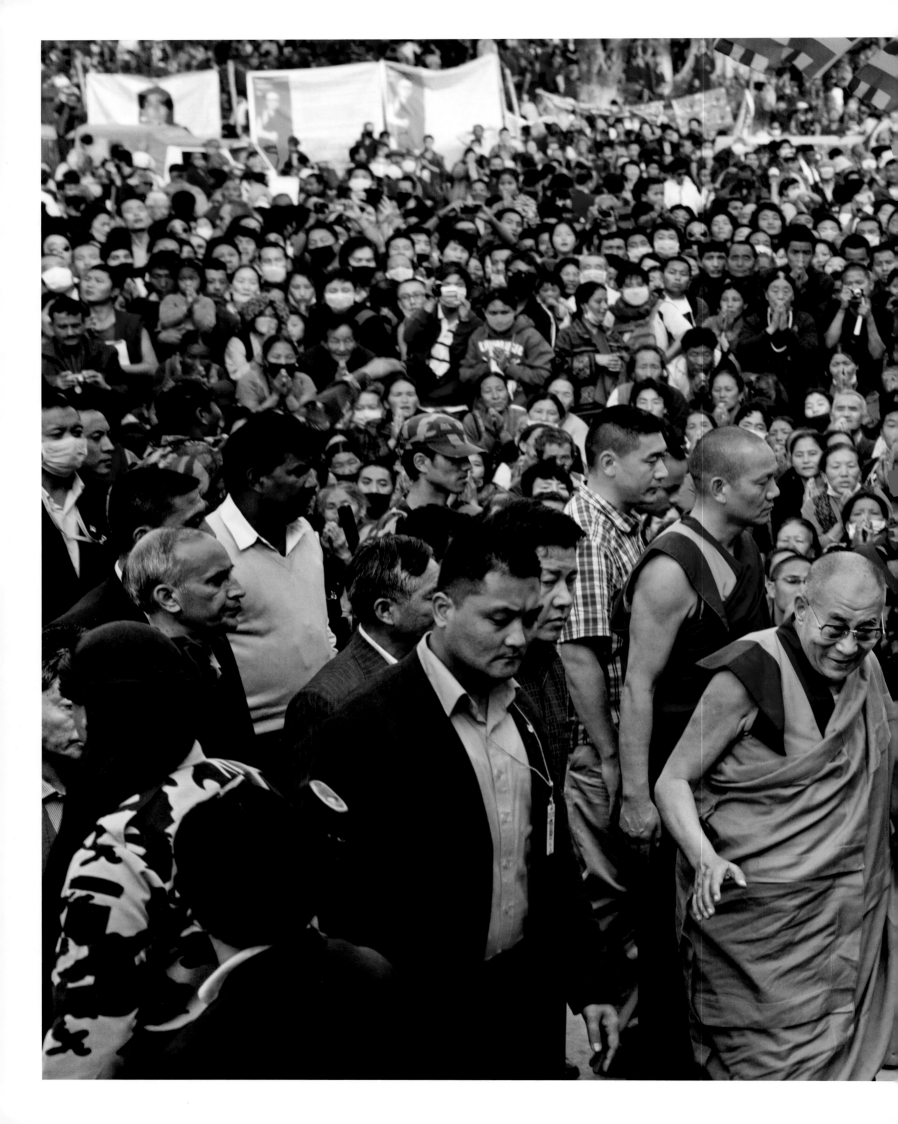

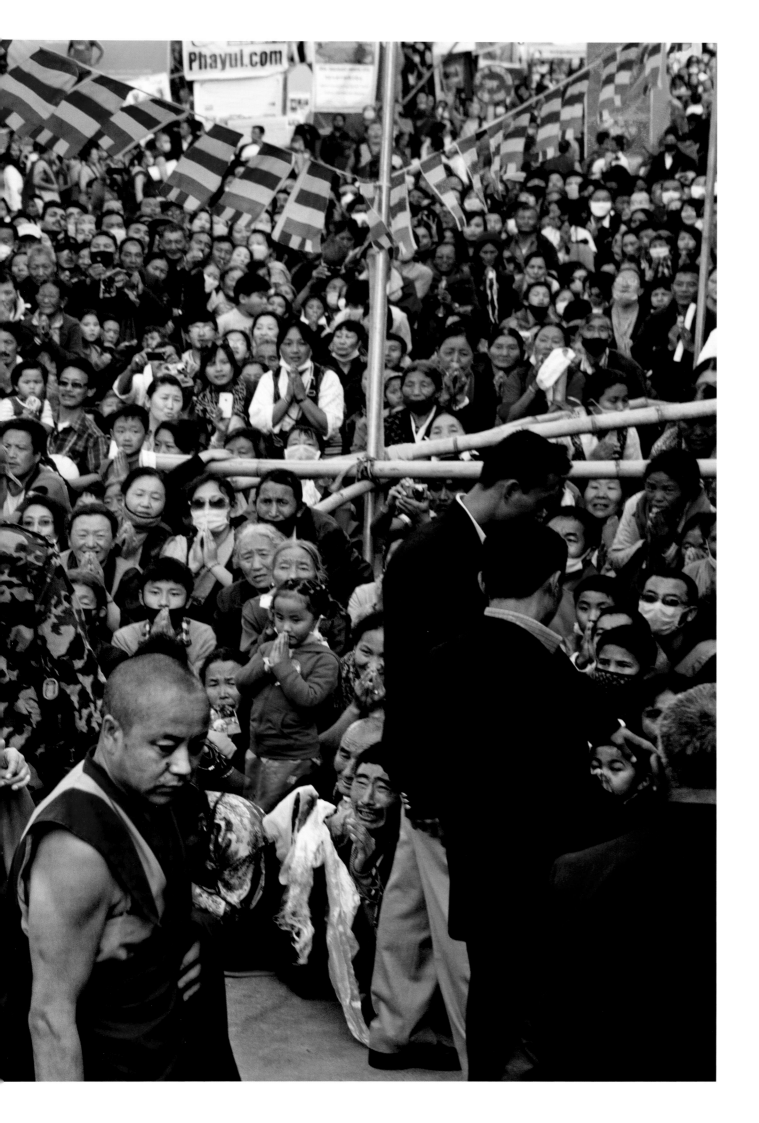

BODH GAYA, BIHAR, INDIA - His Holiness the Dalai Lama greets the crowd as he walks towards the stage during the 2012 Kalachakra, an event for teachings and prayers in Bodh Gaya, where Buddha is supposed to have gained enlightenment. Over a ten day period 200,000 devotees attended.

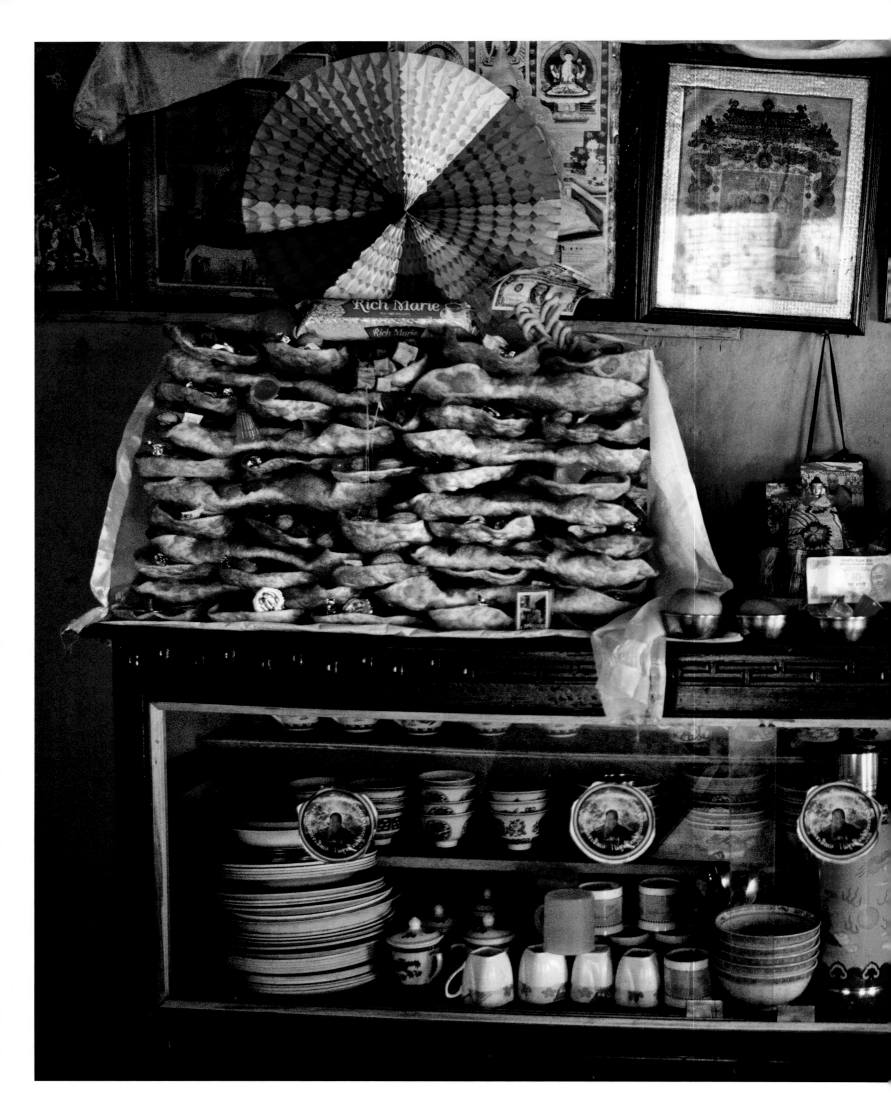

BYLAKUPPE, KARNATAKA, INDIA - An altar with offerings in a house in Bylakuppe, the largest Tibetan Refugee settlement.

DHARAMSALA, HIMACHAL PRADESH, INDIA - Tibetan nuns at Gaden Choelling nunnery debate Buddhist philosophical principles. This is a regular practice in most monasteries and nunneries to enhance debating skills as well as to further understand Buddhist philosophical texts.

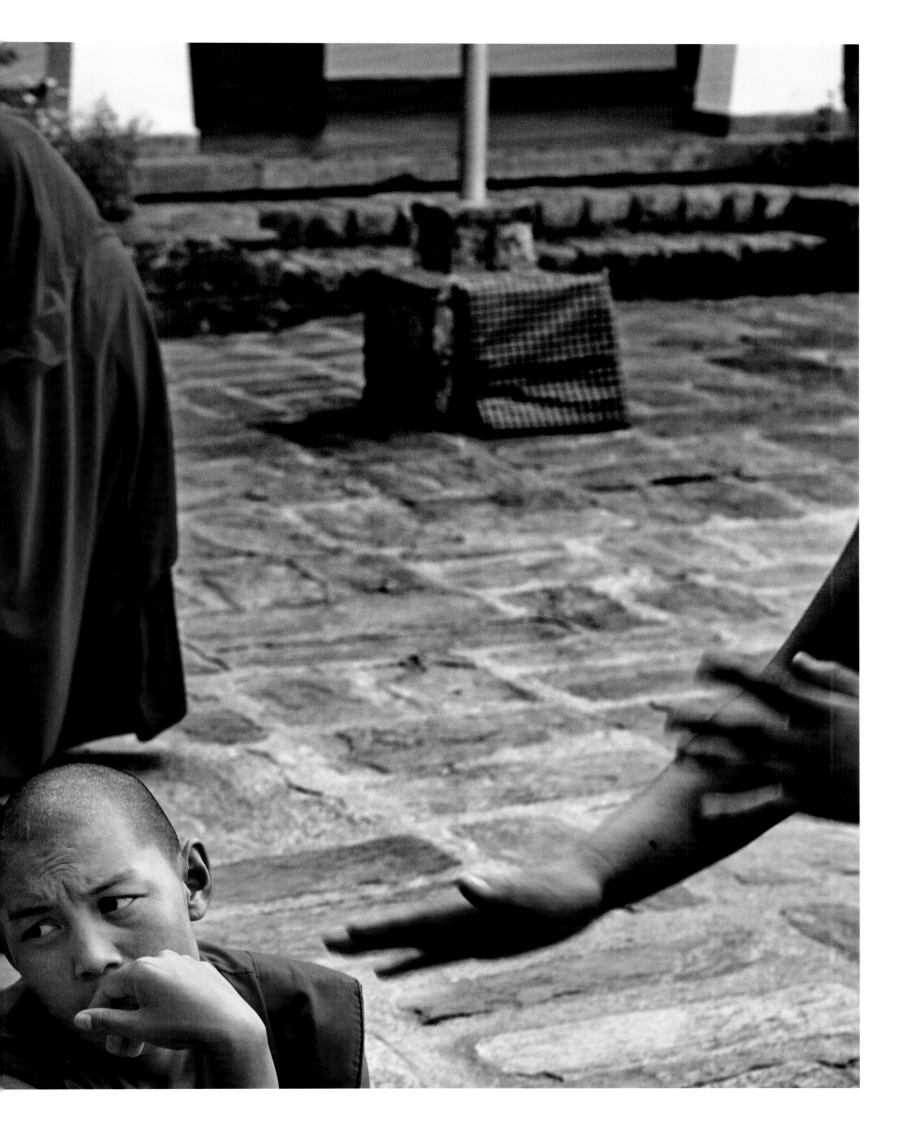

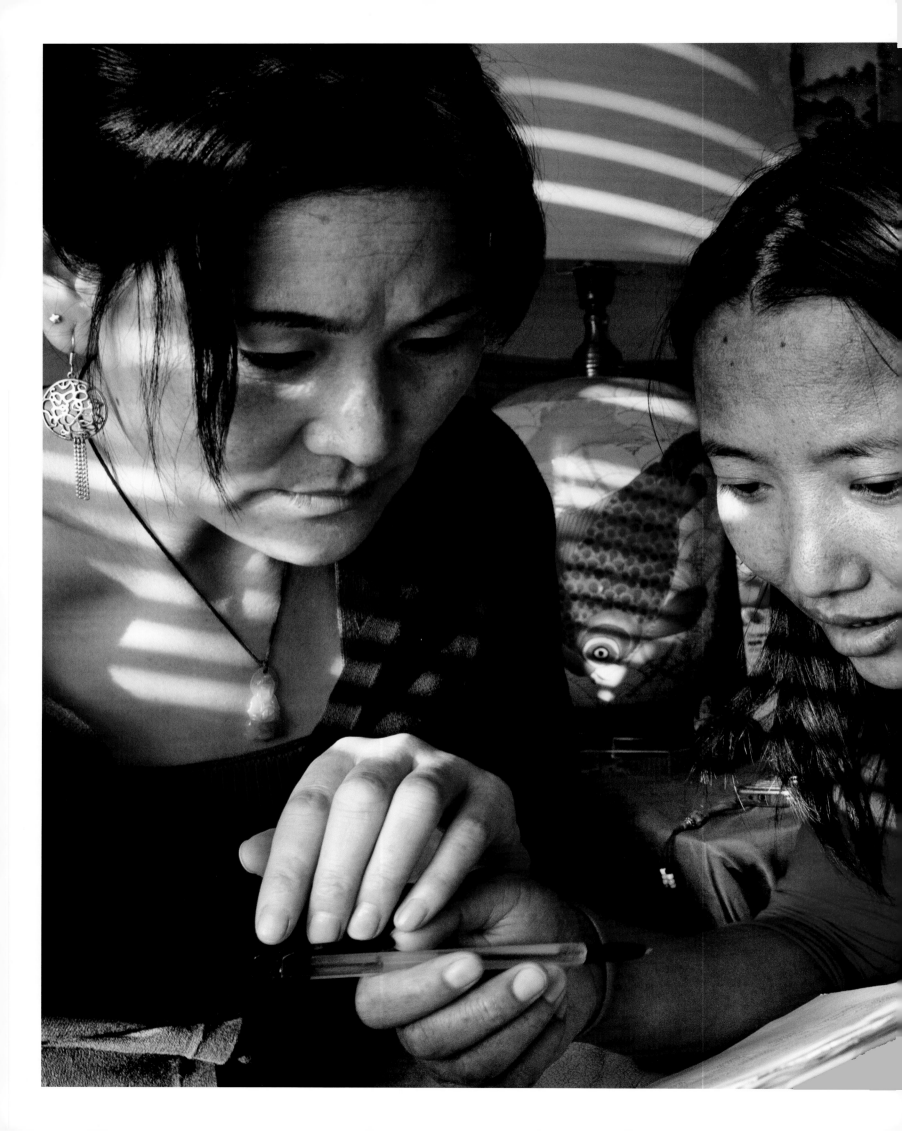

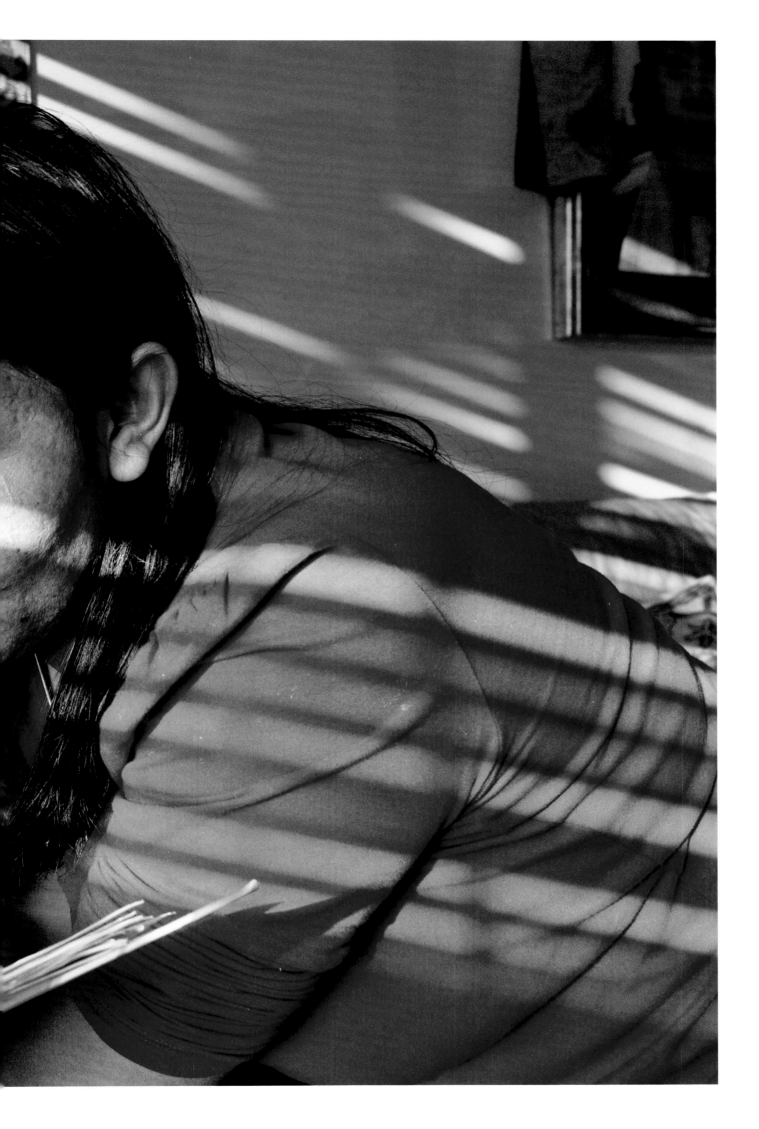

LONDON, UK - Exiled Tibetans, Dolma (right) and her friend Pema (left) practise their English together.

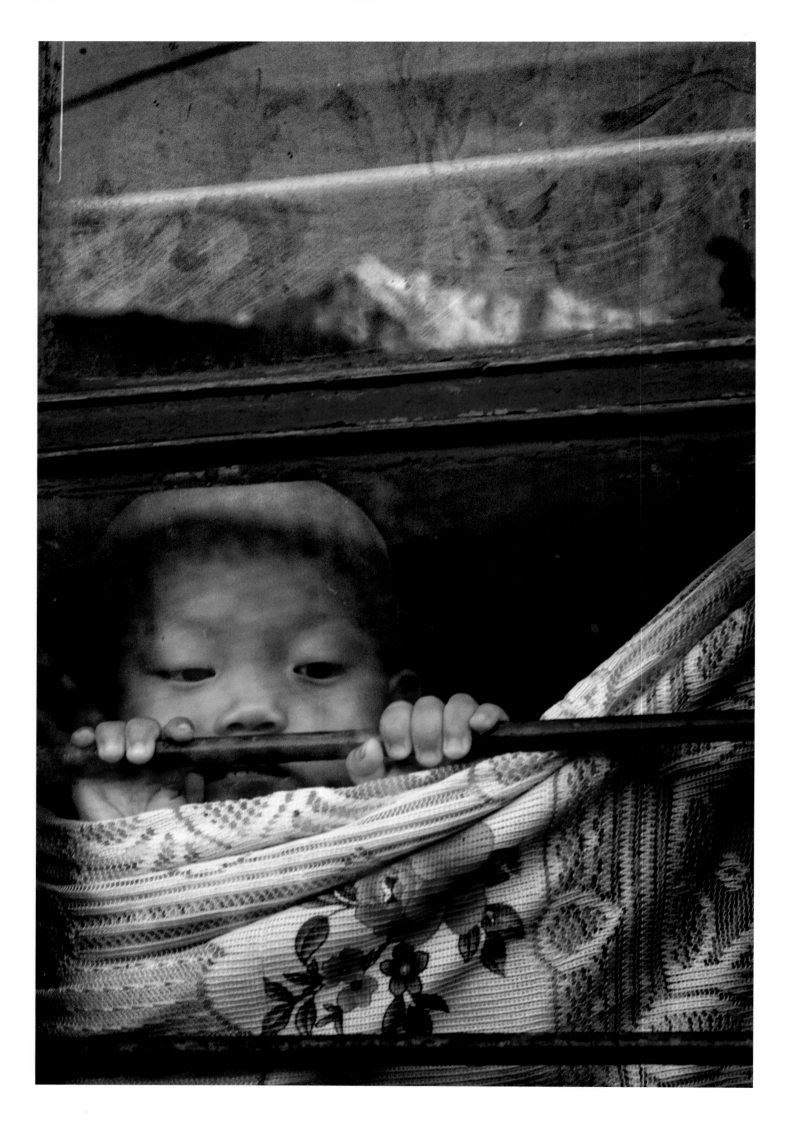

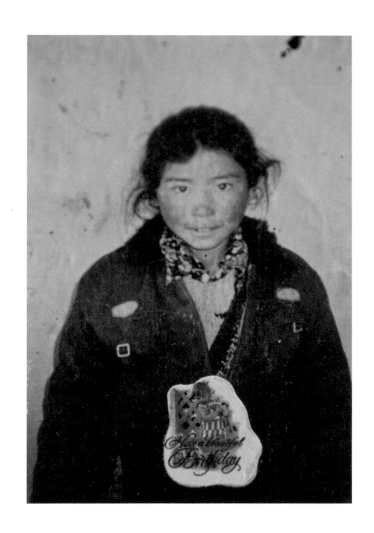

A hanging bridge, ruins of a monastery, big yellow slogans on the wall and nodding fields of barley are my memories of Tibet.

Sonam, Dharamsala, India

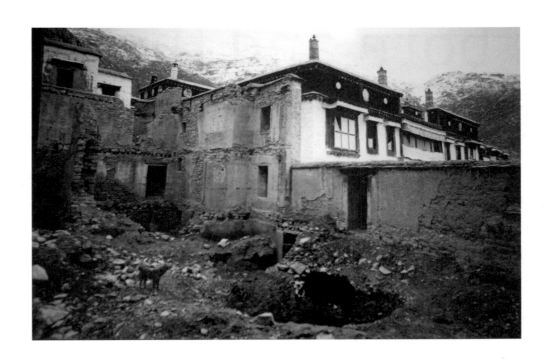

I miss the house where I was born and the village where I spent my few years of childhood. My wish is to take my last breath back in my own land. Tashi, London, UK

DHARAMSALA, HIMACHAL PRADESH, INDIA - A young Tibetan refugee child looks out from a window which reflects the Dhauladhar range of the northern Indian Himalayas.

MUNDGOD, KARNATAKA, INDIA - Tibetan refugees wait for the arrival of His Holiness the Dalai Lama.

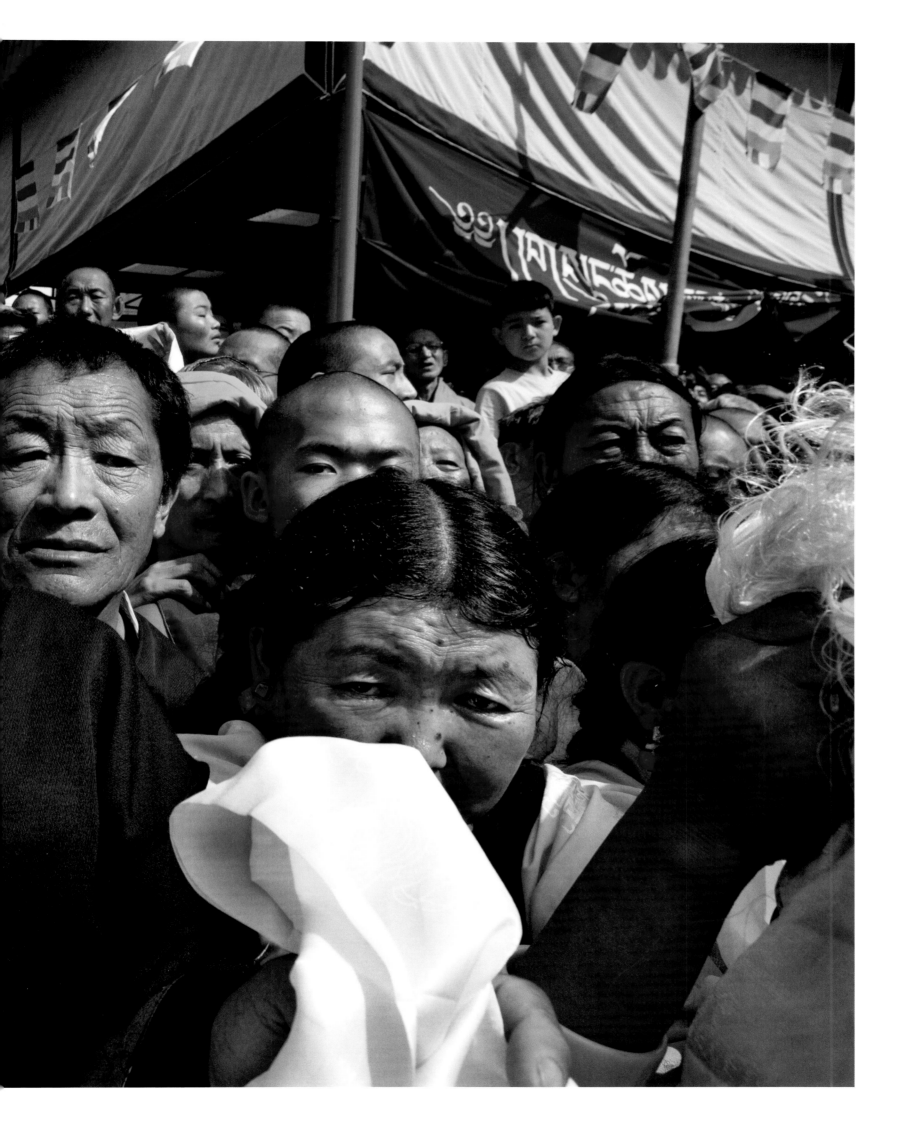

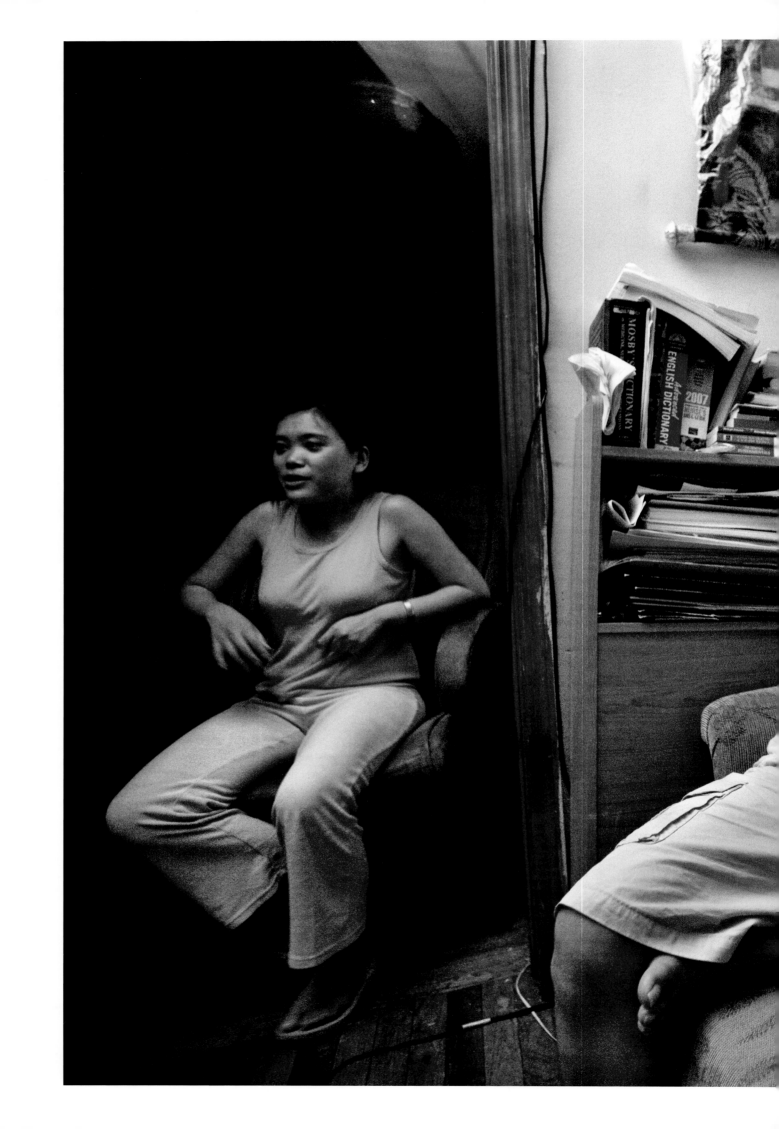

NEW YORK, U.S.A - Tibetan exiles at home in Brooklyn. Tenzin (left) is studying to be a nurse whilst her father (right) is a bricklayer.

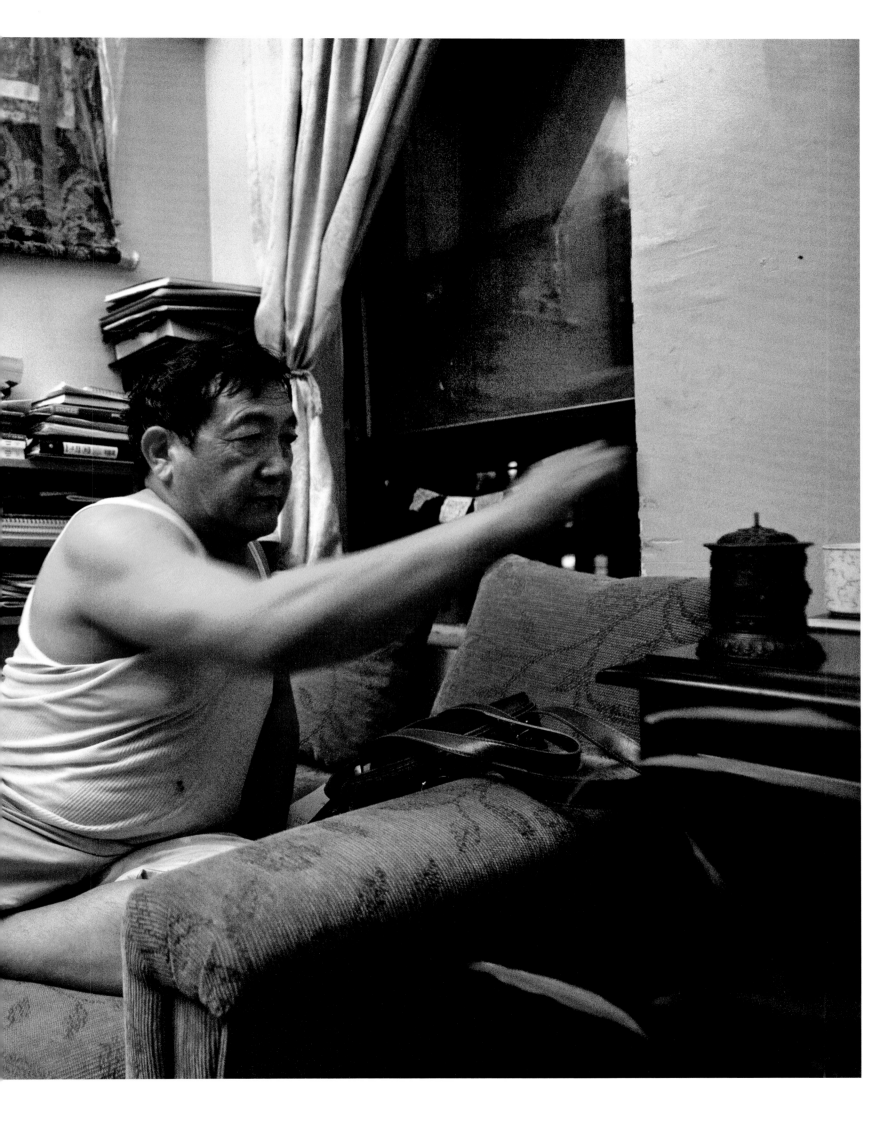

LADAKH, INDIA - An incarnate Rinpoche in his tent in the Rupsu valley blesses a nomadic Tibetan child.

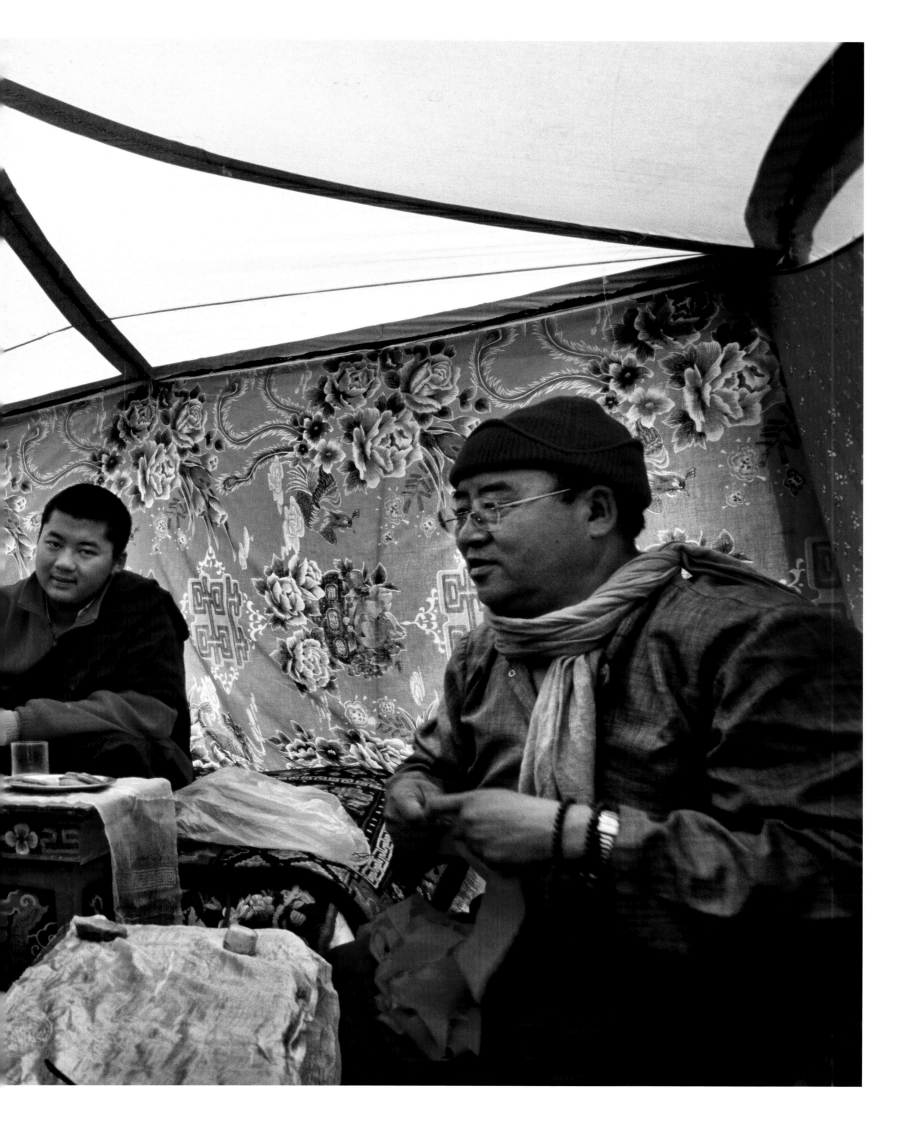

BYLAKUPPE, KARNATAKA, INDIA - A large 'Thangka' of 'Guru Rinpoche' (the spiritual guru who brought Buddhism from India to Tibet) hangs on the 'Golden Temple' during Losar, the Tibetan New Year.

I escaped from Tibet because the Chinese occupied our country and there was no freedom. There are no Human Rights in Tibet. Tibetans are fighting for basic human rights even now. Palmo, Bulakuppe, India

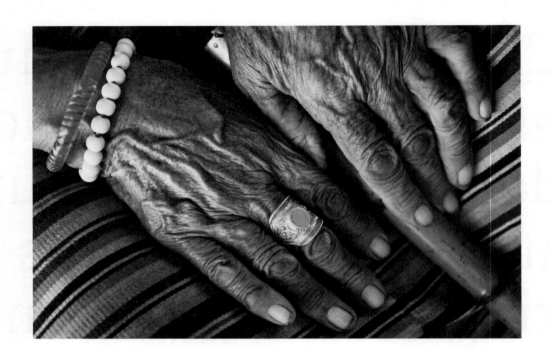

Ironically, in order to be a real Tibetan, I had to flee Tibet.

Norbu, Dharamsala, India

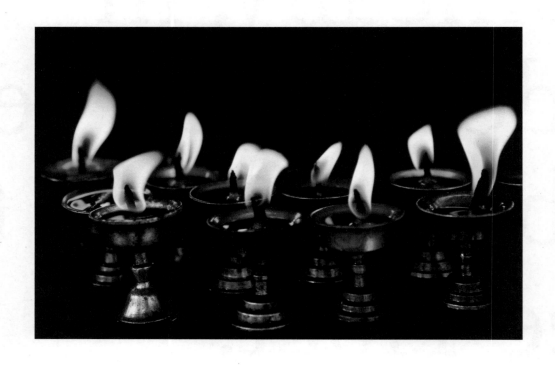

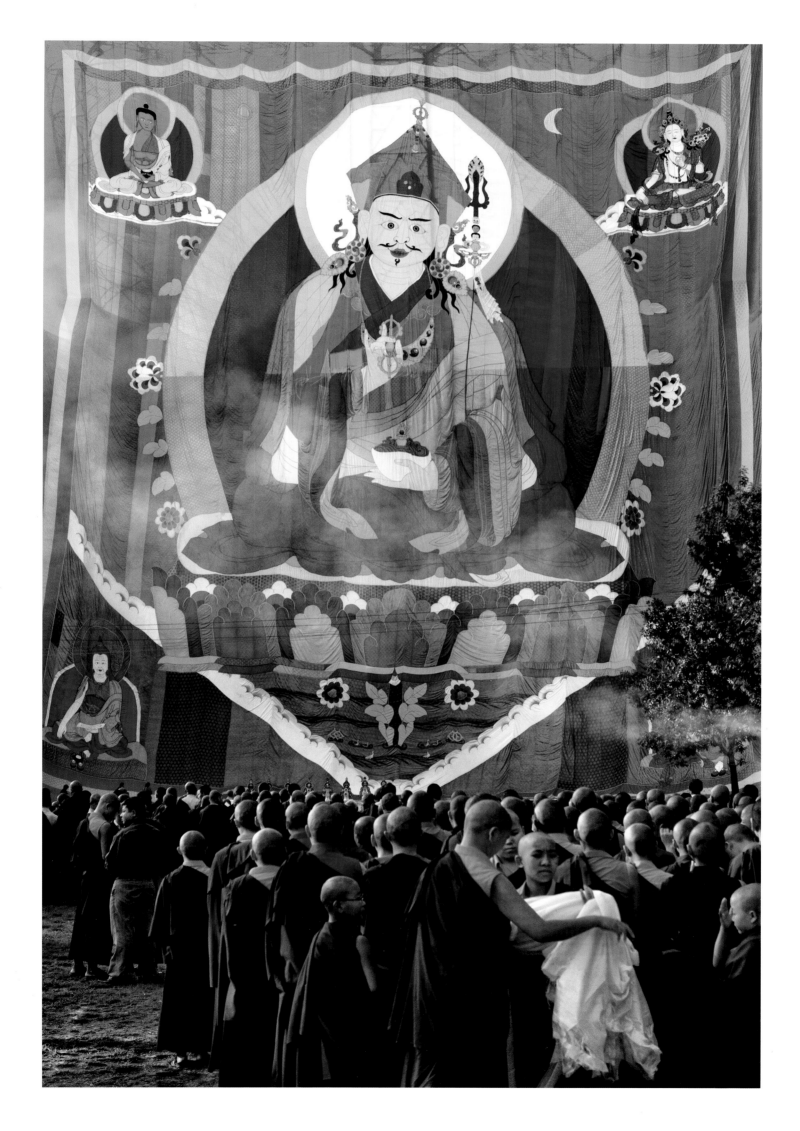

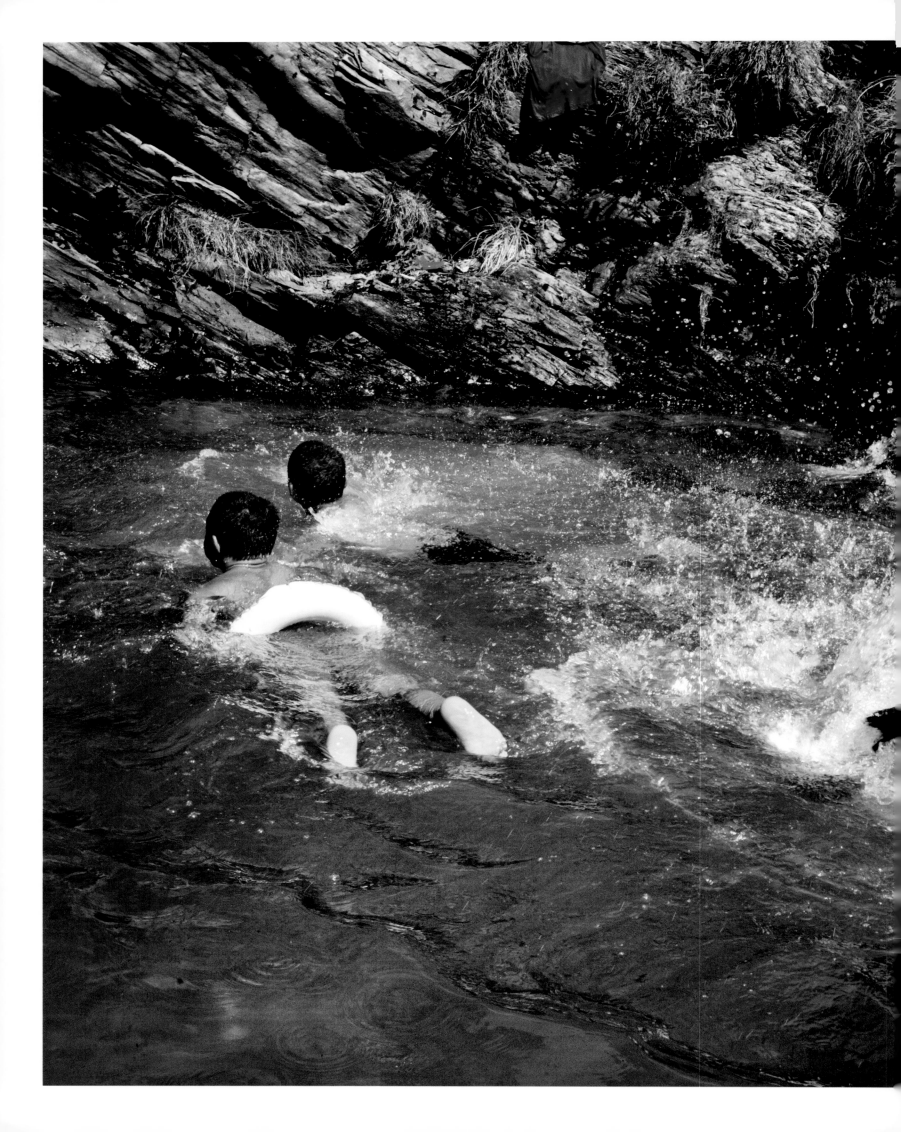

BHAGSU, HIMACHAL PRADESH, INDIA - Tibetan monks at a waterfall where they swim and also do their weekly laundry.

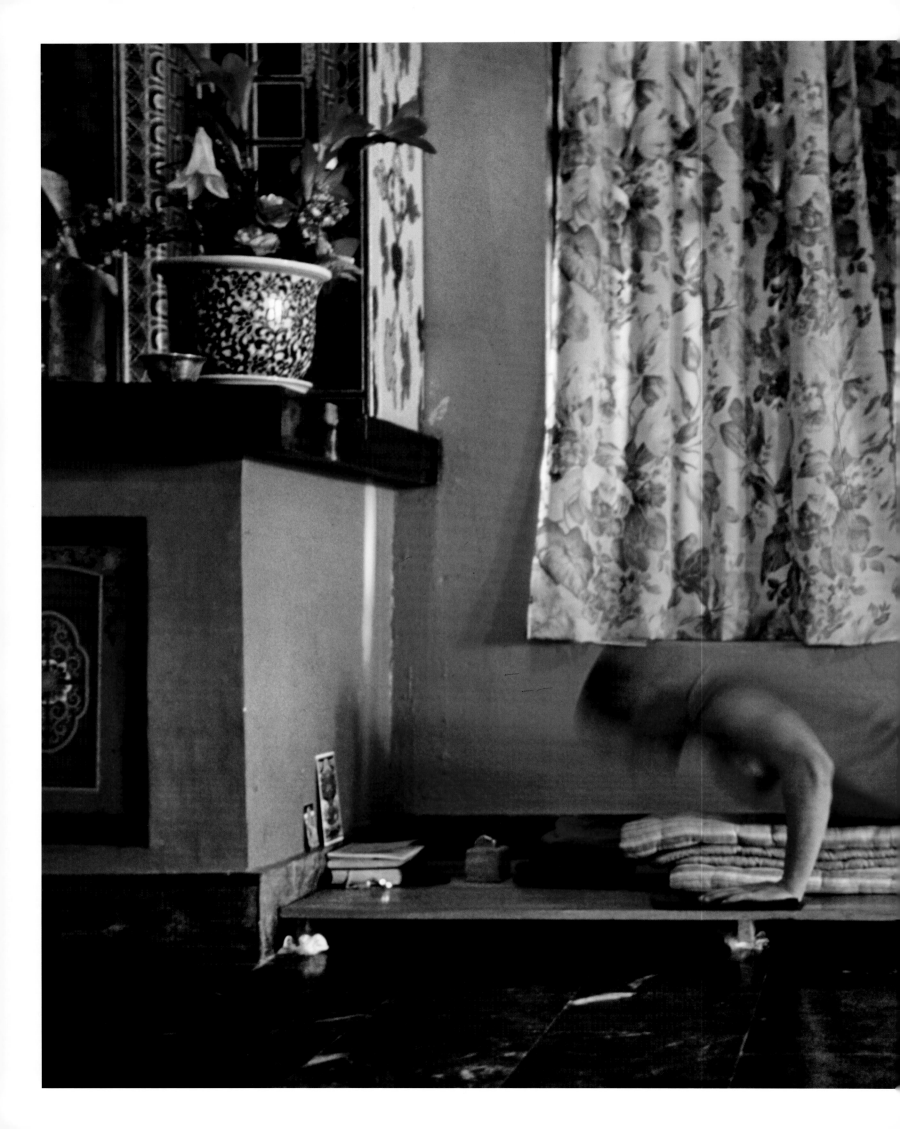

SIKKIM, INDIA - A Tibetan monk in exile offers prostrations.

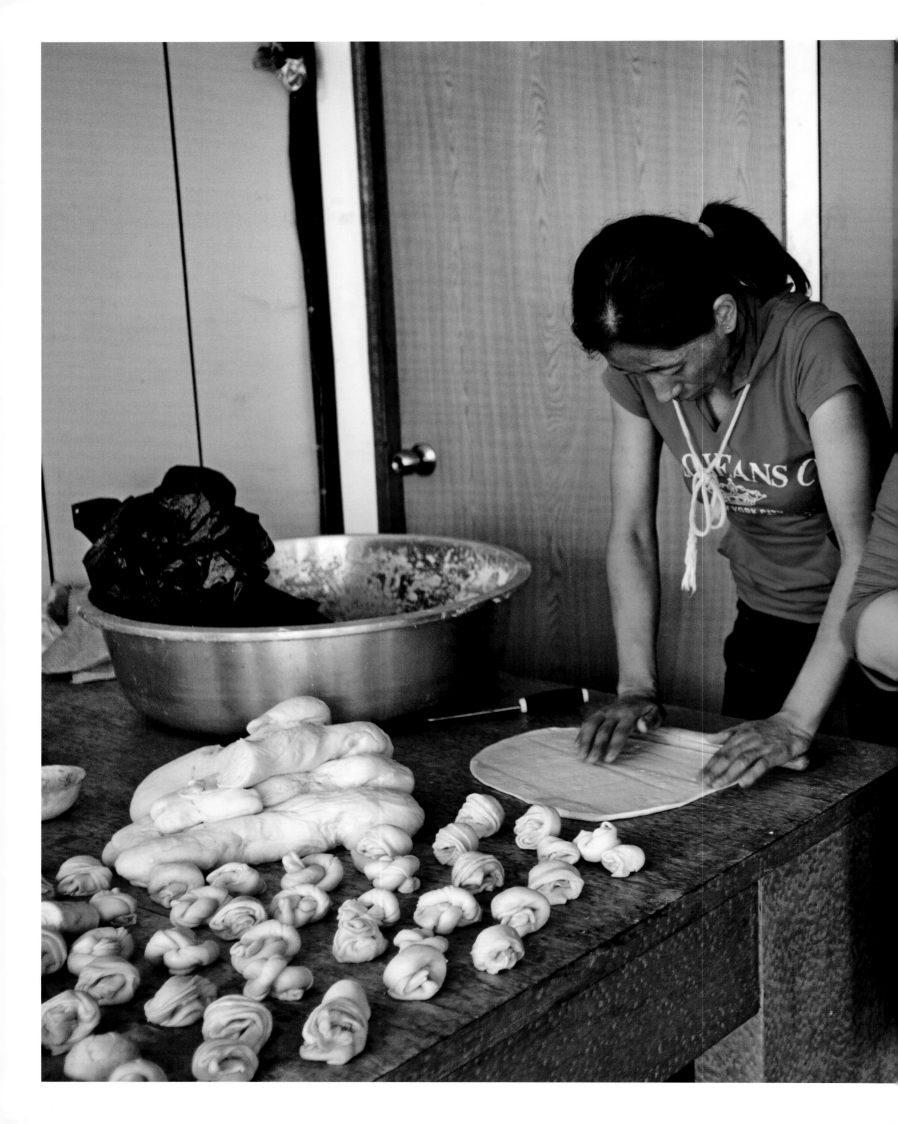

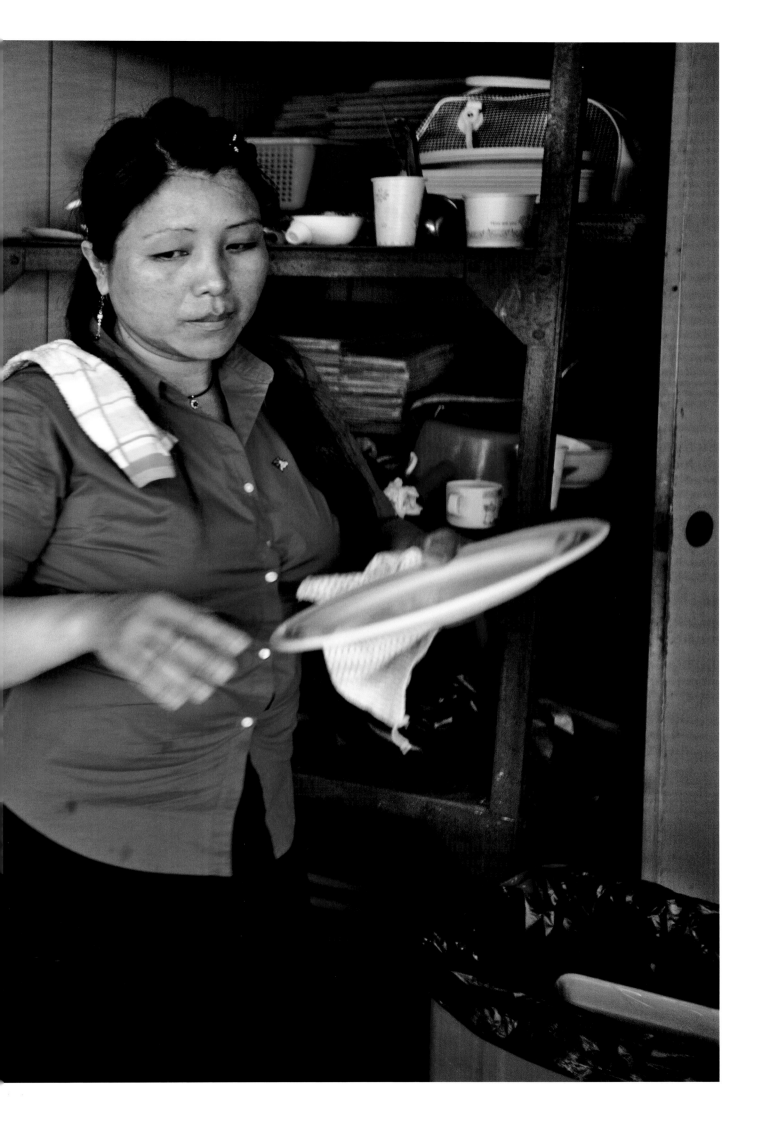

TAOYUAN, TAIWAN - Tibetan women busy in a kitchen preparing 'Tingmo', traditional Tibetan steamed bread, for a celebration organised by the Tibetan community of Taoyuan for the 74th birthday of His Holiness the Dalai Lama.

DARJEELING, INDIA - A Tibetan woman uses a traditional Ghandi style spinning wheel to spin wool into the threads used to weave carpets. Many exiled Tibetans, especially in and around Nepal, work in the carpet industry, which is often run as a traditional family business.

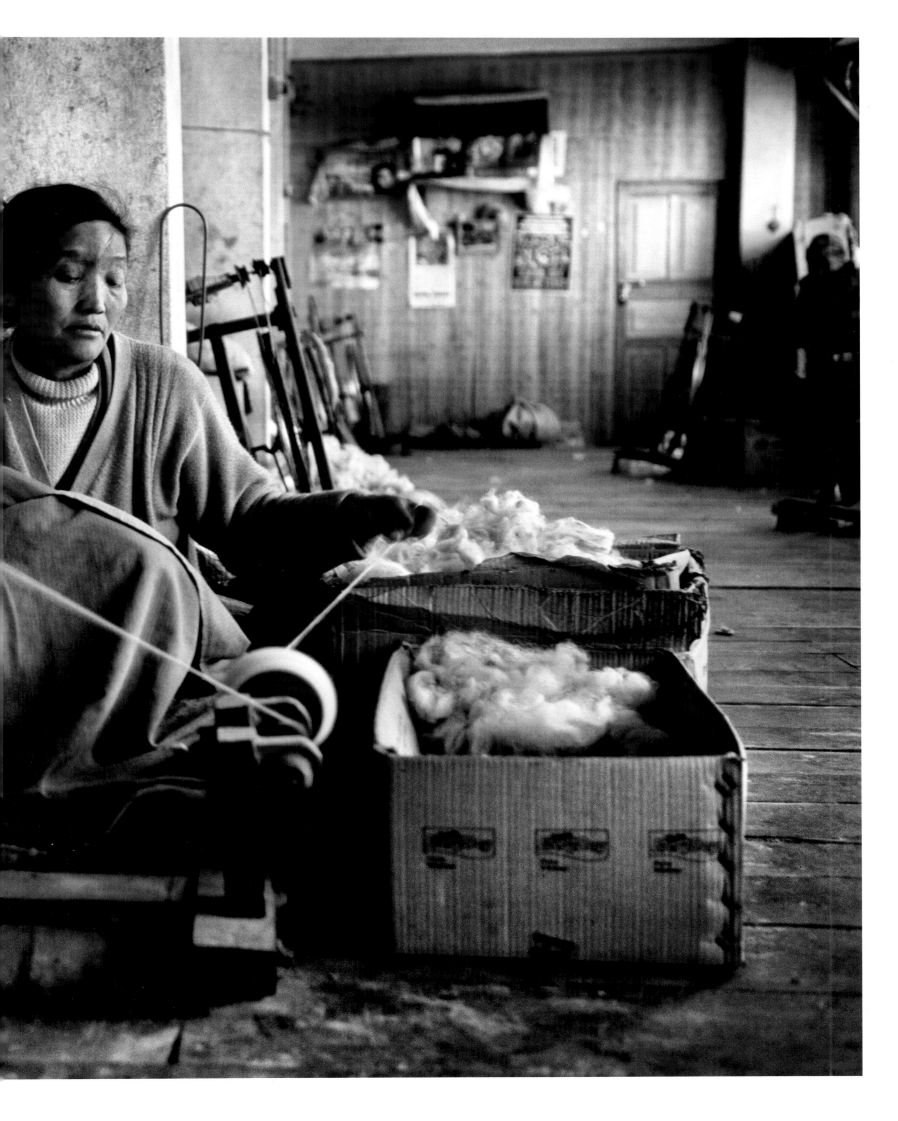

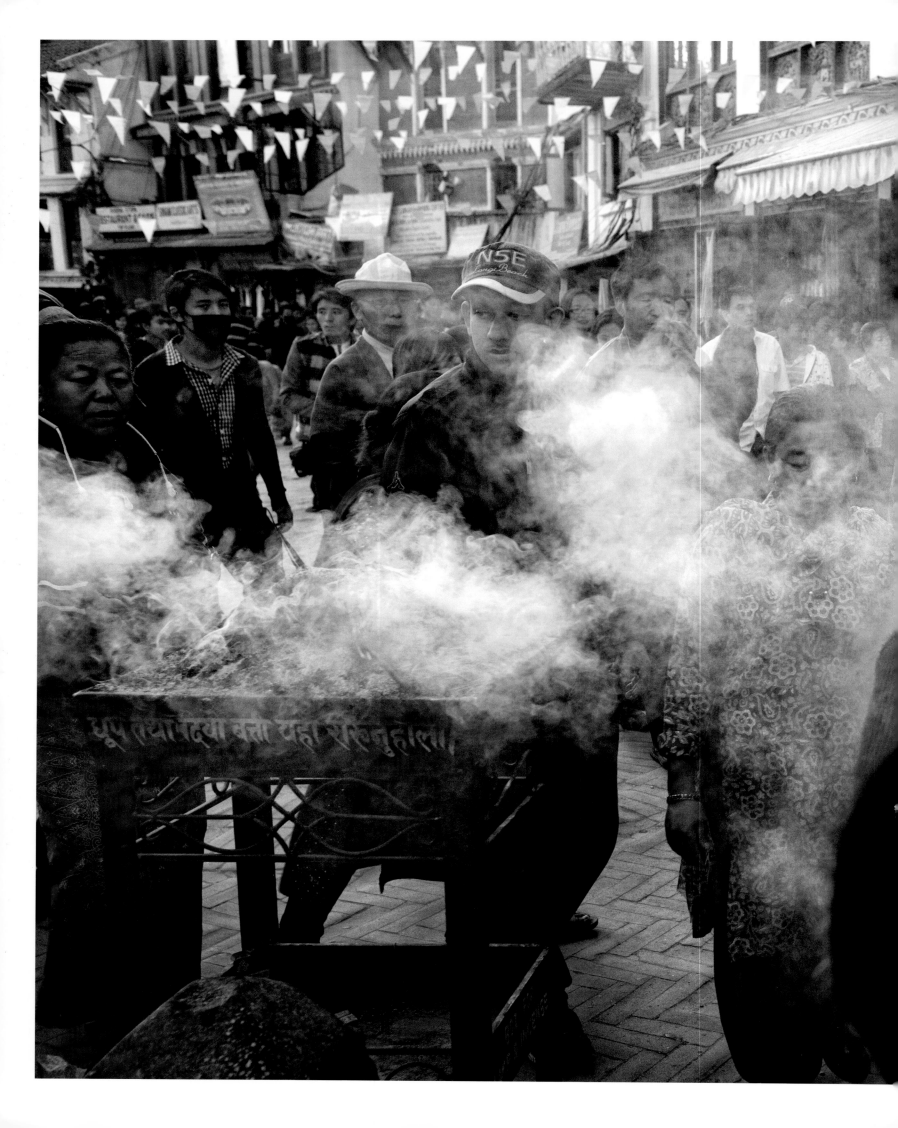

MONASTERIES
1. GURU LHAKHANG MONASTERY
2. CHHOTEN TASHI TAMANG MONASTERY 4471908
3. TEMPLE OF 1000 BUDDHAS 4470787
4. SAMTENLING MONASTERY 4471106
5. JAMCHEN LHAKHANG 4470992
6. THRANGU TASHI CHOLING 4470028
7. SHECHEN TENNYE DARGYELING 4470721
8. KA-NYING SHEDRUB LING 4470915
9. SAKYA THARIG MONASTERY 4471914
10. PAL - OILYAG MONASTERY
11. PAL - NYE - GHON 4480162
12. THARLAM SADANG NAMGYAL LING 4473884
13. SHERPA SERVICE CENTER
14.

KATHMANDU, NEPAL - Tibetan refugees pray and circumambulate at Boudhanath Stupa, one of the holiest Buddhist sites.

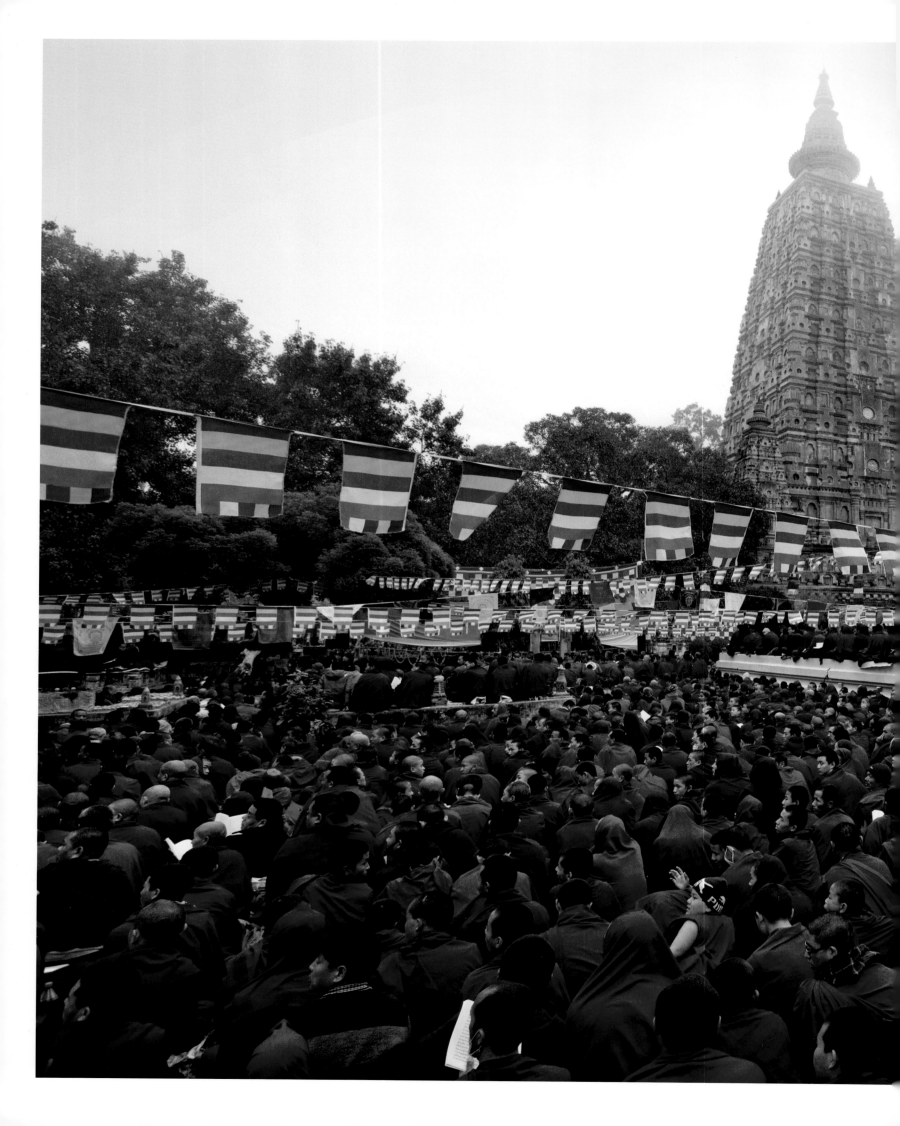

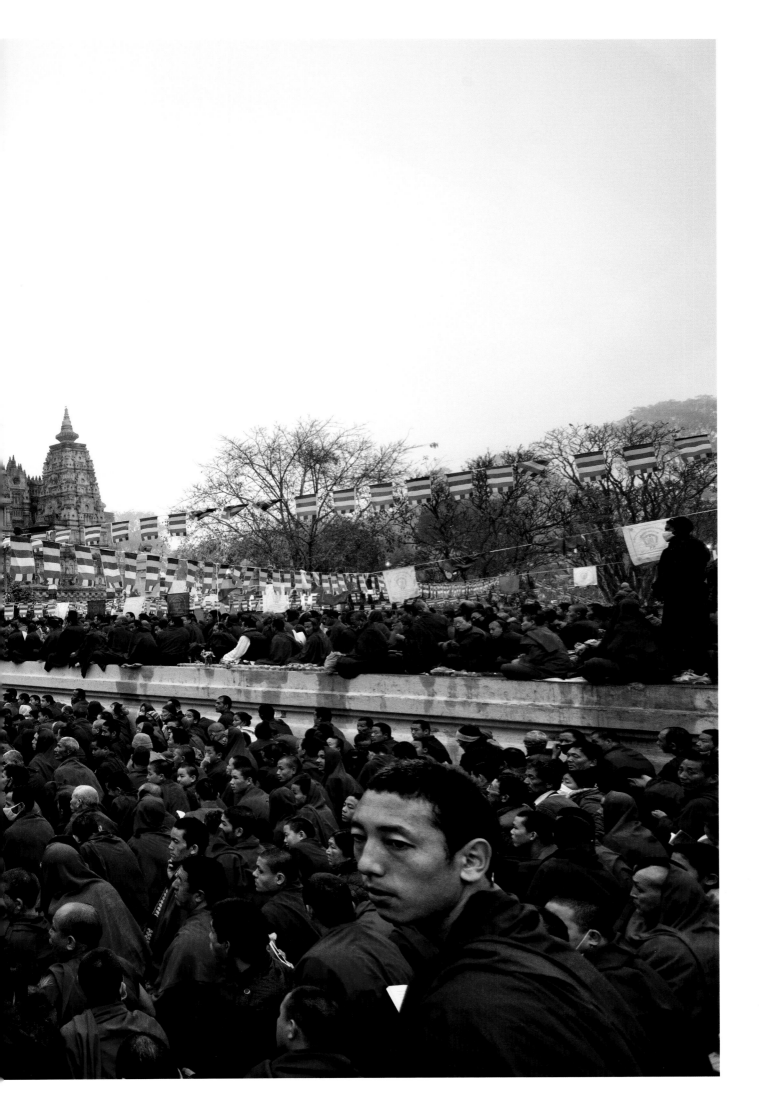

BODH GAYA, BIHAR, INDIA - Thousands of monks gather during the 2012 Kalachakra prayers in front of the Mahabodhi Temple, where the Buddha is said to have attained enlightenment under the Bodhi Tree over 2500 years ago.

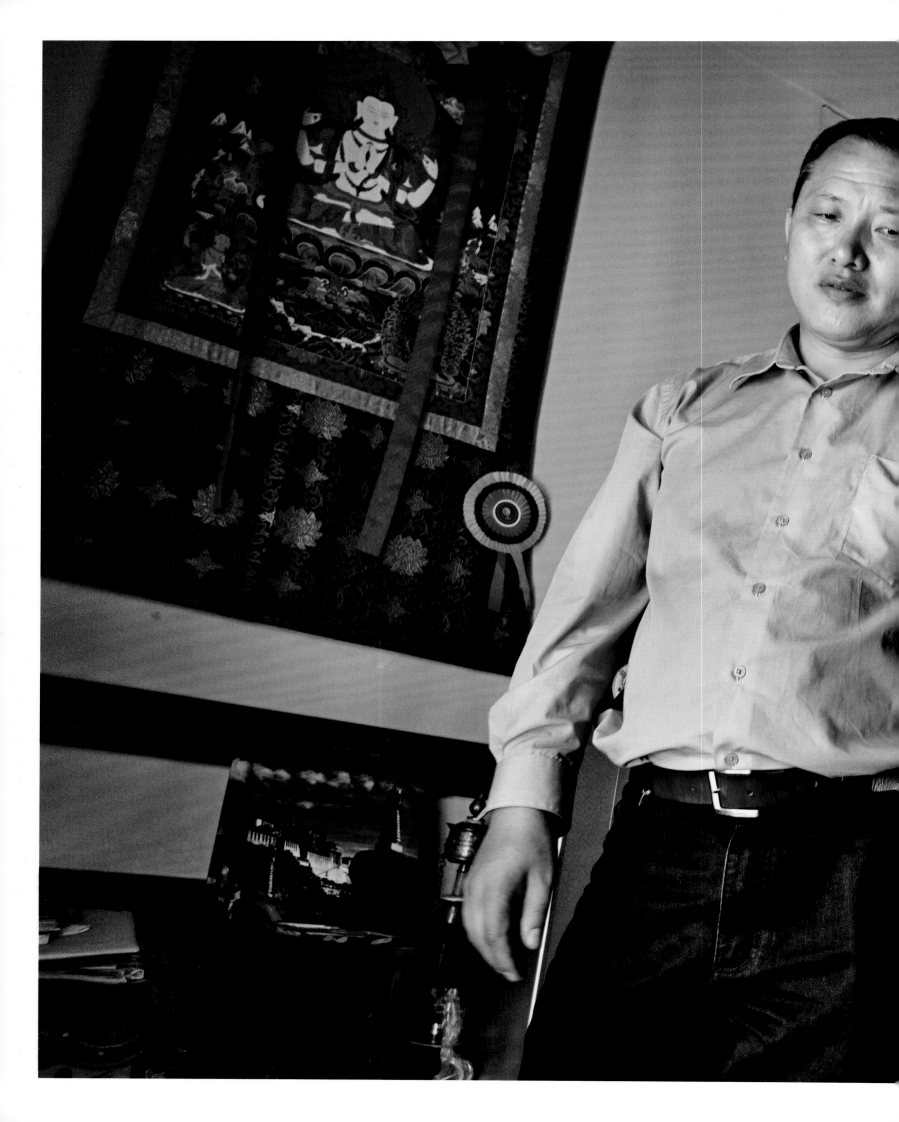

TAOYUAN, TAIWAN - Markham Chopel, a typically proud Khampa at home. Born in eastern Tibet, where most of his family still live, he has been in exile for the past 35 years (20 years in India and 15 in Taiwan). Markham is Vice-President of the 'Welfare Society of Central Dokham Chushi Gandrug'.

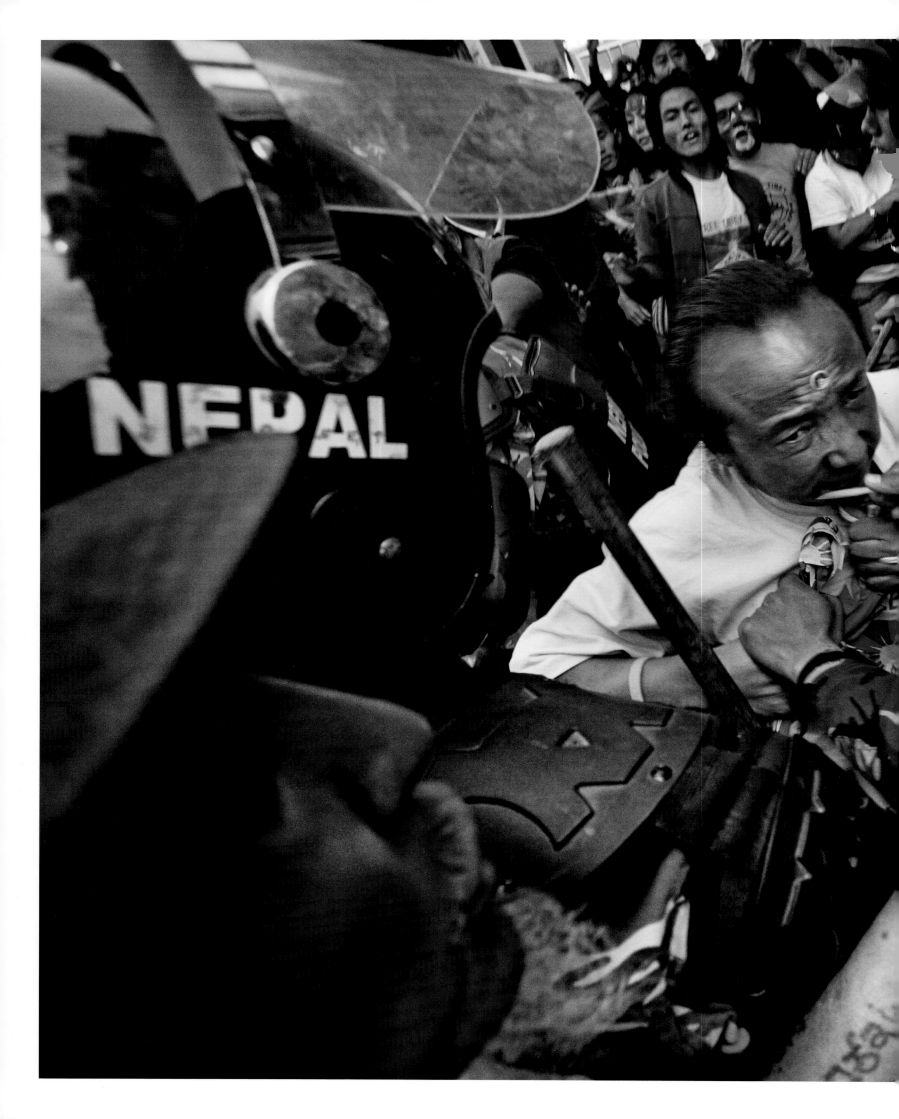

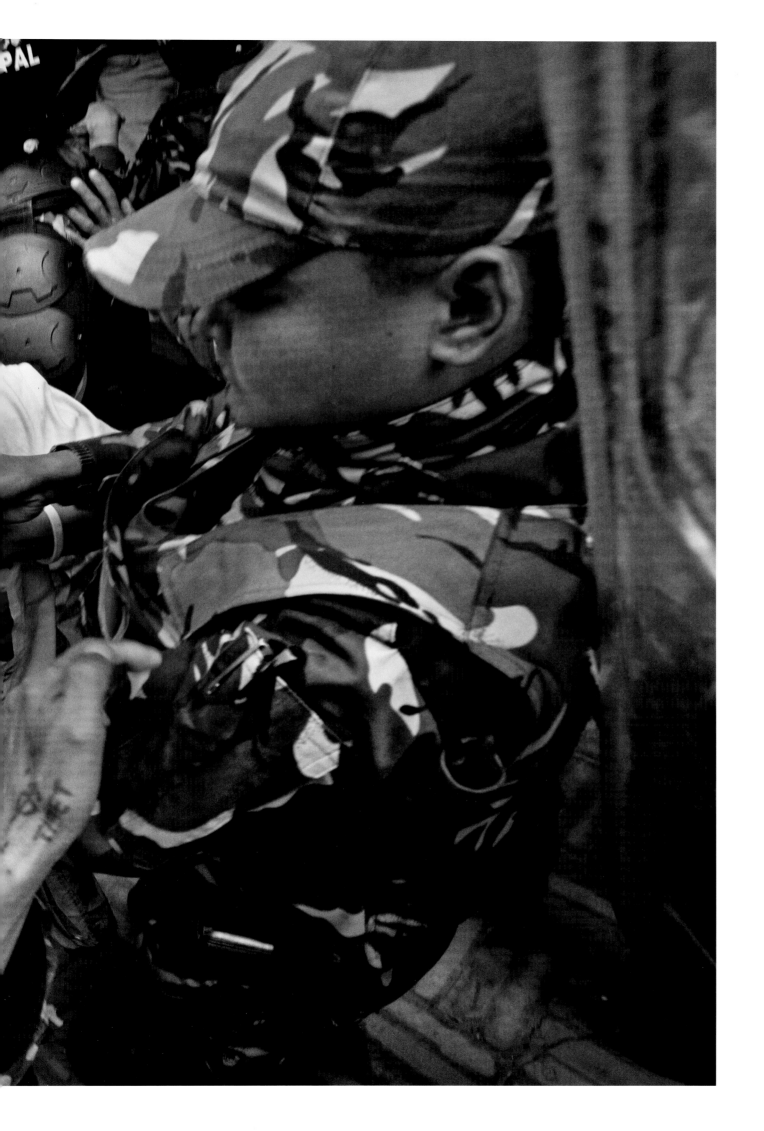

KATHMANDU, NEPAL - Nepalese police grab an exiled Tibetan protestor on 10 March 2011, the 52nd anniversary of the Tibetan Uprising. Nepal remains a hot bed of Tibetan protest in spite of the repressive and brutal treatment that is used by Nepalese forces influenced by Chinese policy.

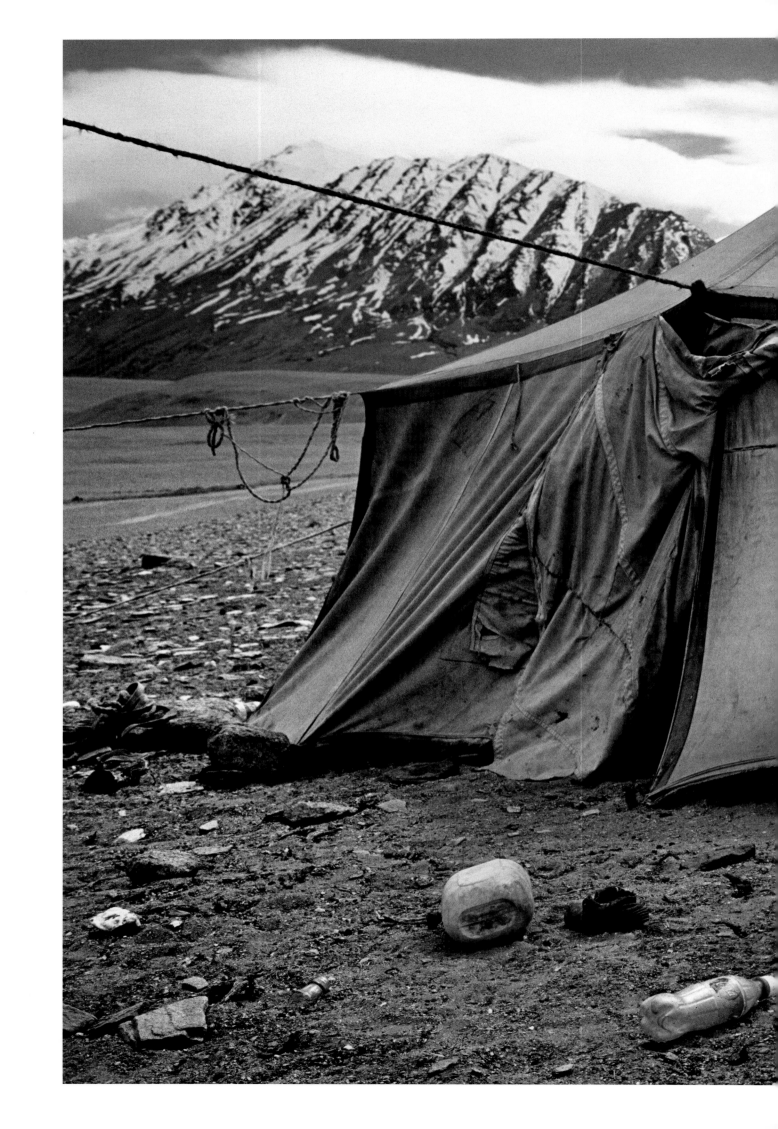

LADAKH, INDIA - Many Tibetan nomads resettled in the Indian territory of Ladakh post 1960 and were unable to return because of the 1962 SinoIndian war. The Nomads use modern army style tents as shelters while they graze their cattle around the rugged Himalayan terrain of Rupsu valley.

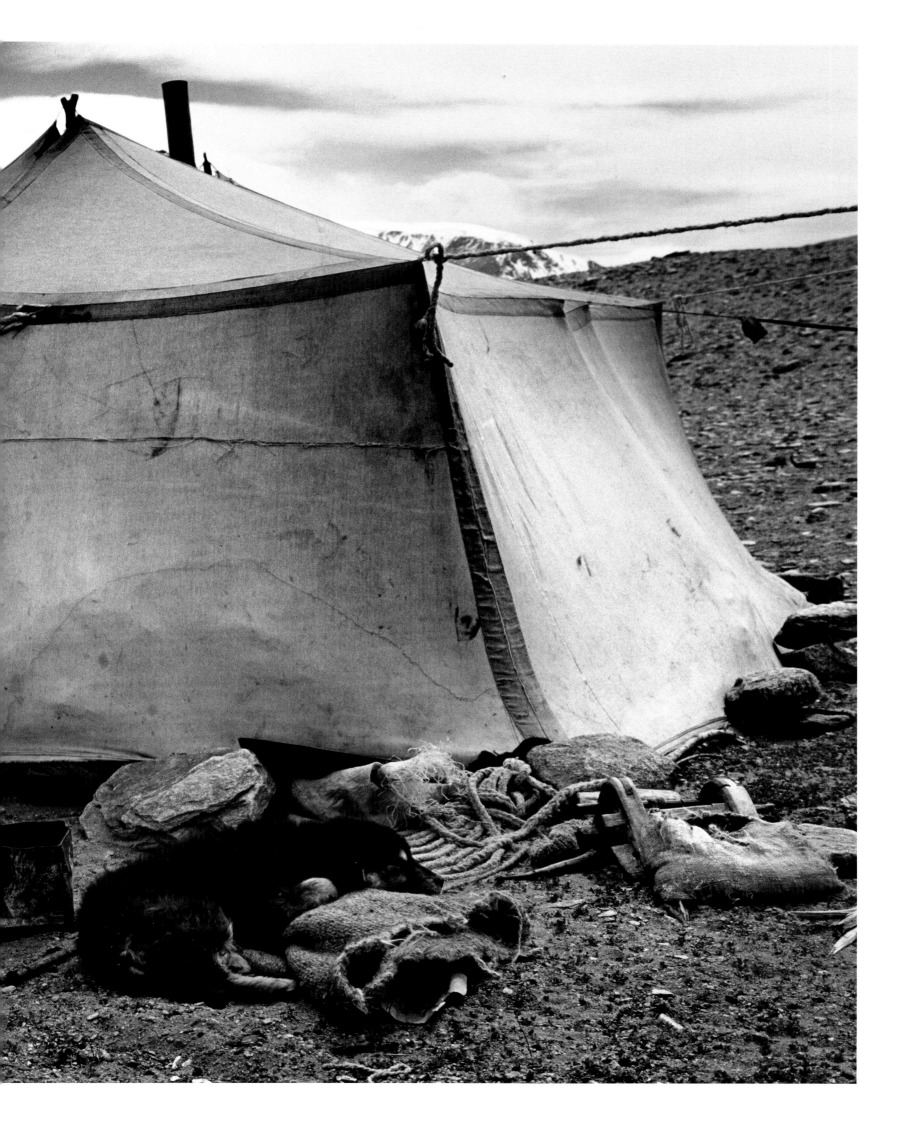

BYLAKUPPE, KARNATAKA, INDIA - Pema Tsedon, 79, from western Tibet, was one of the first immigrants from Tibet to settle in Bylakuppe, the largest and first Tibetan settlement camp in Southern India. Dressed in traditional attire, Pema is wearing rare coral beads.

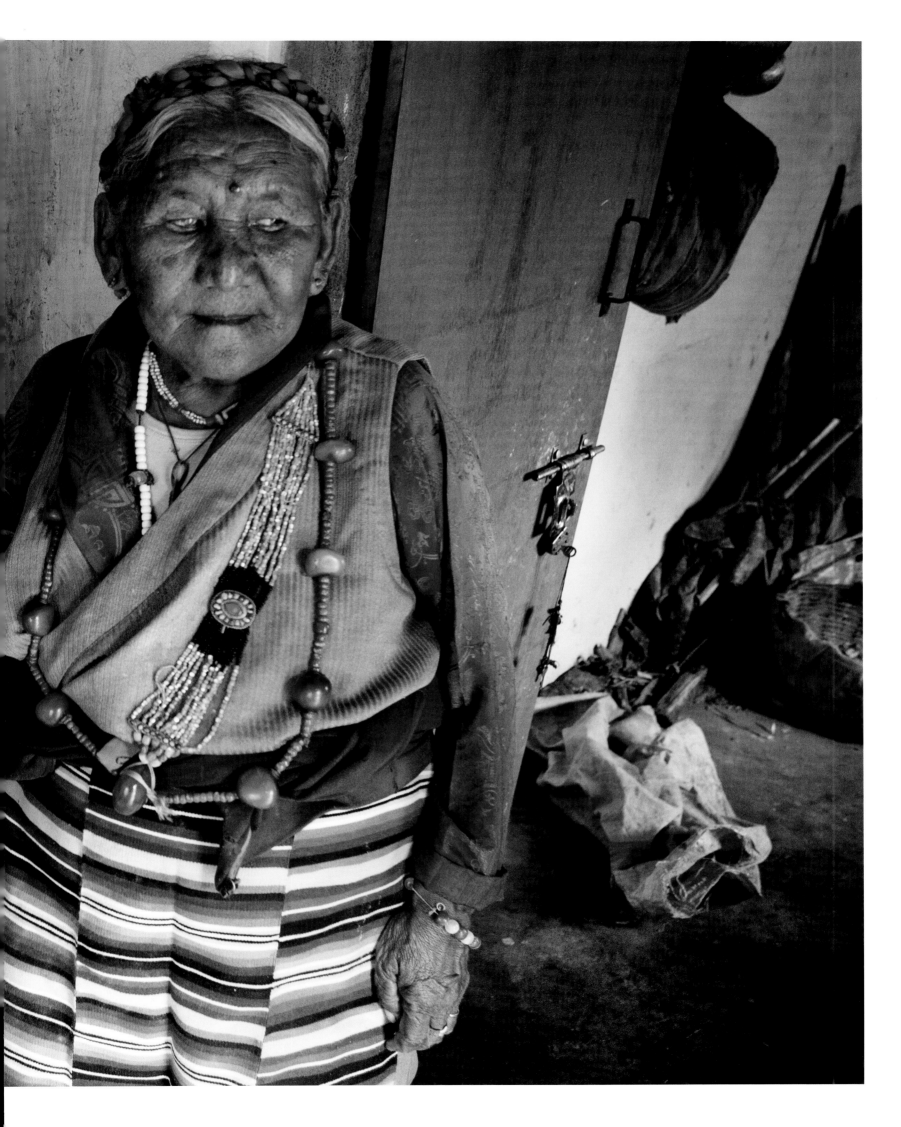

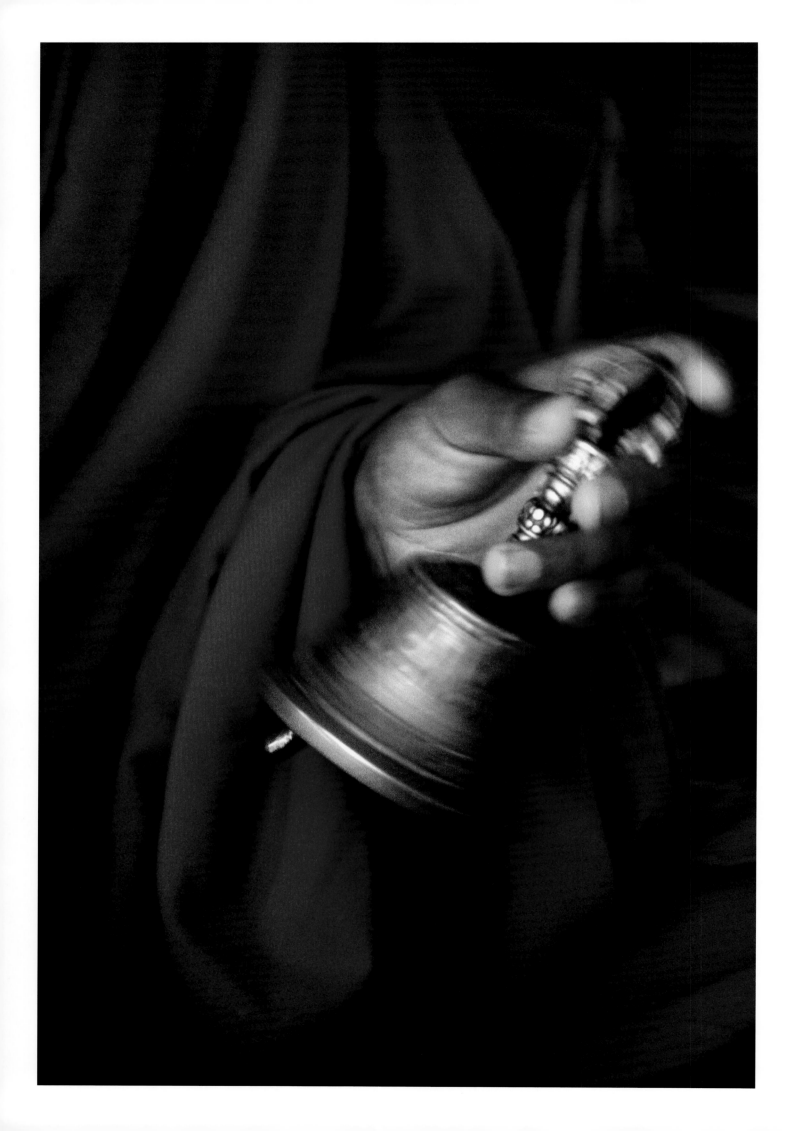

BYLAKUPPE, KARNATAKA, INDIA - A Tibetan monk holds a ritual prayer bell.

LADAKH, INDIA - A young Tibetan nun listens to a philosophical debate at Julichen nunnery.

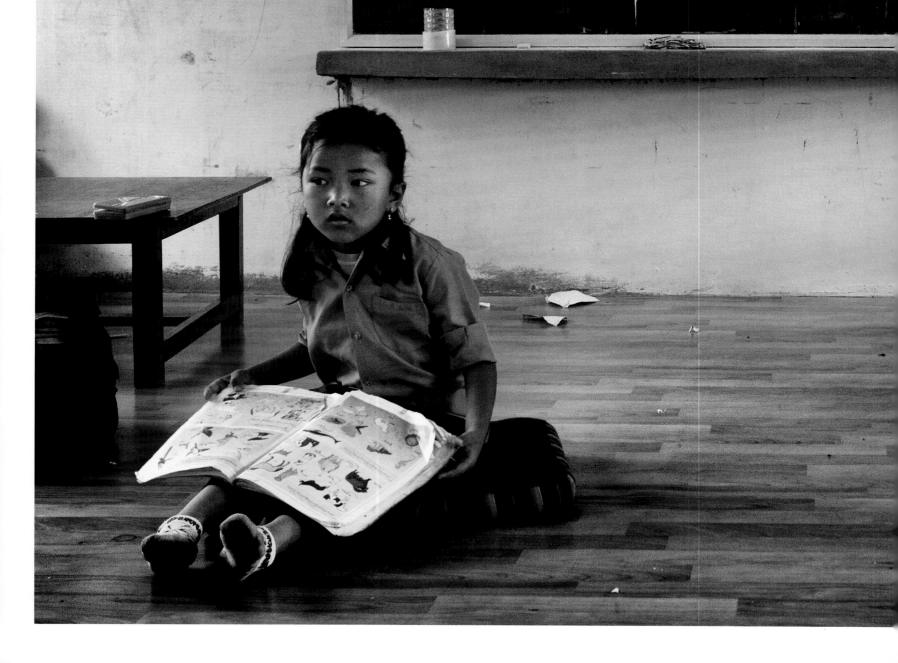

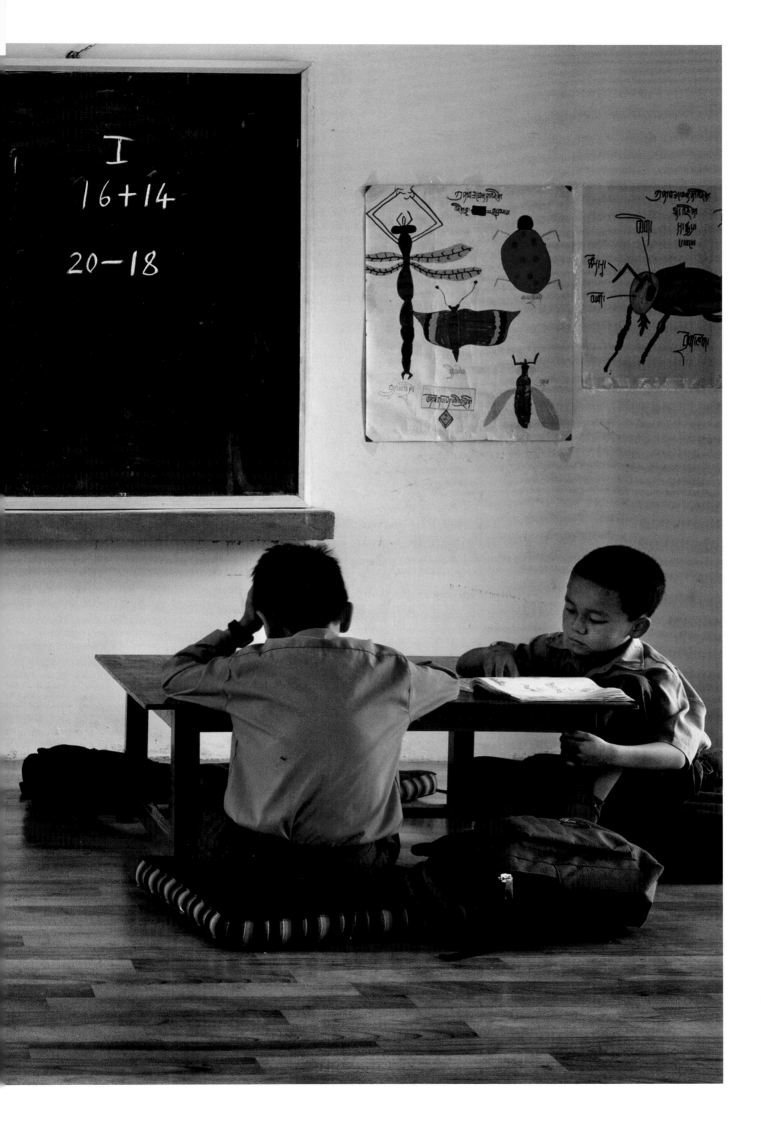

BIR, HIMACHAL PRADESH, INDIA - Tibetan children study in a classroom at Tibetan Central School, a free school which uses Tibetan as the medium of instruction.

AMSTERDAM, HOLLAND - Tibetan teenagers at the 'Tibet Restaurant' during a Sunday reunion of the Tibetan community.

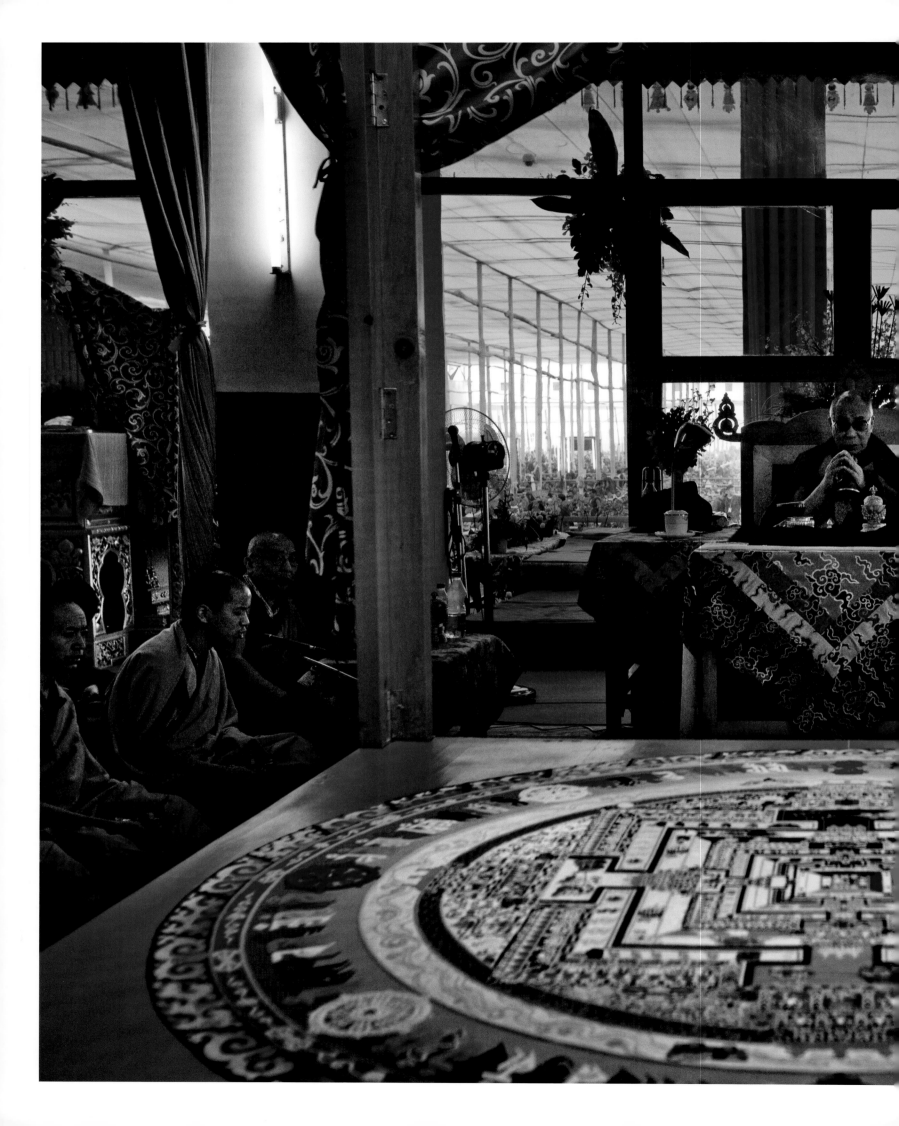

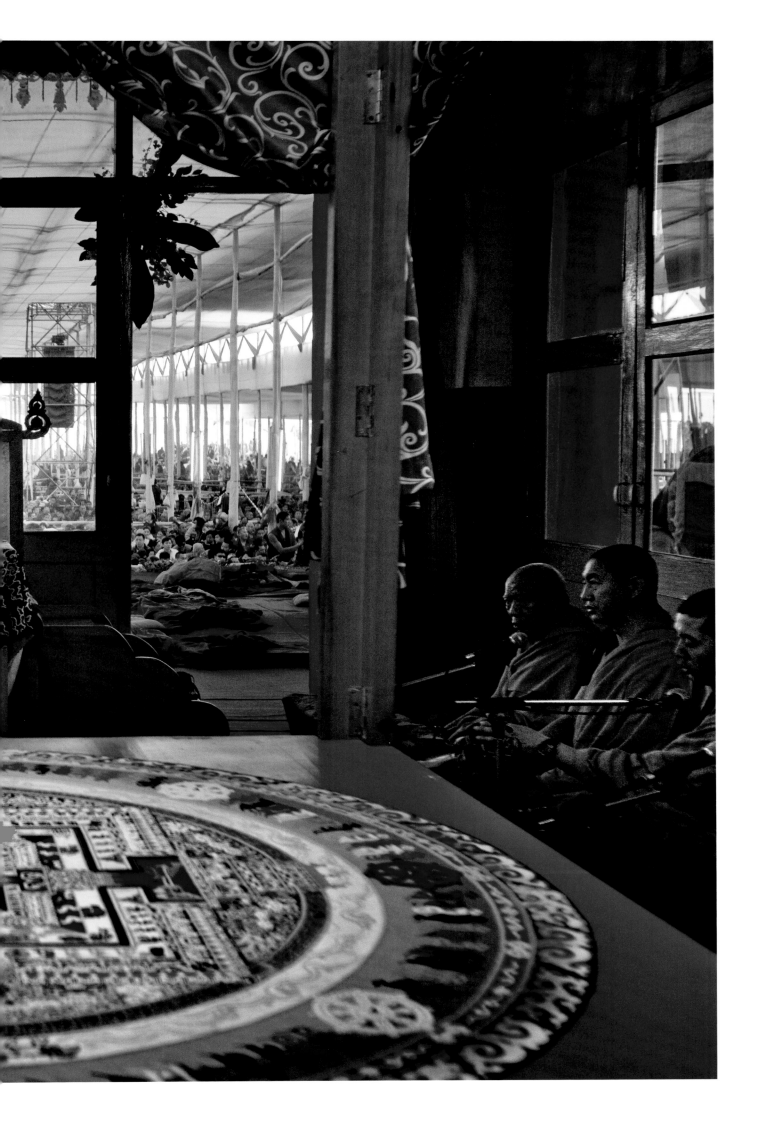

BODH GAYA, BIHAR, INDIA - His Holiness the Dalai Lama prays in front of the Kalachakra Mandala.
Made entirely of coloured sand, the intricate mandala is created by monks from the Namgyal Monastery.
Once completed it is destroyed to signify the impermanence of life.

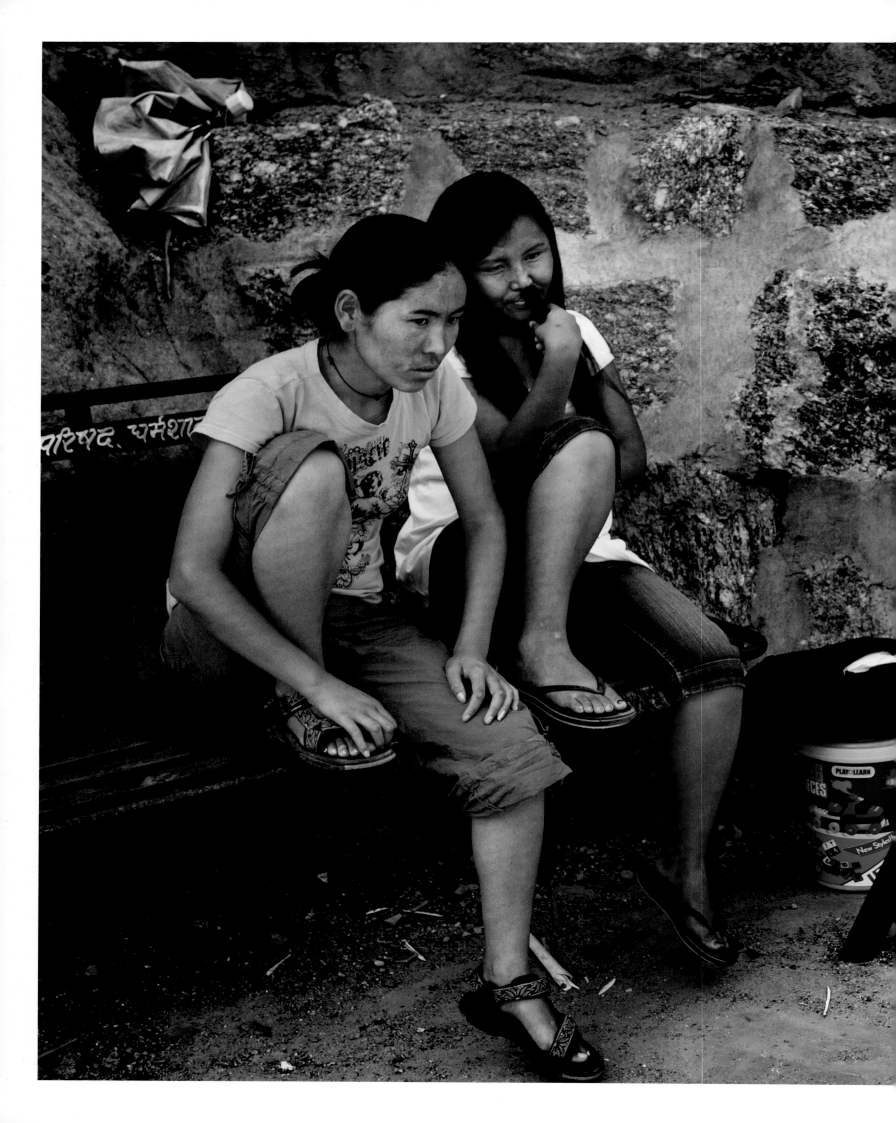

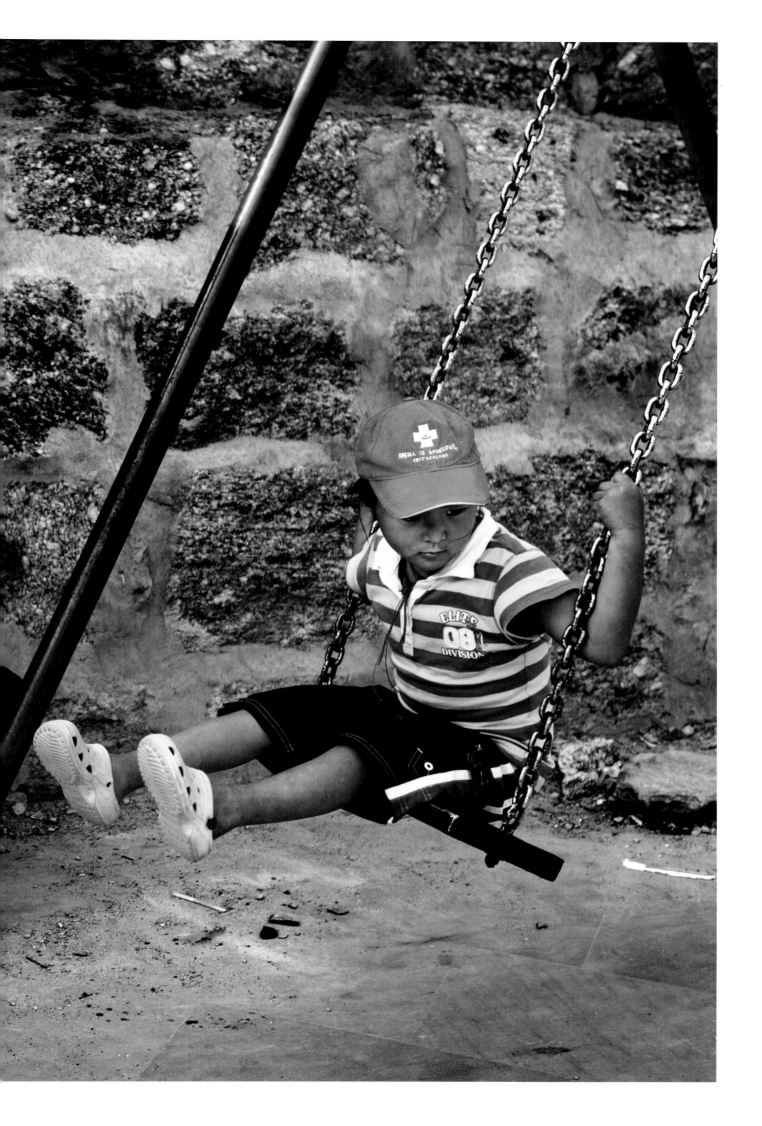

DHRAMSALA HIMACHAL PRADESH, INDIA - Karma, Tenzin and Deyang, three sisters
(the first two born in Tibet, the third in India) take a Sunday afternoon break.

BHAGSU, HIMACHAL PRADESH, INDIA - Tibetan girls learning to swim in a public pool.

To keep Tibetan culture alive the first thing to save is our language. In the schools, with the coming of the Chinese, our language is being replaced by Chinese and education is being focused on Chinese culture. By keeping the Tibetan language alive we will be able to read our texts and keep Tibetan culture intact.

Jigme, Bylakuppe, India

I dream of a Tibet where there are no police in the monastery overseeing the monks, and no Chinese telling you what you should be doing or what you should believe – controlling every aspect of your life.

Tenzin Losel, Dharamsala, India

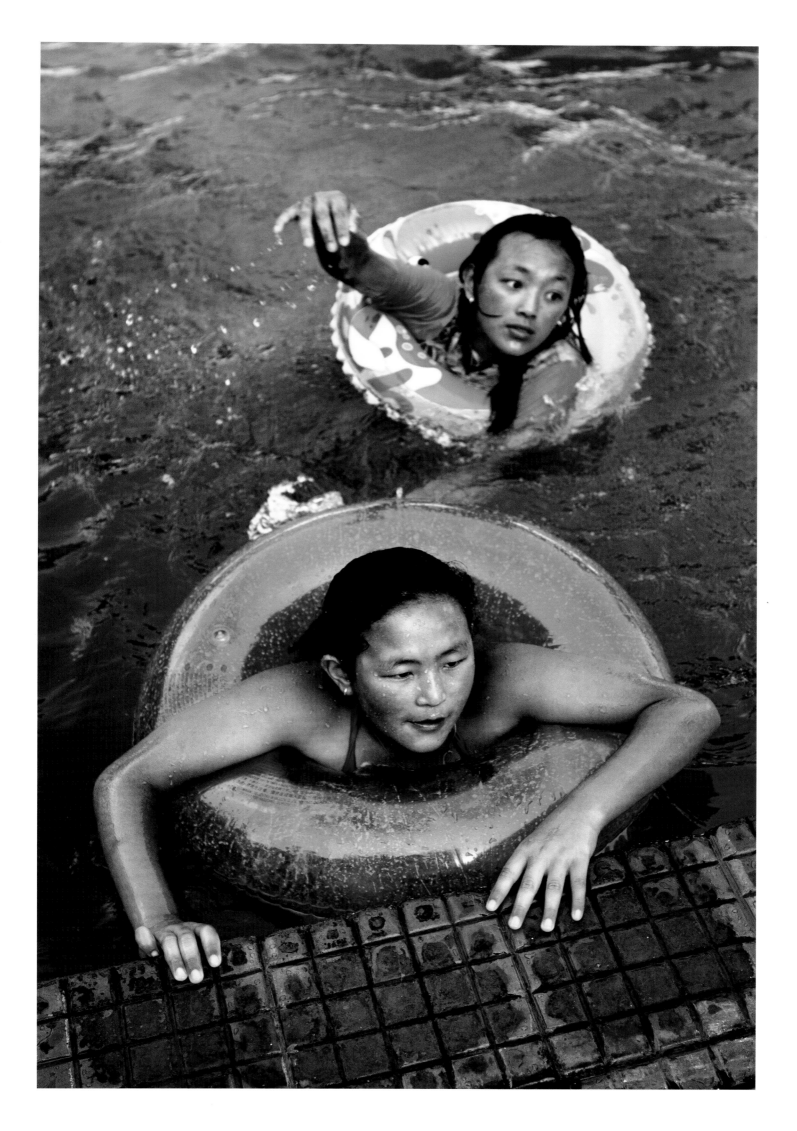

BRUSSELS, BELGIUM - Exiled Tibetans Lobsang Kunga (right) and Geshe Dhondup (left) wait at Charleroi airport for their flight back home to Bolzano, Italy, after participating in the 'European Solidarity Rally for Tibet'. 10 March 2013.

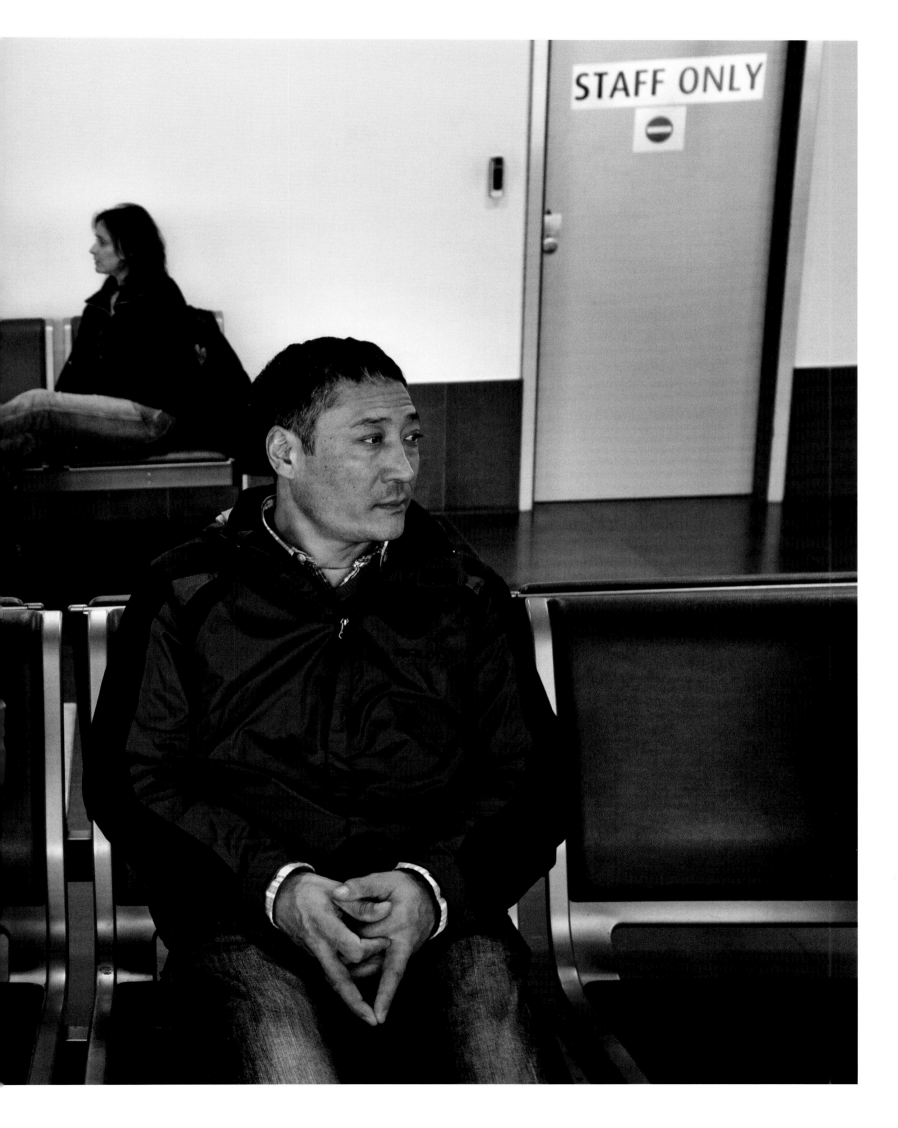

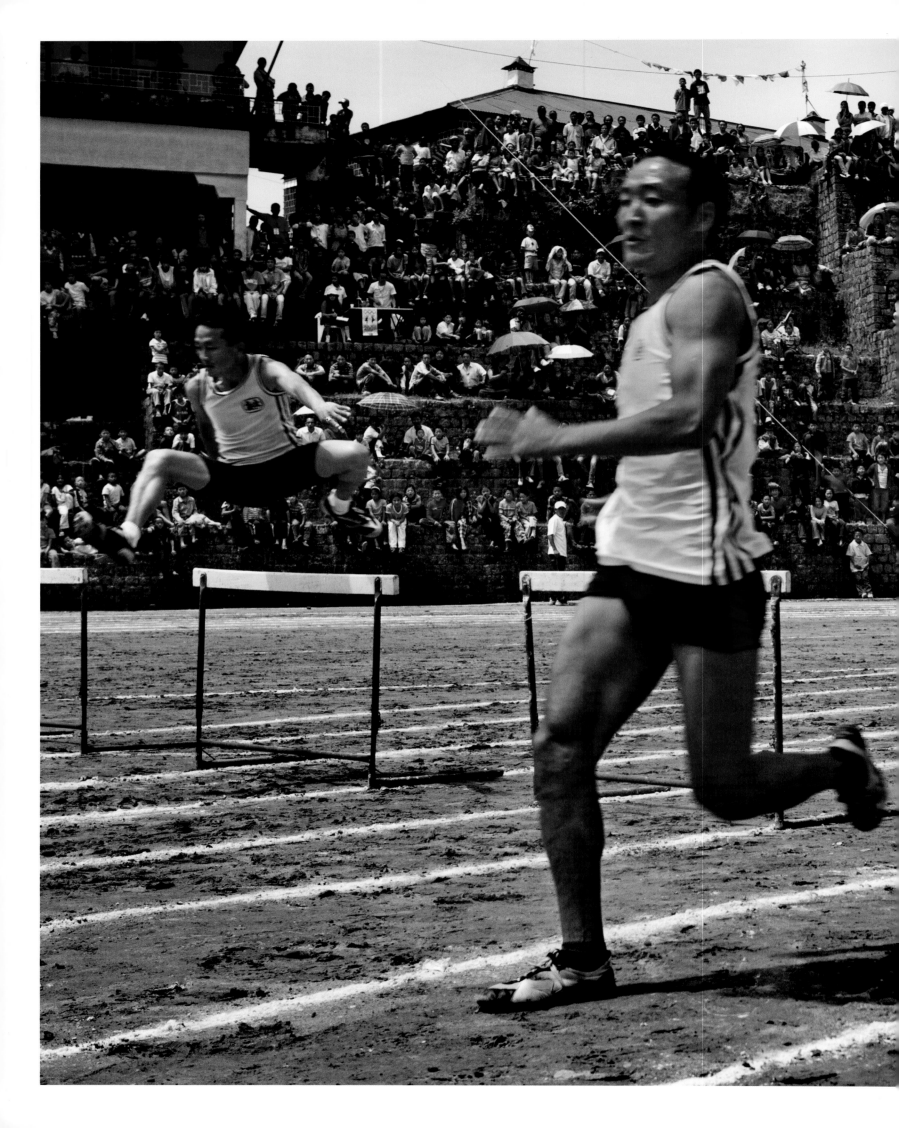

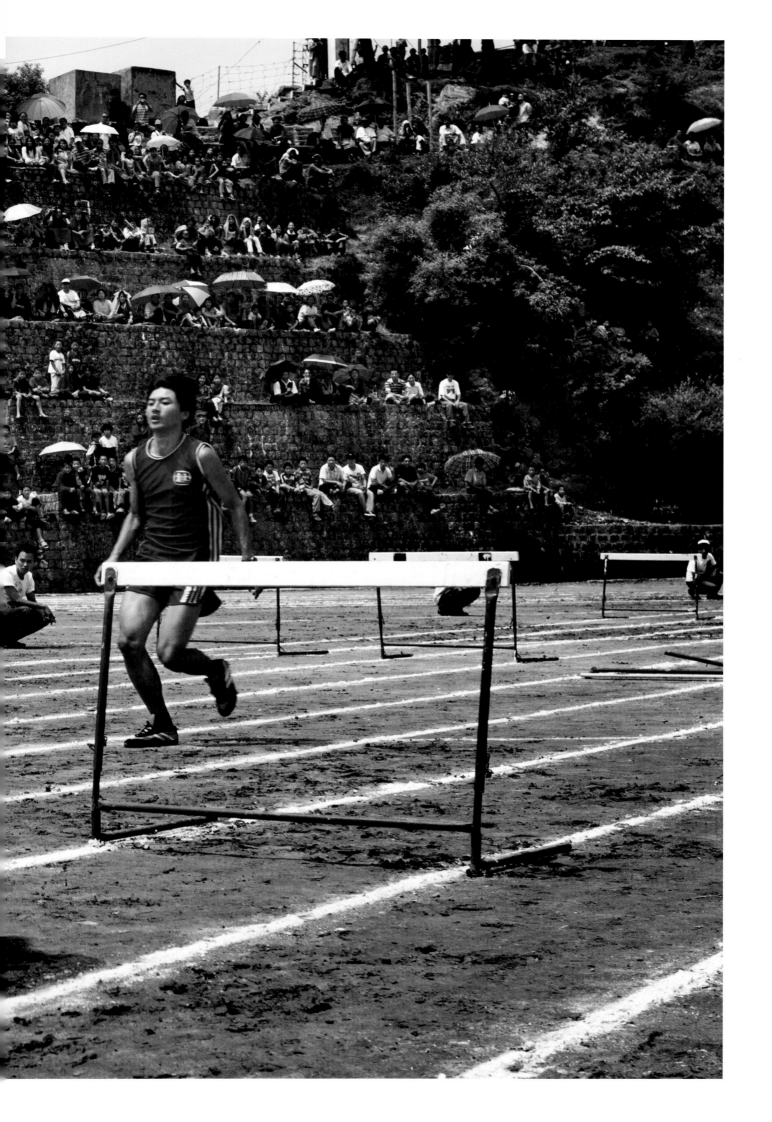

DHRAMSALA, HIMACHAL PRADESH, INDIA - Tibetan athletes at the 'Tibetan Olympics', a competition organised at the time of the 2008 Beijing Olympics, as a symbolic event to allow Tibetans, who were not represented at the games, to join in the celebration.

BYLAKUPPE, KARNATAKA, INDIA - Namgyal a tuberculosis patient, in her hospital room. The images behind her belong to a young boy who previously occupied the room. She dislikes them and would like to change them for photographs of Tibet, but is too weak to do so. Namgyal died in 2008, less than a year after this picture was taken. Tuberculosis remains a major public health problem amongst Tibetan refugees in India.

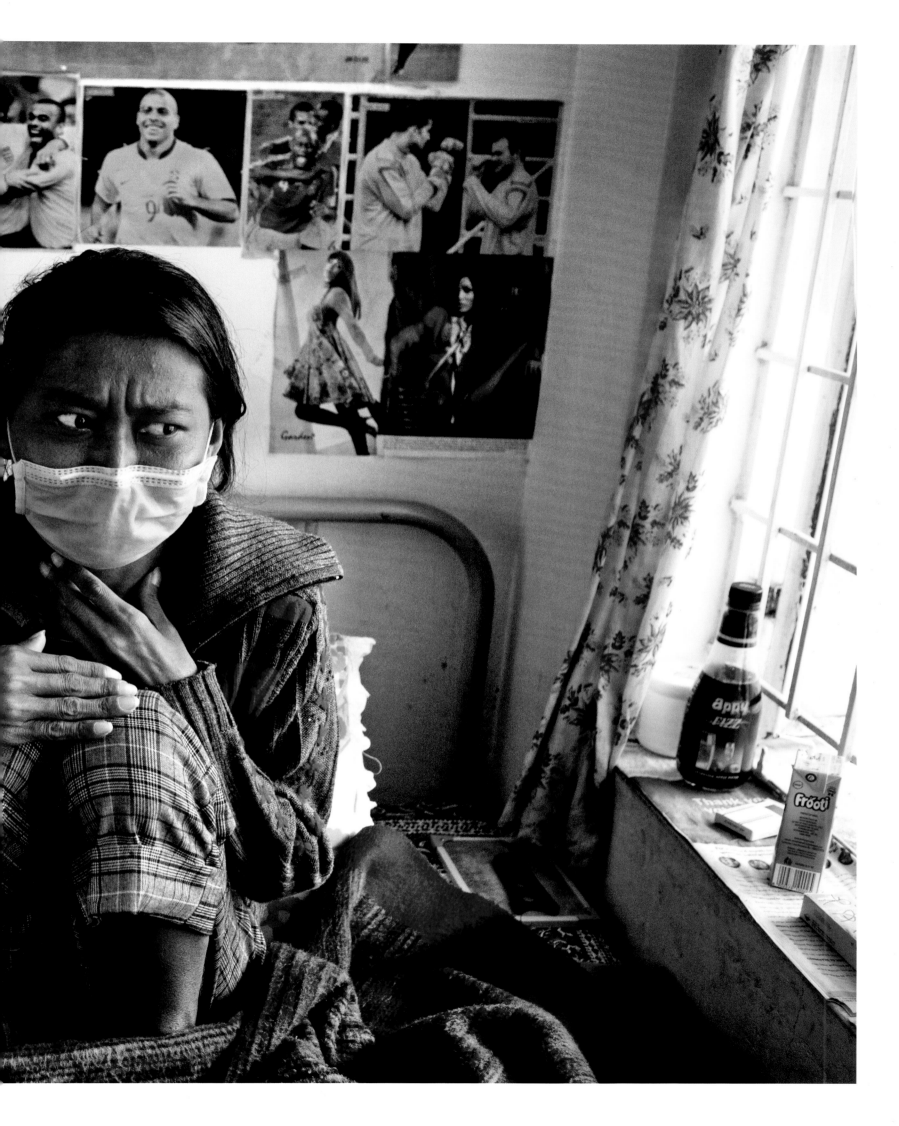

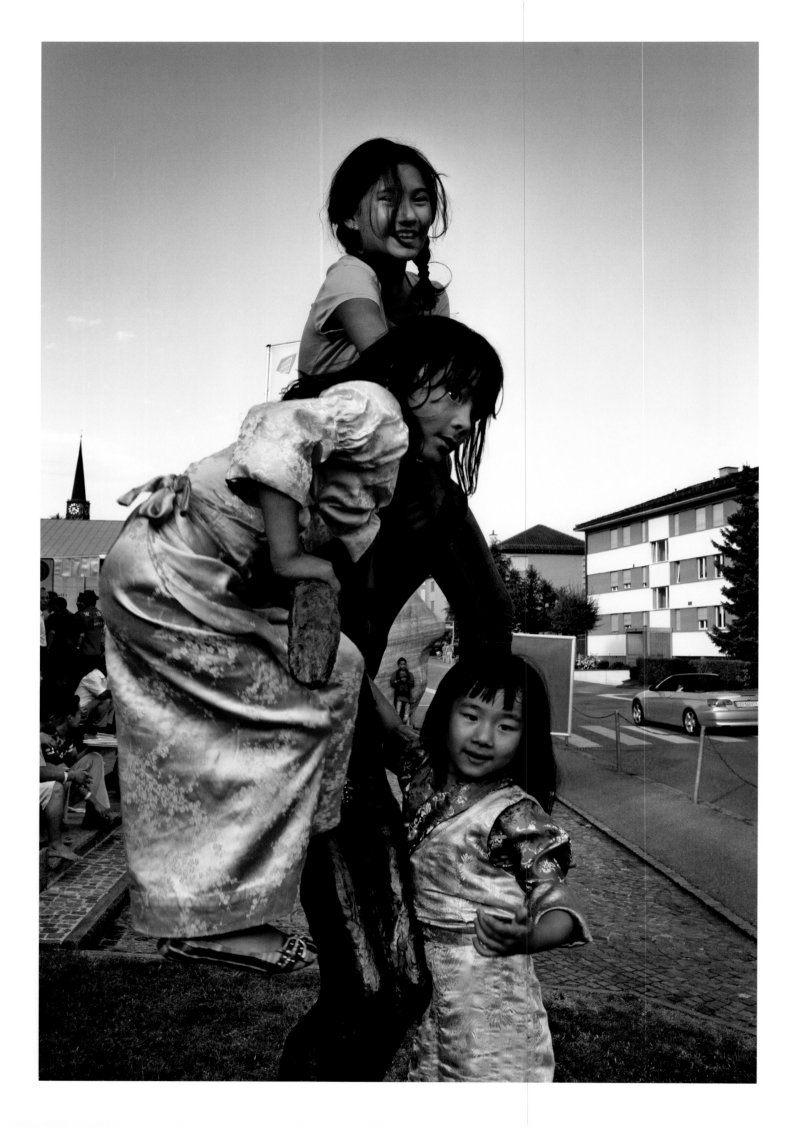

I hope that people know that there is also a great civilization beyond Himalaya that could in some way contribute to this world of today

Lobsang Jamphel, Dharamsala, India

Sometimes I help my mum with her work at Lhasa Fast Food. I really enjoy it because all the Tibetans in New York come here to eat traditional Tibetan food, buy Tibetan CDs and movies and to chat. Most of my friends are Tibetan, because they can understand my situation; I am more confident with them around me. I also think that it's important to stay together and to meet regularly to keep our language and culture alive. Tenzin, New York, USA

ZURICH, SWITZERLAND - Exiled Tibetan children in their traditional costume play on a street corner outside the Bulach Stadthalle. where a celebration is being held for the 75th birthday of their spiritual leader, the Dalai Lama.

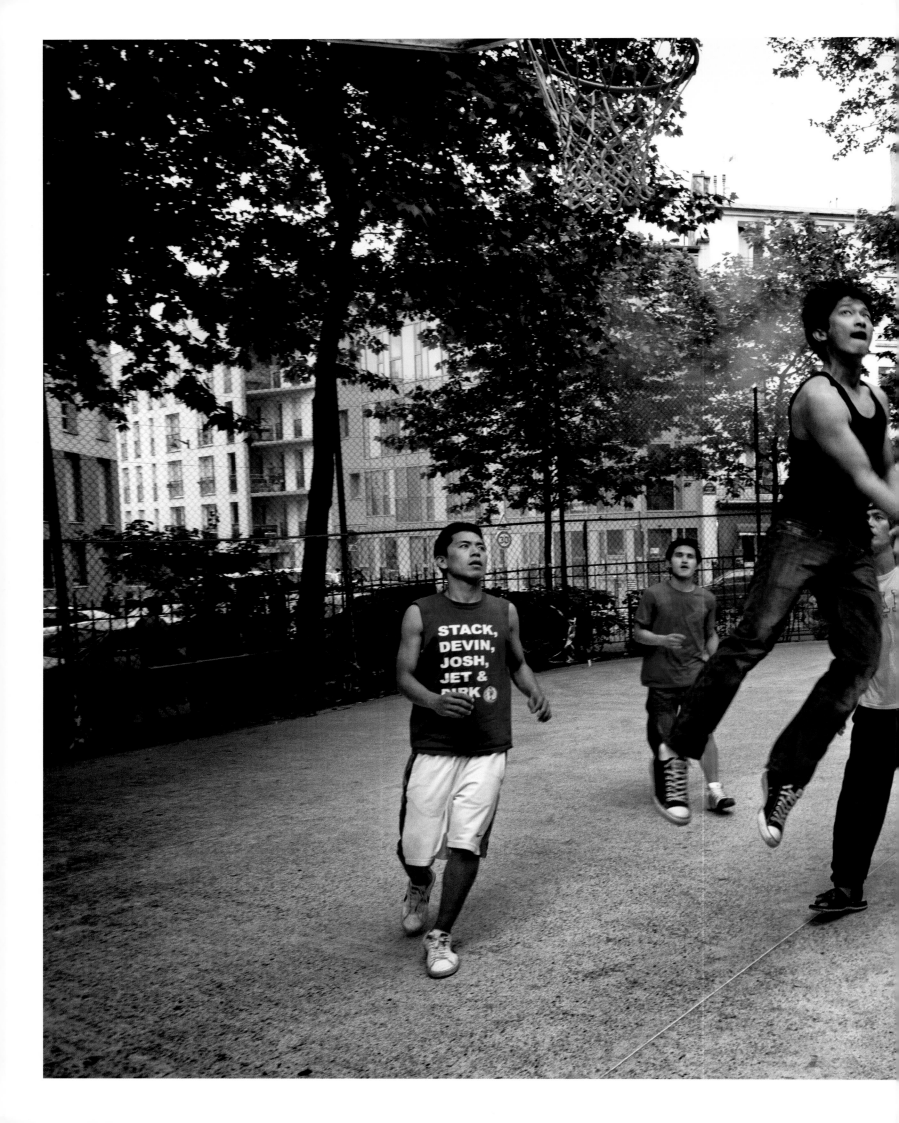

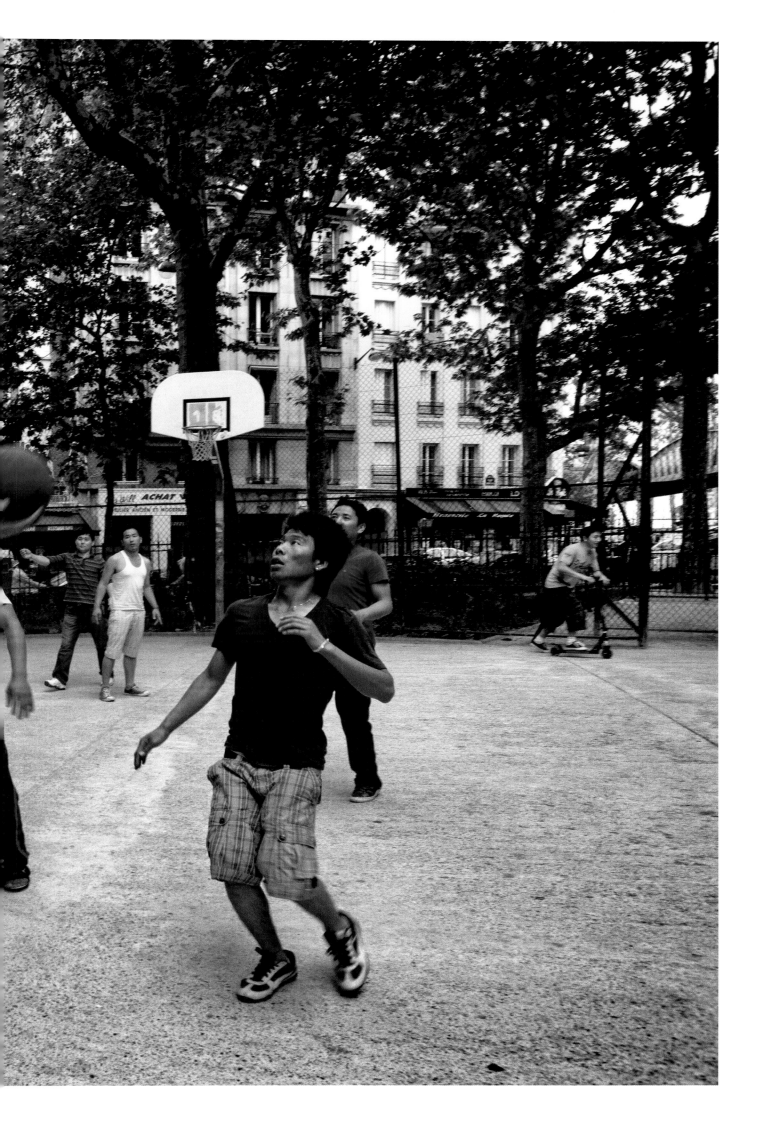

PARIS, FRANCE - Young exiled Tibetan refugees gather at the weekend to play basketball.

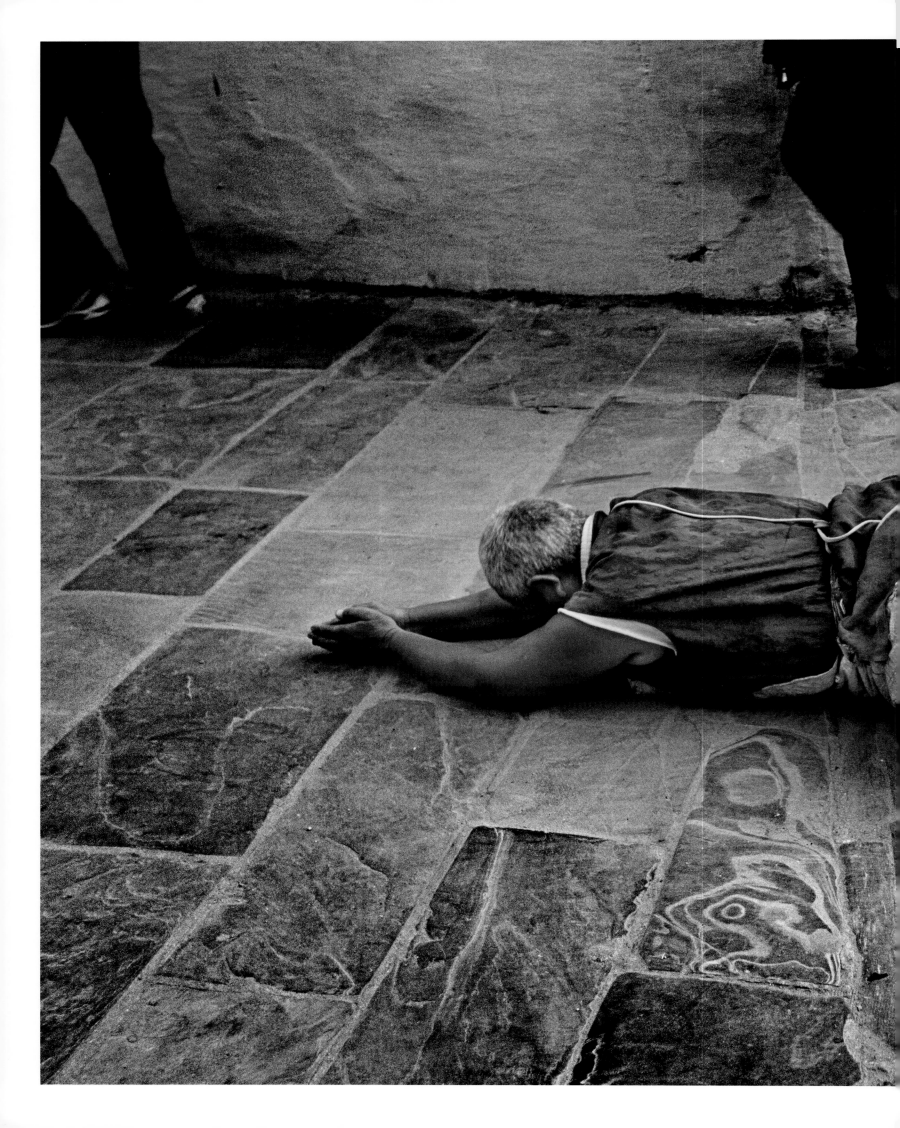

KATHMANDU, NEPAL - An elderly nun prostrates herself at Boudhanath, one of the largest and holiest Buddhist stupa in the world.

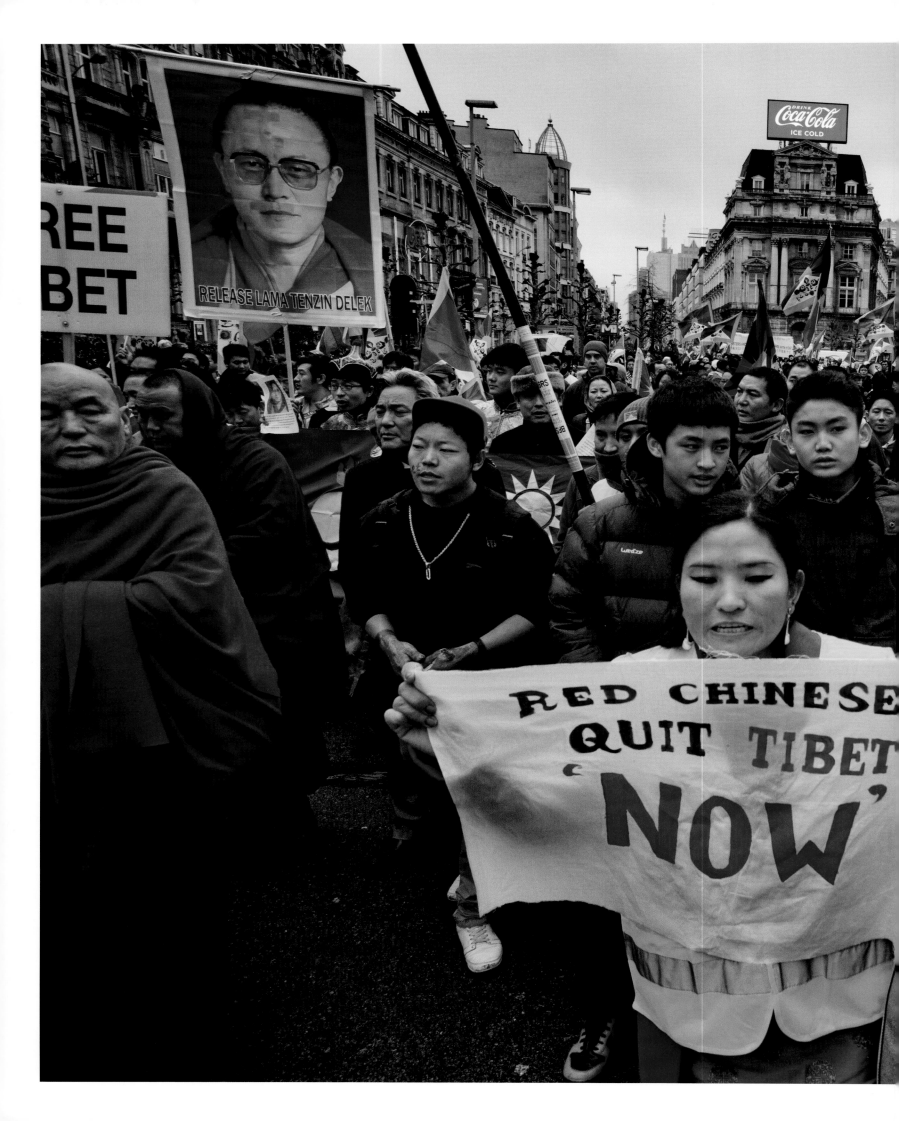

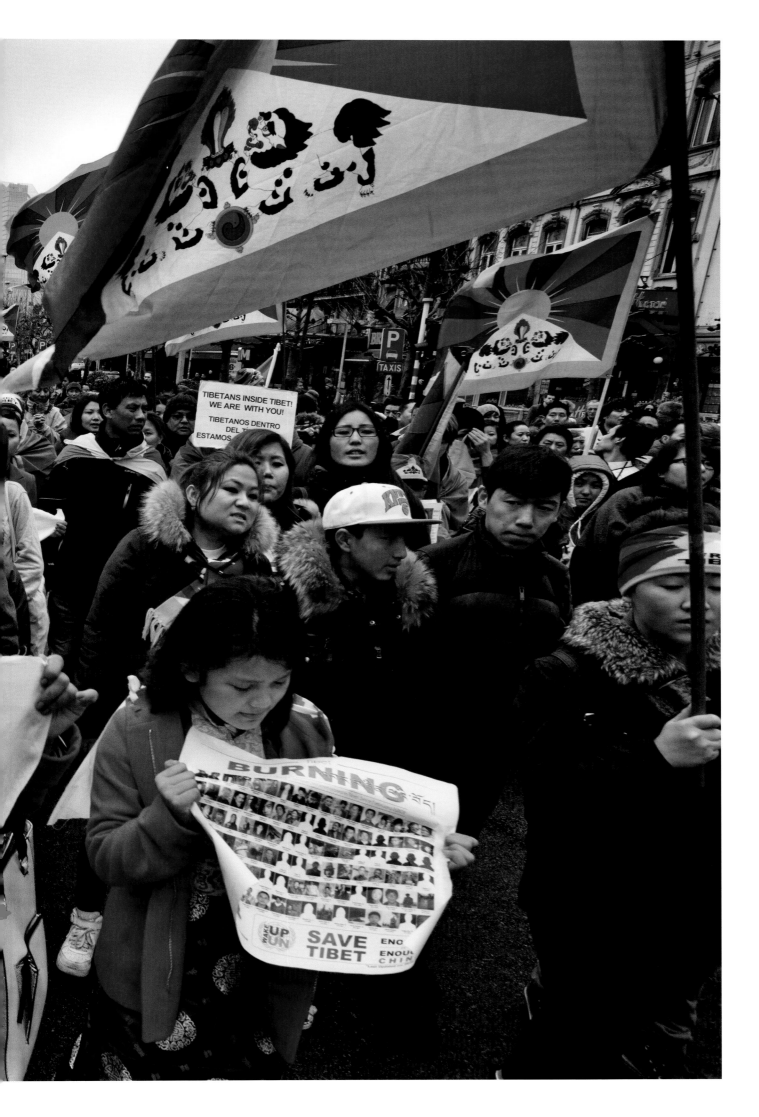

BRUSSELS, BELGIUM - Thousands of Tibetans, from all over Europe, march in Brussels, during the 'European Solidarity Rally for Tibet' to express solidarity with Tibetans within Tibet and to protest against the Chinese occupation of their homeland. The mass rally held on 10th of March 2013, marked the 54th Tibetan 'uprising day', and sought to persuade the European Union to make Tibet the 'top priority' in their bilateral relations with China and to help to find a peaceful resolution to the Tibetan issue.

DHARAMSALA, HIMACHAL PRADESH, INDIA - Tibetans at a candlelit vigil at Tsuglakhang, the main Temple of the Dalai Lama in exile. They are expressing their solidarity with Tibetans inside Tibet during the protests, uprising and crackdown in 2008.

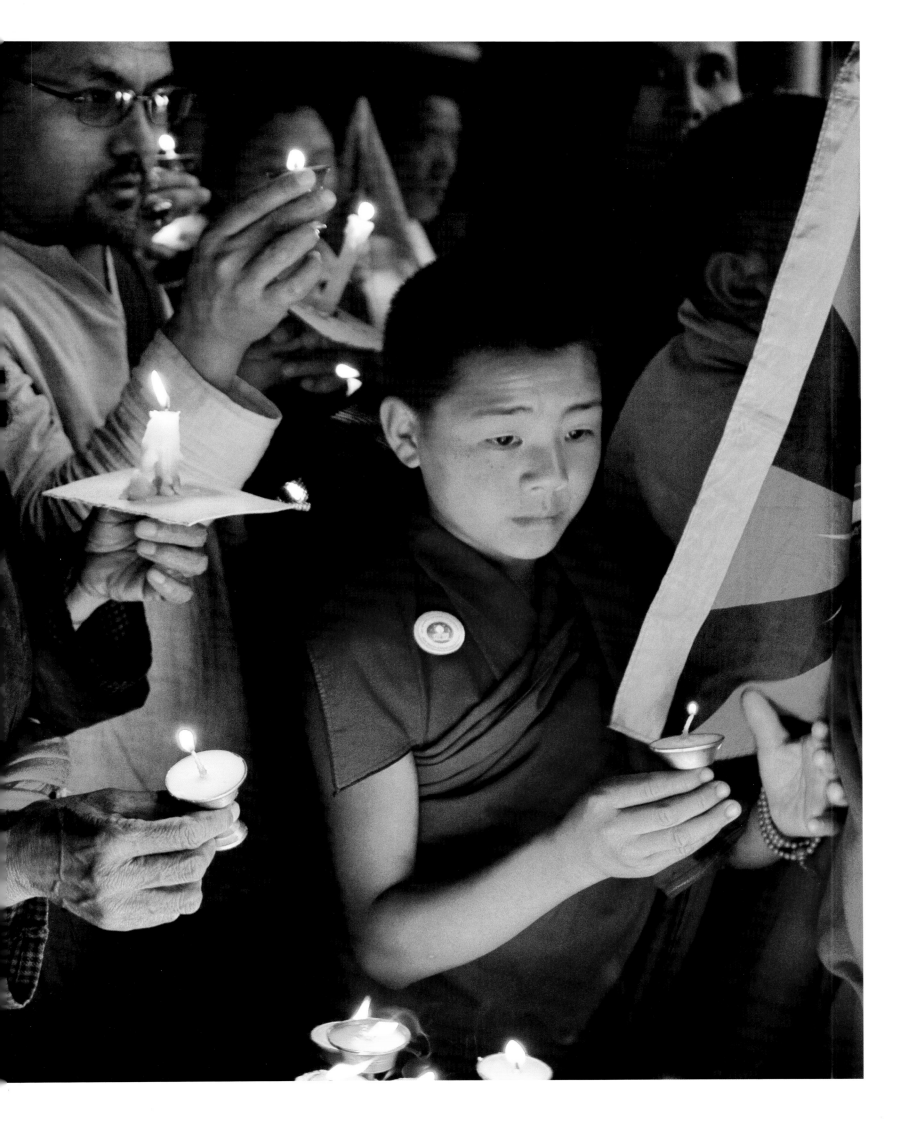

MUNDGOD, KARNATAKA, INDIA - His Holiness the Dalai Lama performing a ritual and prayer during a teaching session held in 2008.

MUNDGOD, KARNATAKA, INDIA - Nechung Oracle, the state Oracle of Tibet, goes into a trance during a prayer gathering. As for many ancient civilizations, the phenomenon of oracles remains an important part of the Tibetan way of life. Tibetans rely on oracles for various reasons, not just to foretell the future. They are called upon as protectors and sometimes as healers. However, their primary function is to protect the Buddha Dharma and its practitioners.

KATHMANDU, NEPAL - The Tibetan community in Nepal gathers at Boudhanath on the third day of Losar, the Tibetan New Year, to offer prayers and exchange New Year greetings. They throw 'Tsampa', made of roasted barley and part of the staple Tibetan diet. This tradition is closely connected to the original and native Bon religion of Tibet.

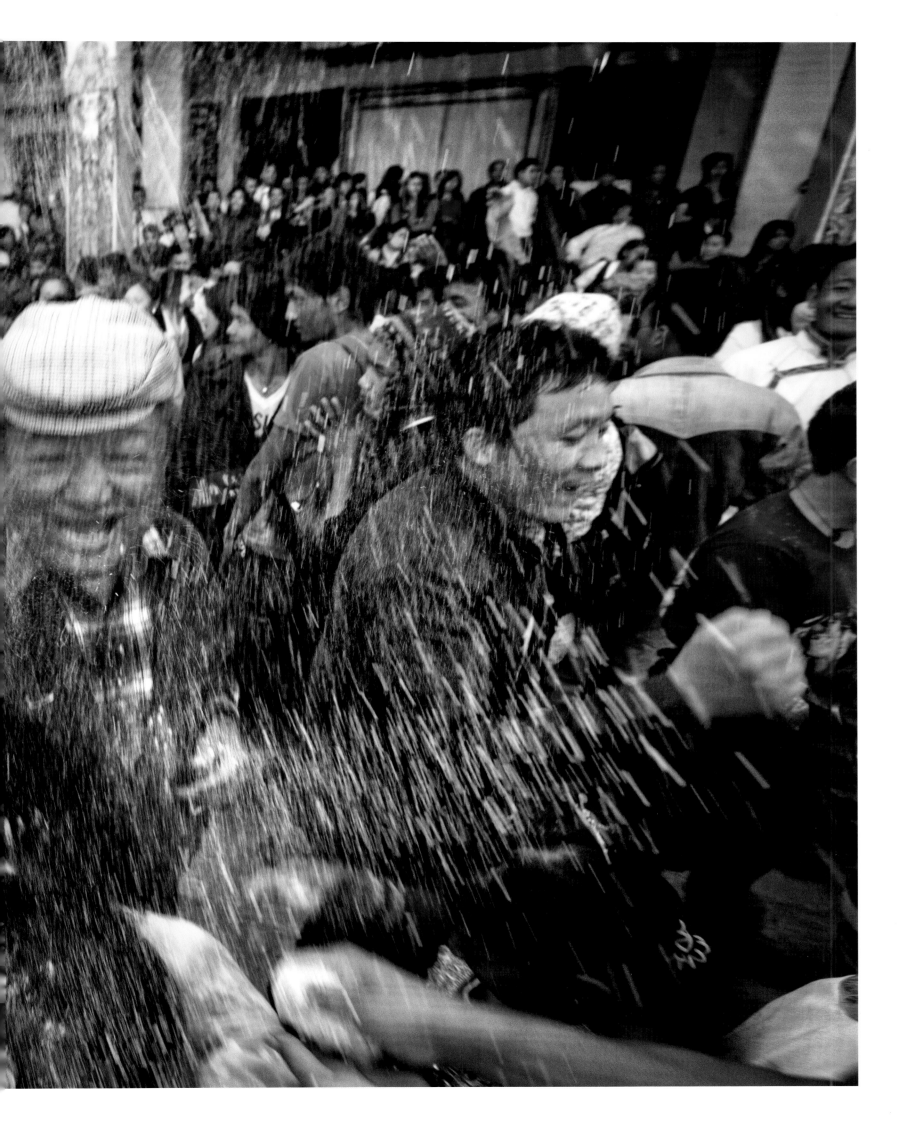

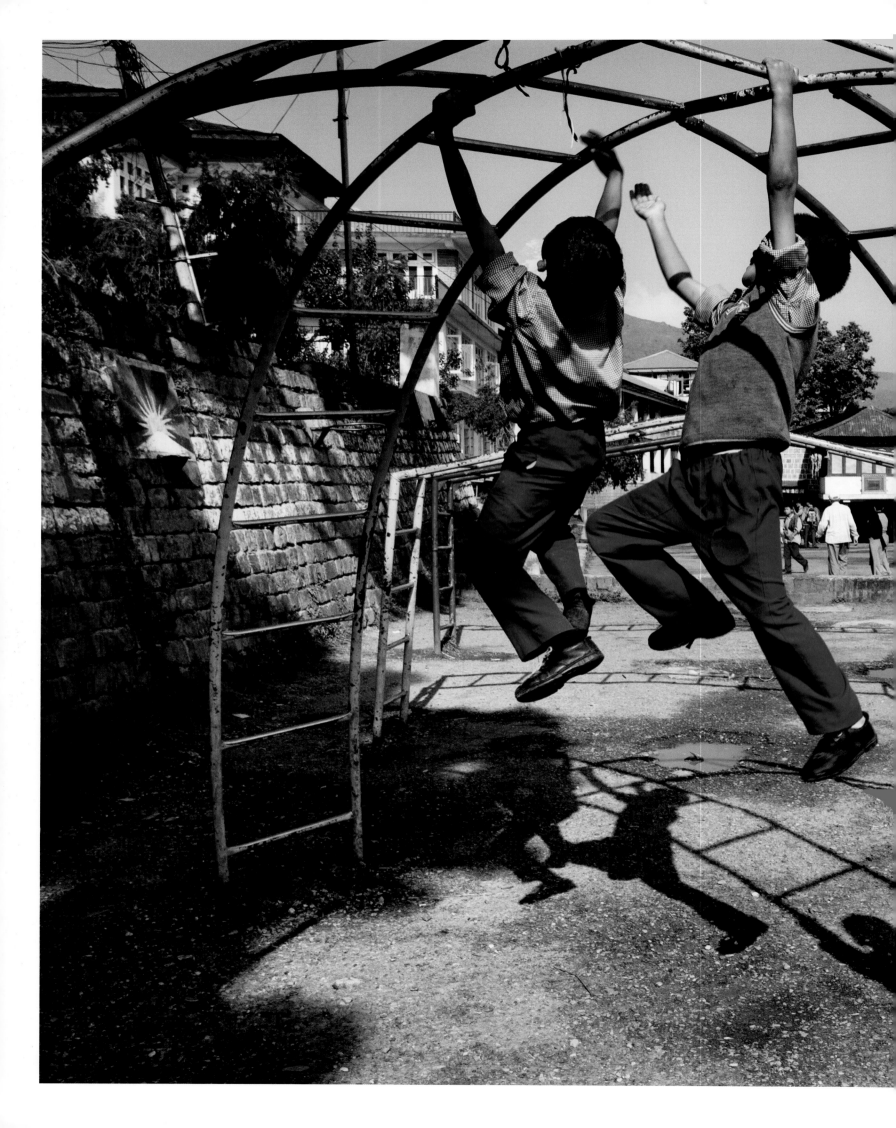

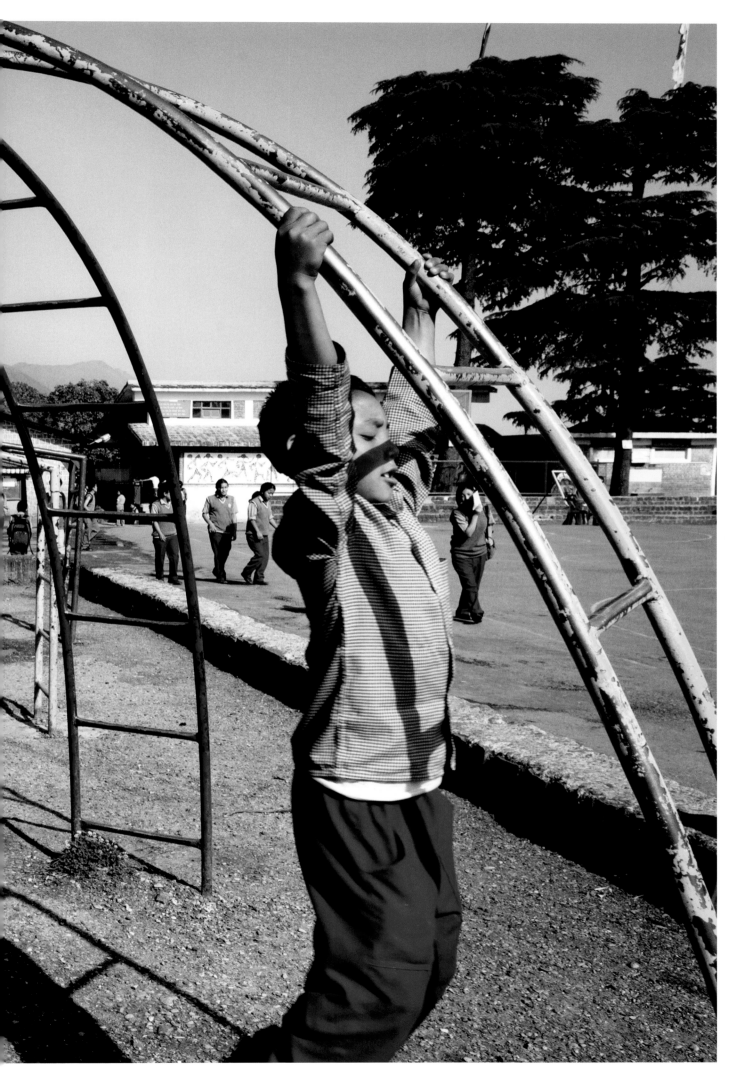

DHARAMSALA, HIMACHAL PRADESH, INDIA - Tibetan children playing at Upper TCV. TCV (Tibetan Children's Village) was founded in 1960 as a nursery and care centre for Tibetan children by Tsering Dolma Takla, the sister of His Holiness the Dalai Lama. Over the past five decades, it has established itself as the core funding institution for Tibetans in exile with branches from Ladakh in North India to Bylakuppe in the South. It caters for the needs of close to 17,000 Tibetan children, many of whom are orphans or are separated from their families.

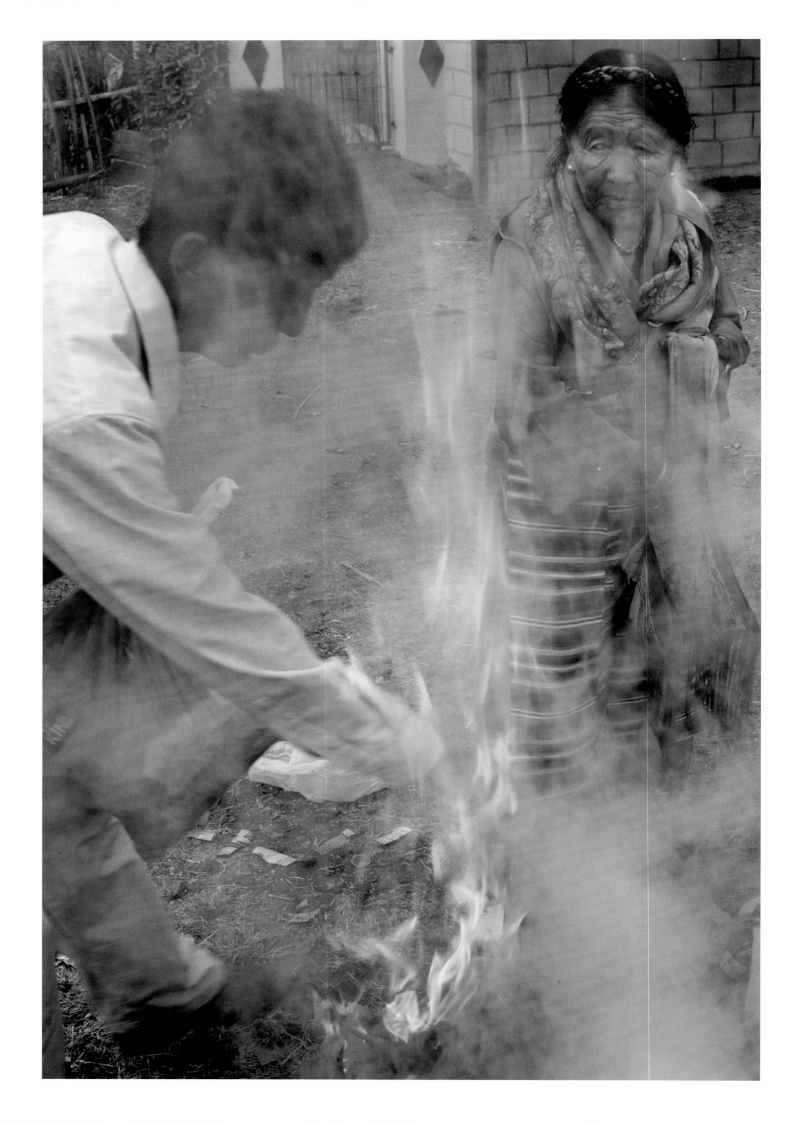

I feel that the Chinese have turned Tibet into a living hell with no freedom at all. Dolma Lhamo, Dharamsala, India

In Lhasa in and around
the police station
rioting October 1987

As long as our politicians continue to kowtow to the Chinese, we in the West can do nothing more than demonstrate and inform people about the fate of Tibet. I am determined never to stop standing up for human rights in Tibet and for the country to be given extensive autonomy, so that my people don't face the same destiny as the Native Americans or the Australian Aborigines. Yangzom Brauen (actress, director and writer), Los Angeles, USA.

BYLAKUPPE, KARNATAKA - Tibetans wearing their best traditional attire burn Juniper incense during 'Losar', the Tibetan New Year, as a part of a religious ritual.

TAOYUAN, TAIWAN - Old photographs from Tibet displayed on the fridge of a refugee's house.

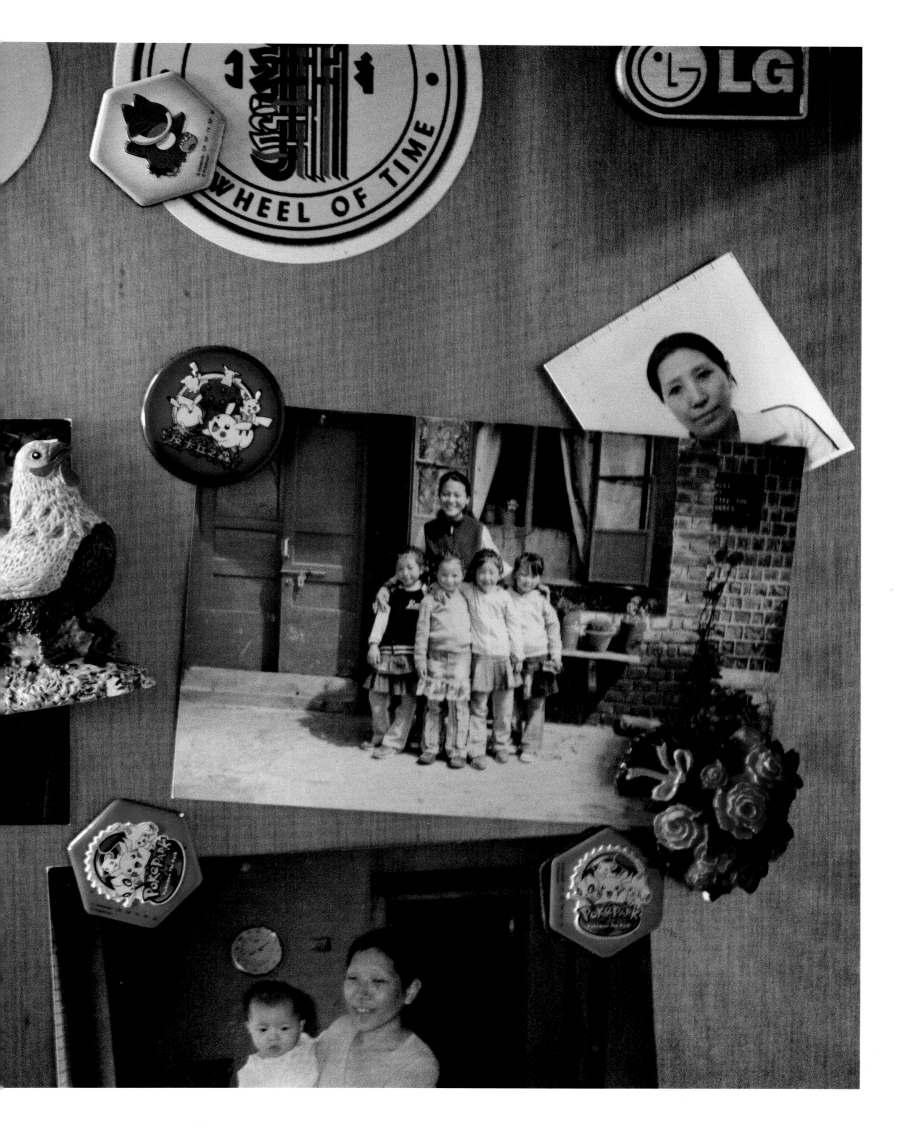

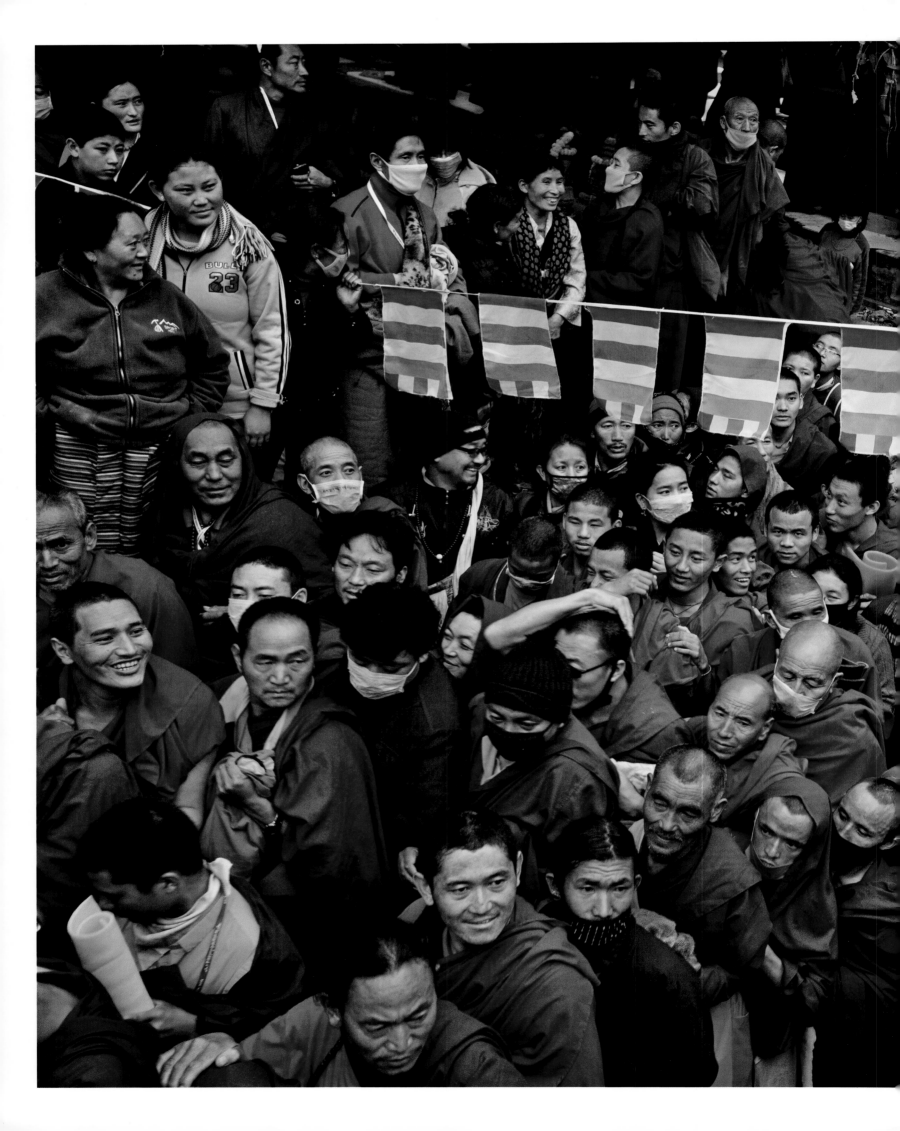

BODH GAYA, BIHAR, INDIA - Thousands of exiled monks, nuns and Tibetans gathered around the Mahabodhi Temple, one of the most sacred Buddhist sites in the world, on the occasion of the 32nd 'Kalachakra' prayers delivered by the Dalai Lama.

TAOYUAN, TAIWAN - Tibetan refugees who move to Taiwan often work in clothes factories. Jantsen, Dolma and Jigme (left to right), work at a factory in Taoyuan. It is hard work with 12 hour shifts in temperatures of up to 40°C. and only two days off a month. However, the pay of 3000 TD a day is seen as good.

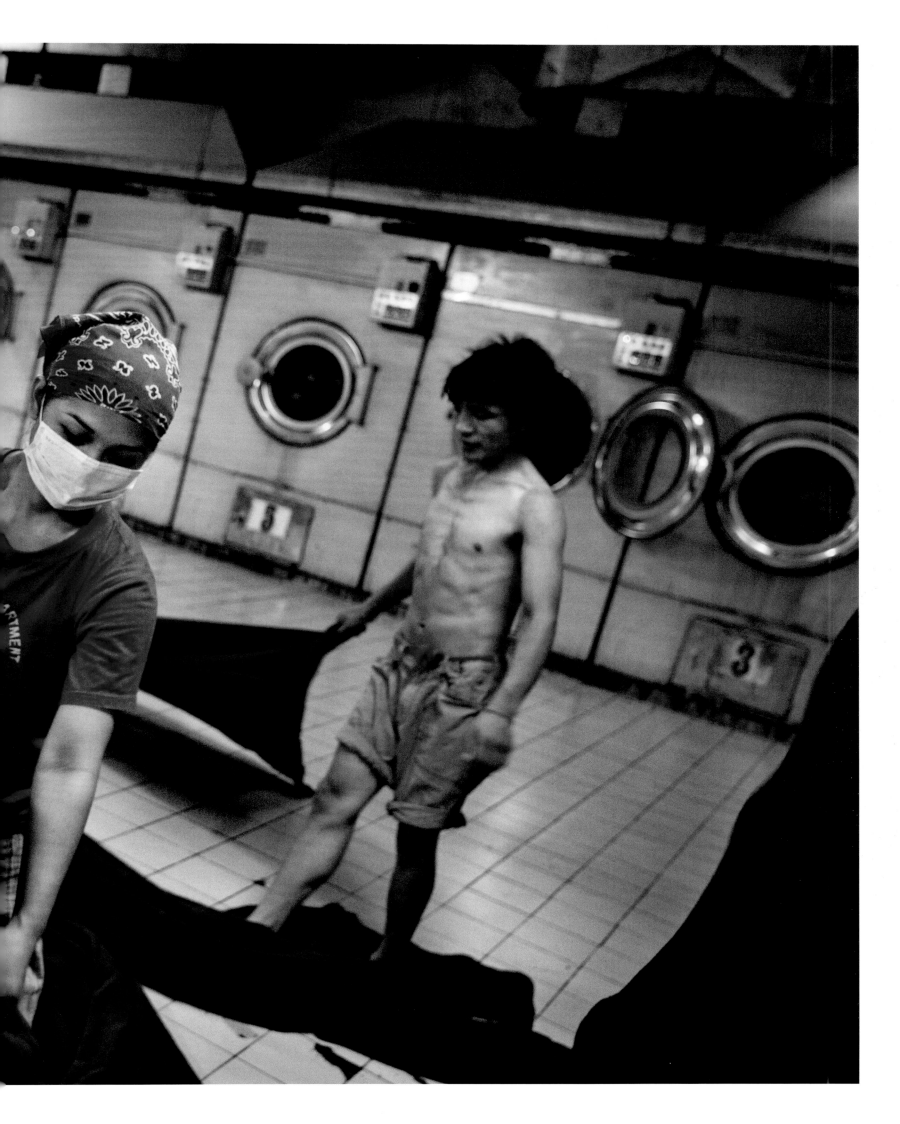

BYLAKUPPE, KARNATAKA, INDIA - Tenzin Dolma, Miss Tibet 2007 (proclaimed by the Tibetan refugees community but not recognised by China) during a fashion show.

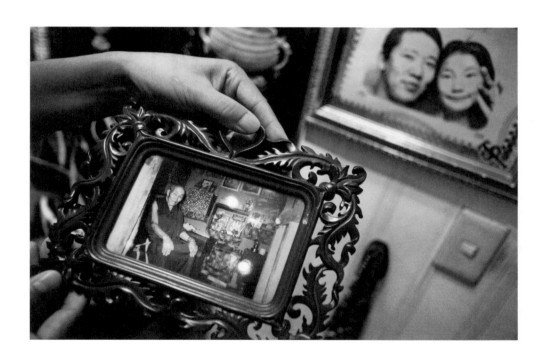

I think it's the duty and responsibility of all Tibetan citizens to work for the survival of our culture and heritage. Tsering Namgyal, New York, USA

Due to the bad experiences of their parents some children only know bad things about Tibet... they think it's all about oppression, killings... I want to also show them positive things such as the fauna, the nature, the songs - so that they can love their country of origin.

Yangchen, Brussels, Belgium

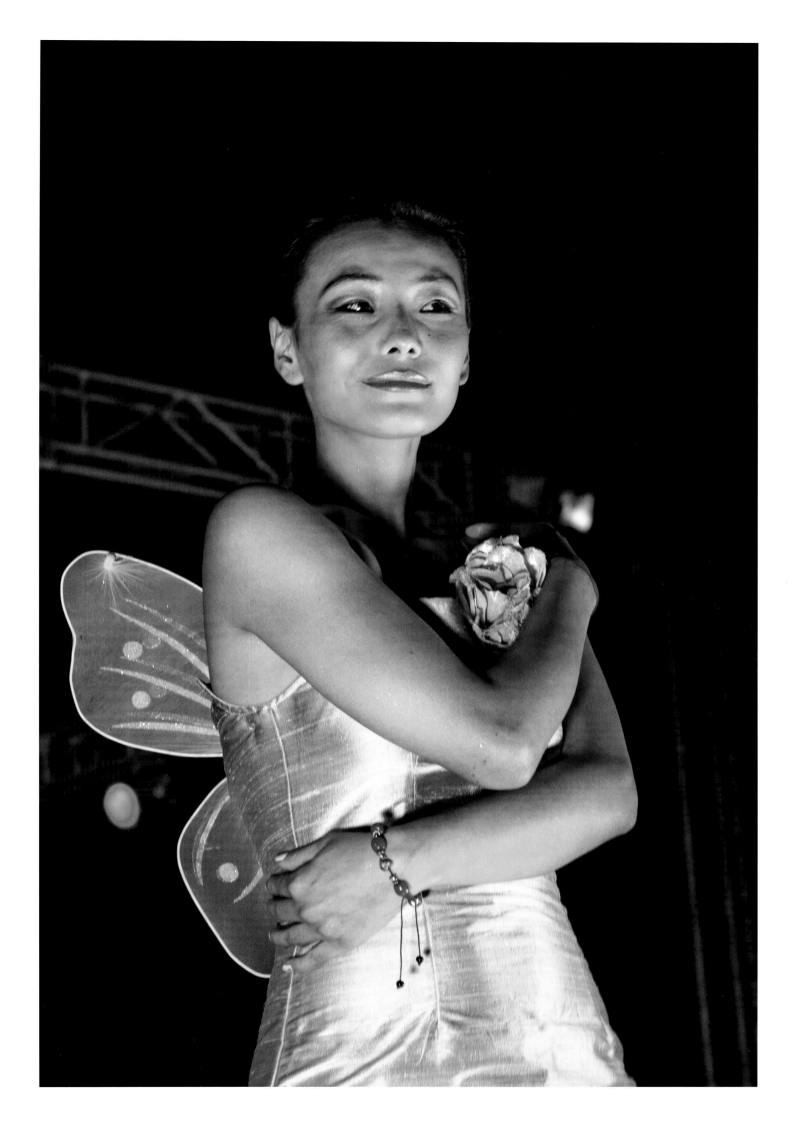

TORONTO, CANADA - His Holiness the Dalai Lama is welcomed as he arrives to inaugurate the Tibetan Canadian Cultural Center.

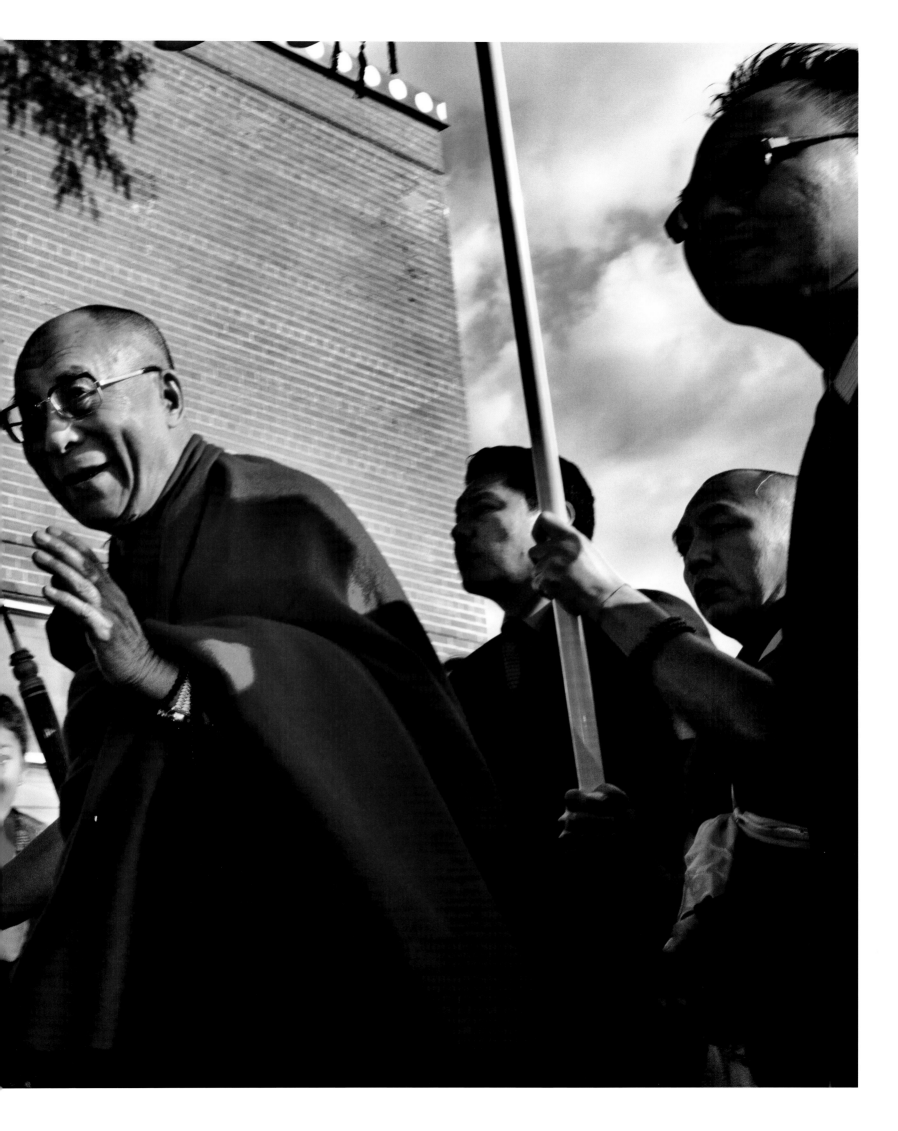

NEW YORK, U.S.A - Young Tibetan girls in exile at a fund raising party.

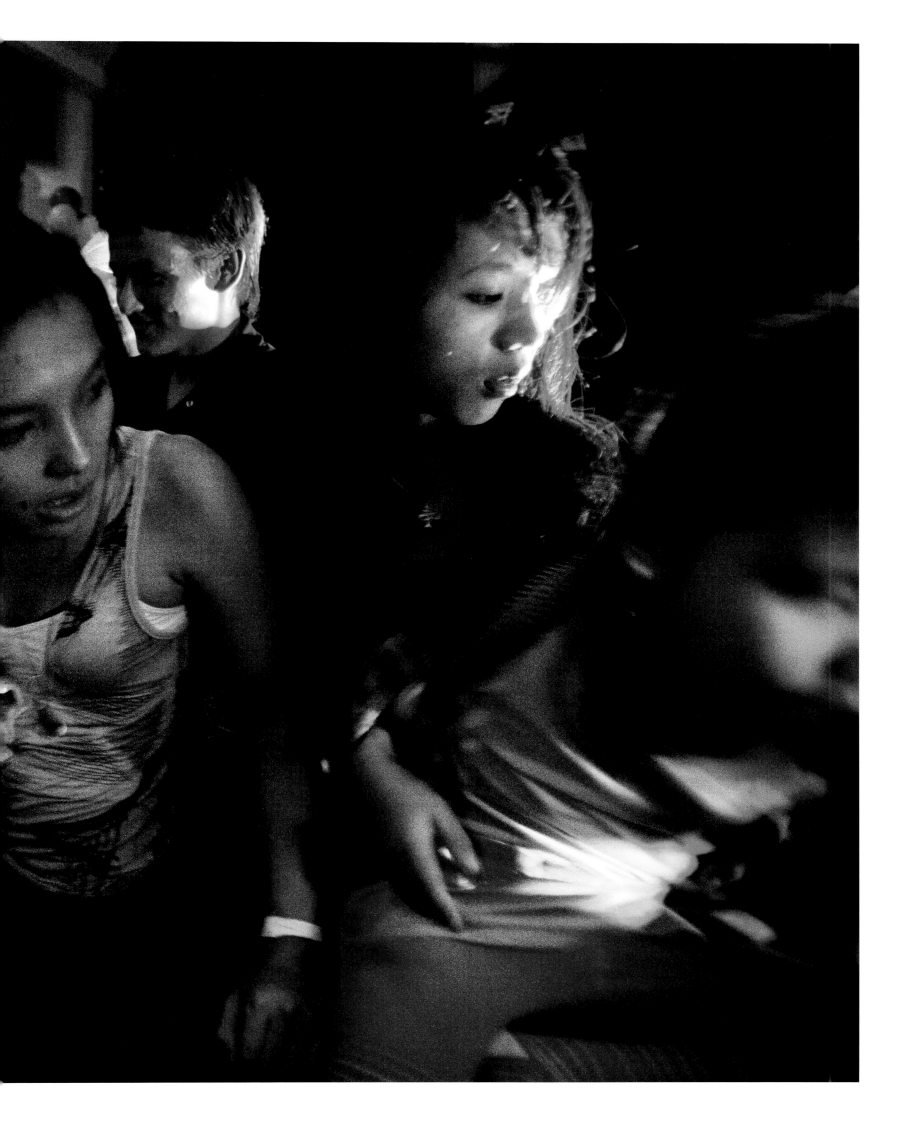

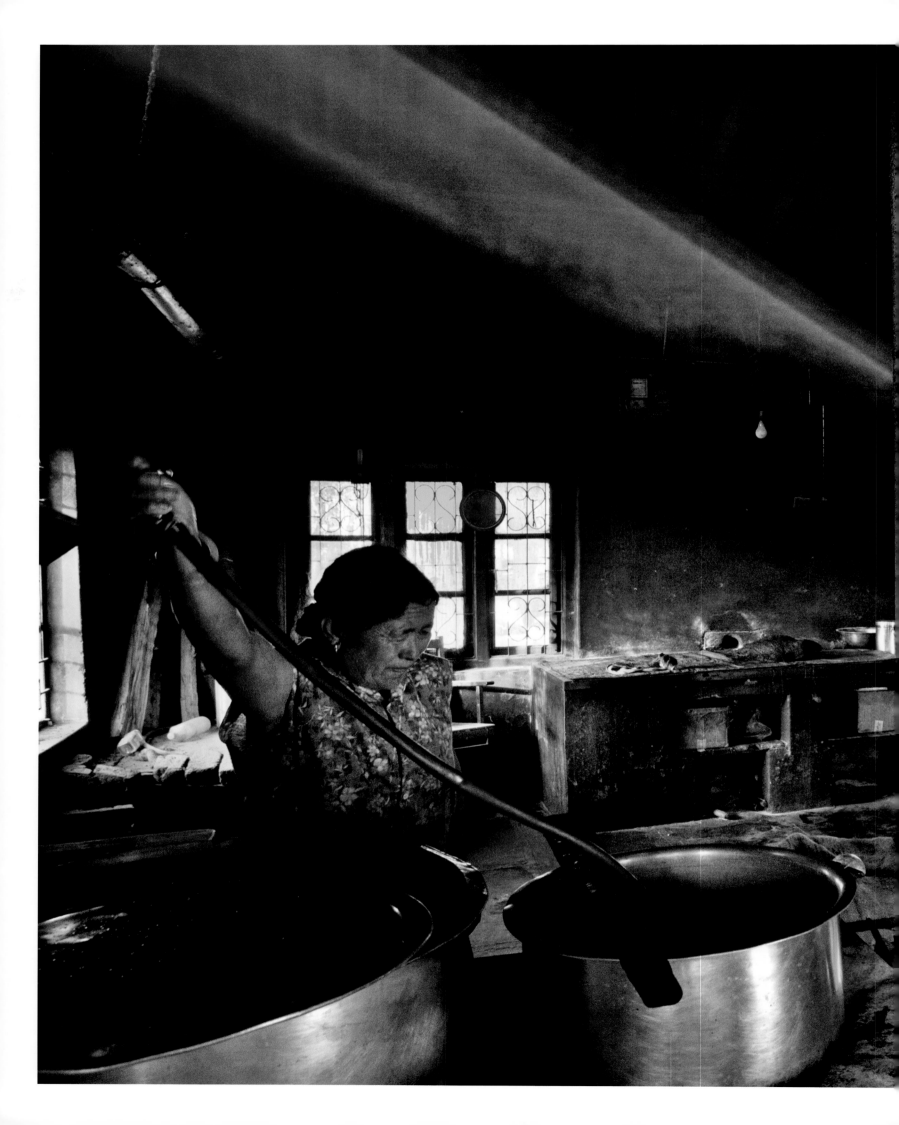

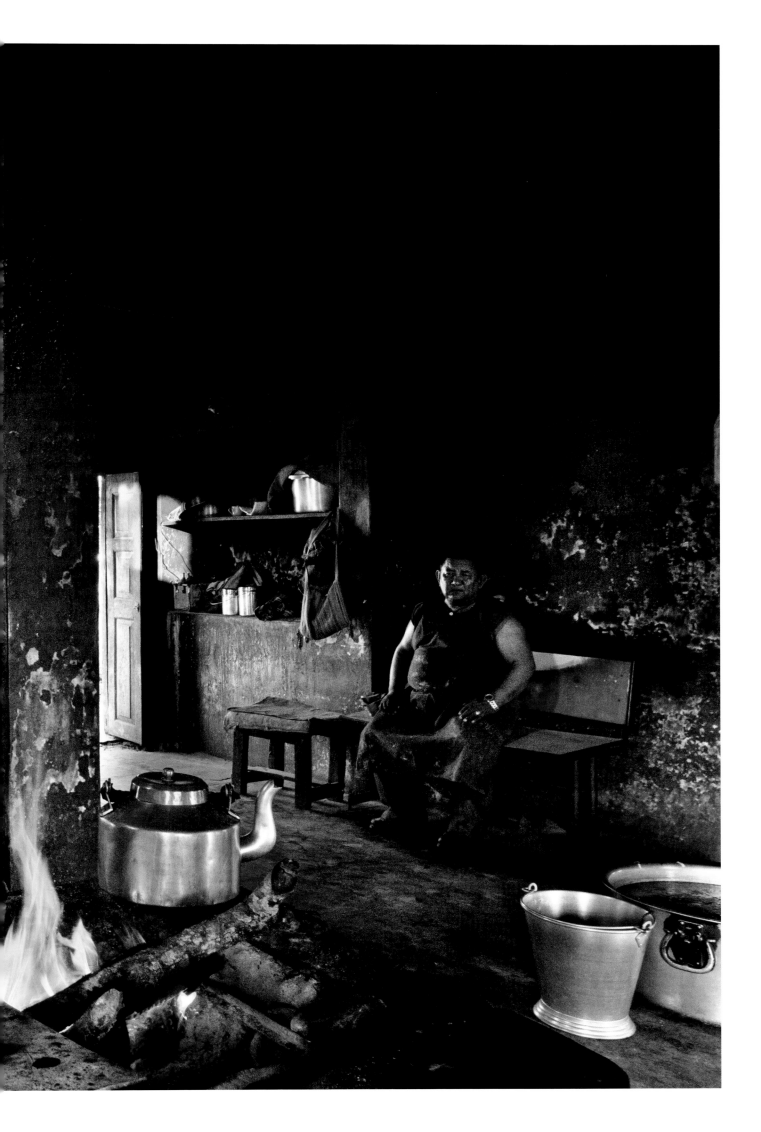

MUNDGOD, KARNATAKA, INDIA - A Tibetan woman prepares tea in the kitchen of the 'old people's home'.

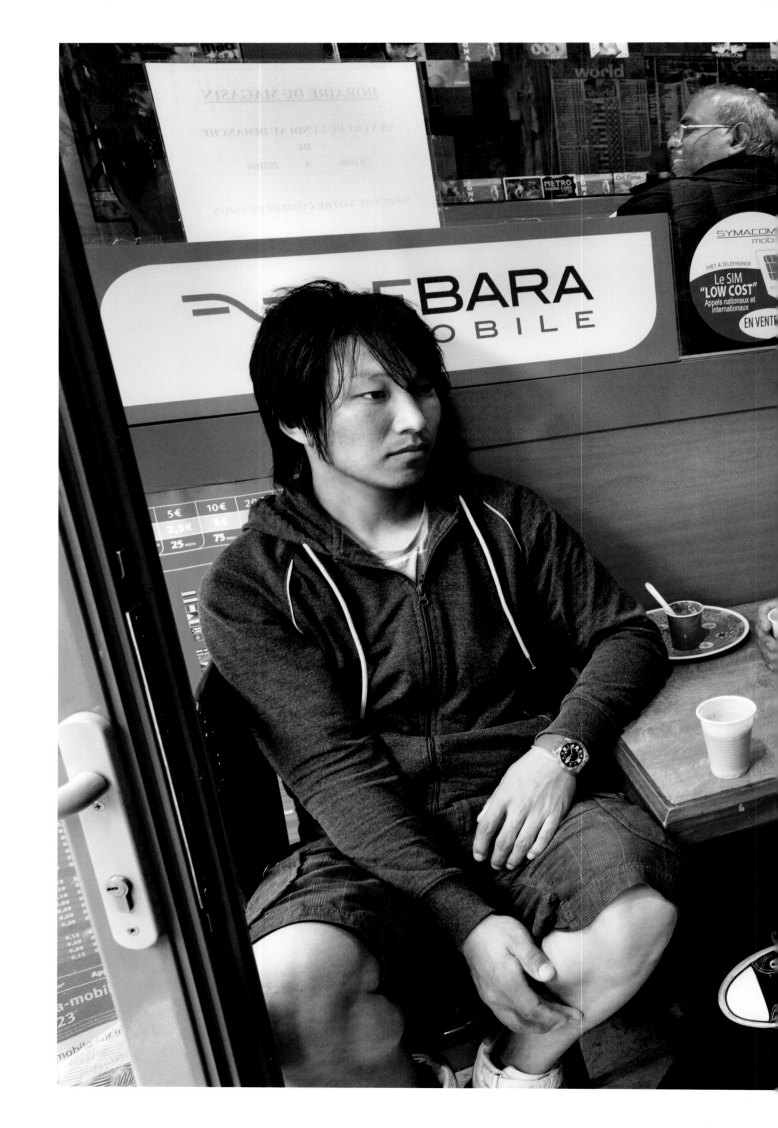

PARIS, FRANCE - Young exiled Tibetans gather at a café, a regular hang out in the Indian neighborhood near Place de la Chapelle.

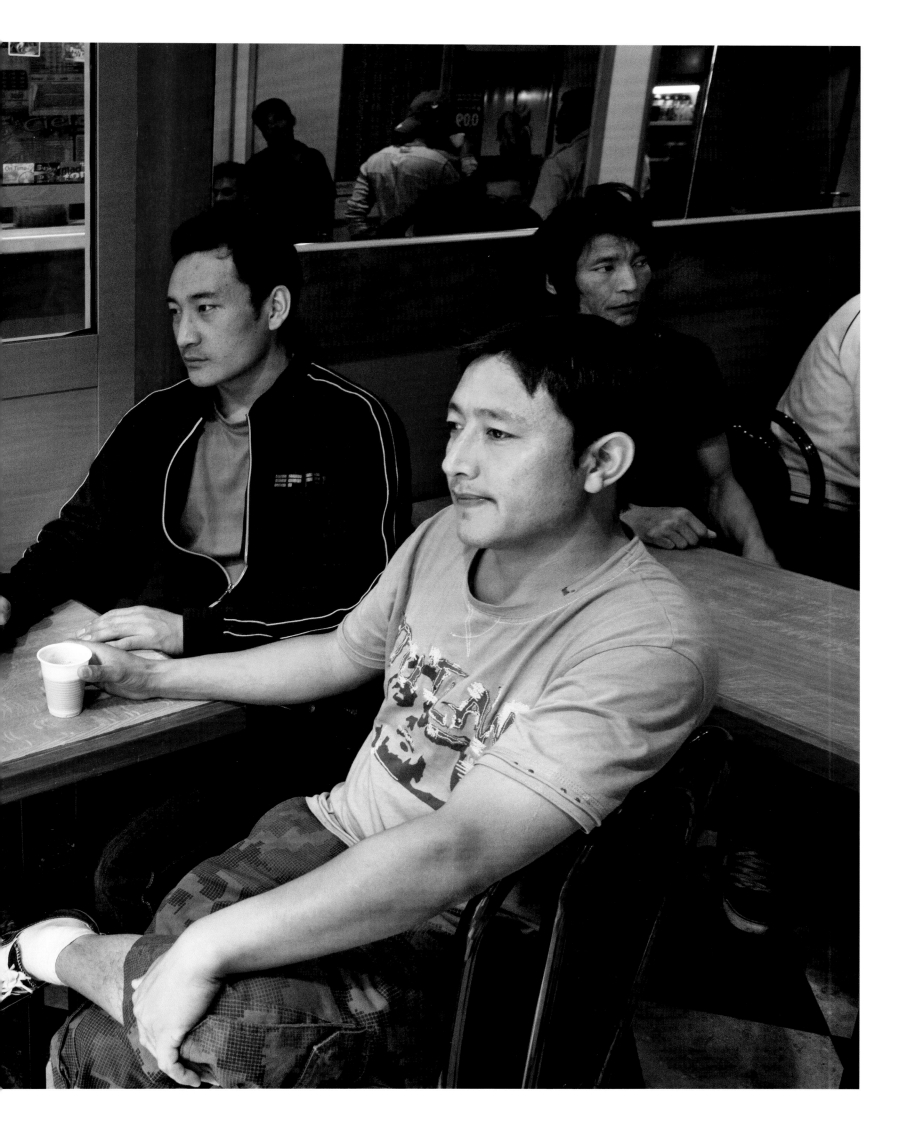

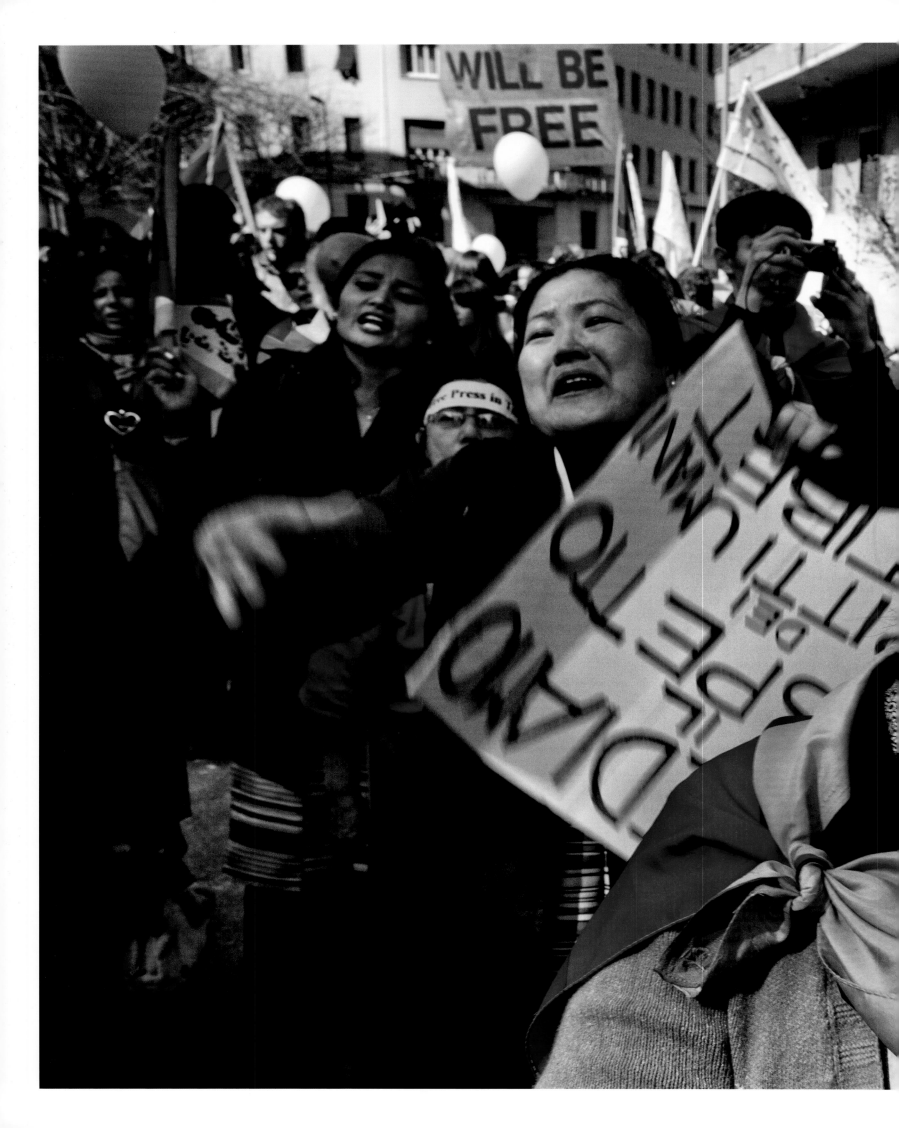

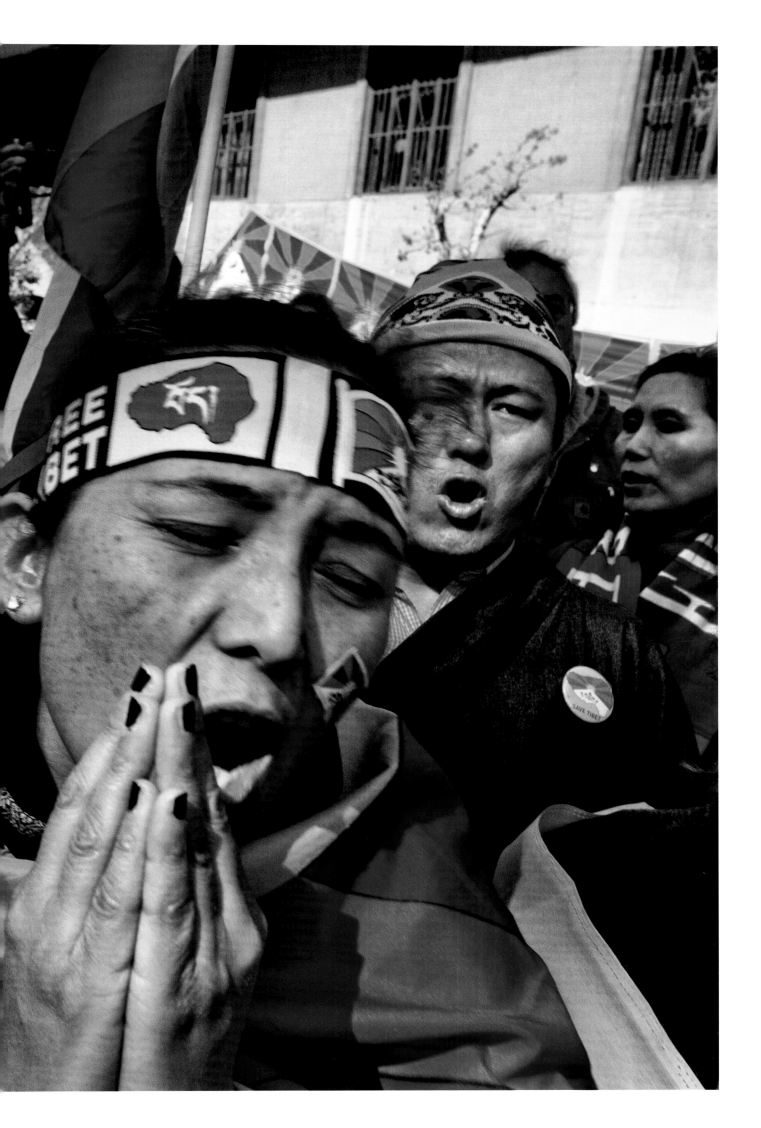

ROME, ITALY - Commemoration of the 53rd anniversary of the 'Tibetan National Uprising Day'.
Tibetan refugees and their supporters shout slogans of freedom and wave their national flag in front
of the Chinese Embassy. 10 March 2012.

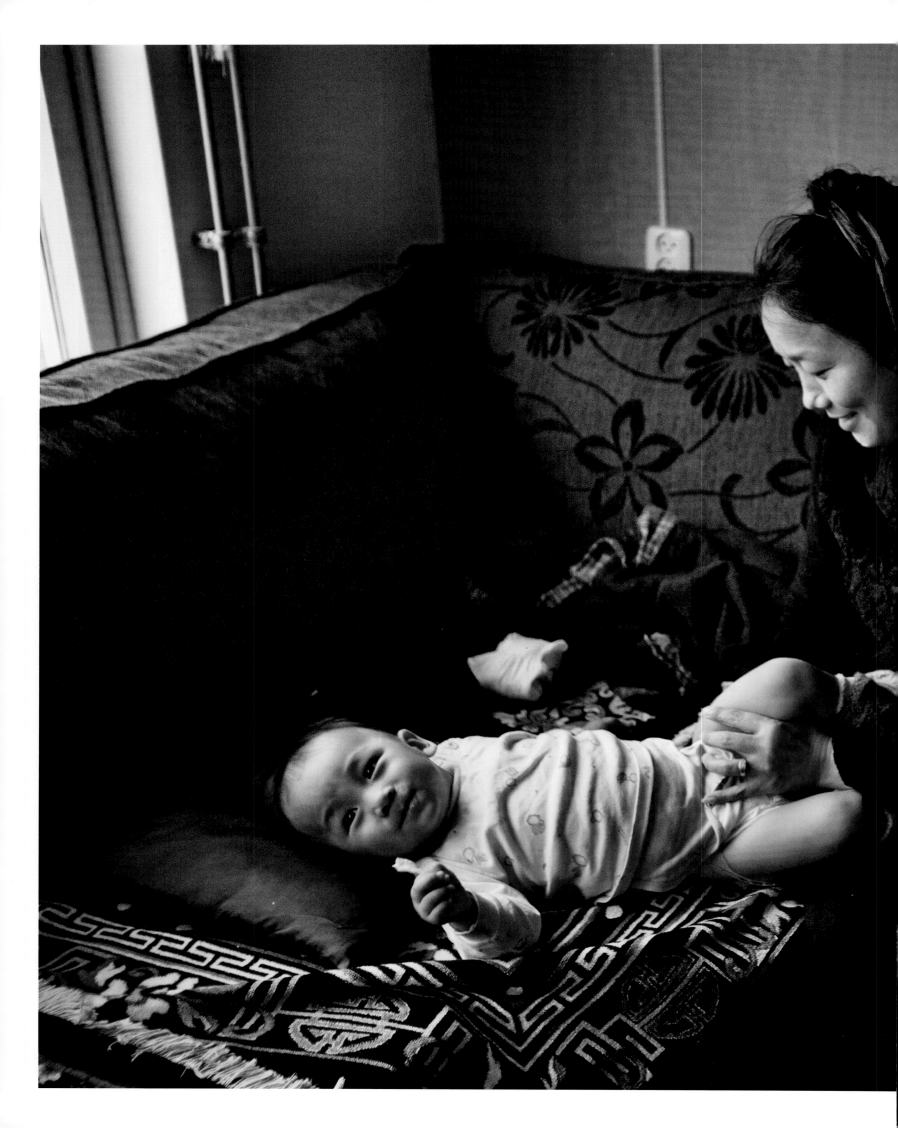

AMSTERDAM, HOLLAND - Dolma, a young Tibetan mother tends to her two children at their home. Dolma has been living in Holland for four years and both of her children, Tenzin Choeyang and Tenzin Sherap, were born there.

DHARAMSALA, HIMACHAL PRADESH, INDIA - A Tibetan offers prostrations as a form of prayer, as well as yoga and offerings at Tsuglakhang Temple, the main Temple of the Dalai Lama in exile. Many Tibetans perform this practice daily over years.

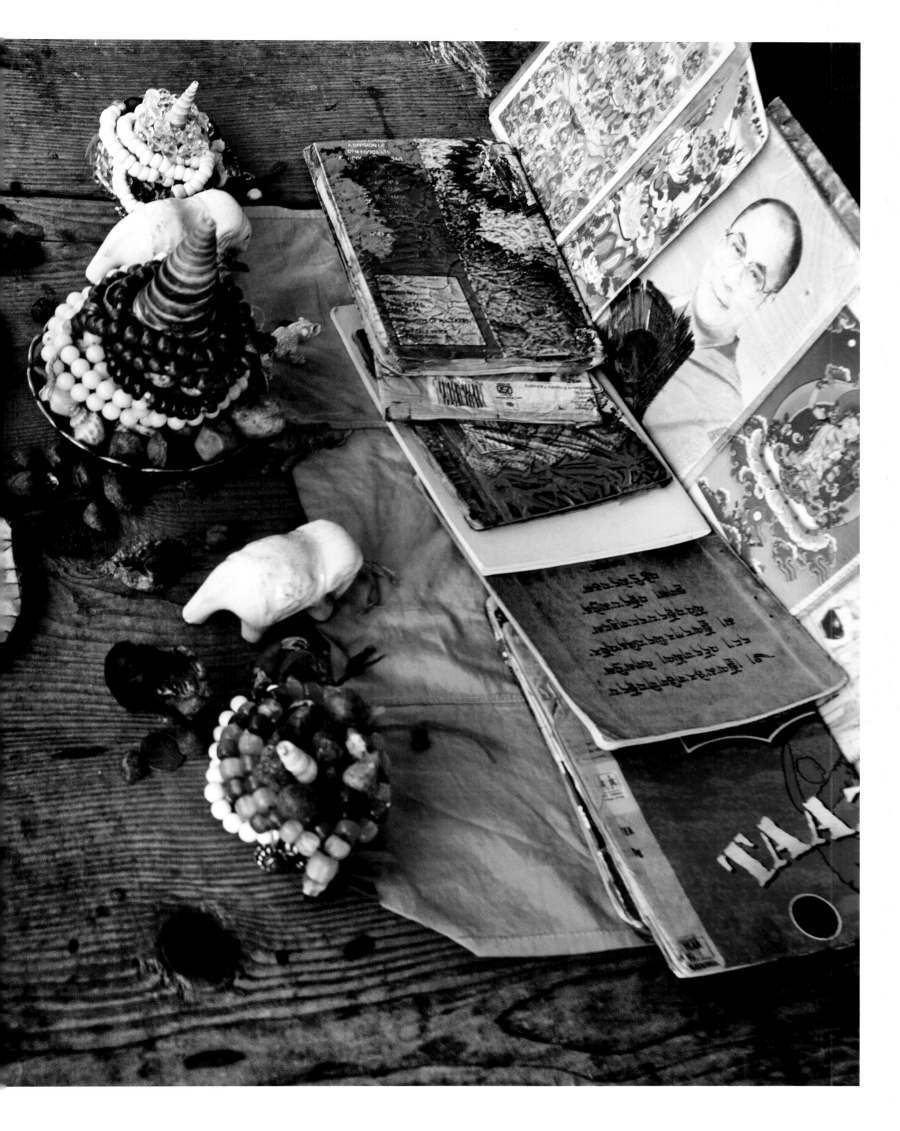

LONDON, UK - Tibetans in exile at a screening of a Tibetan film.

LADAKH, INDIA - Three Tibetan nuns walk past a nomadic camp, on the highest Himalayan plateau in India.

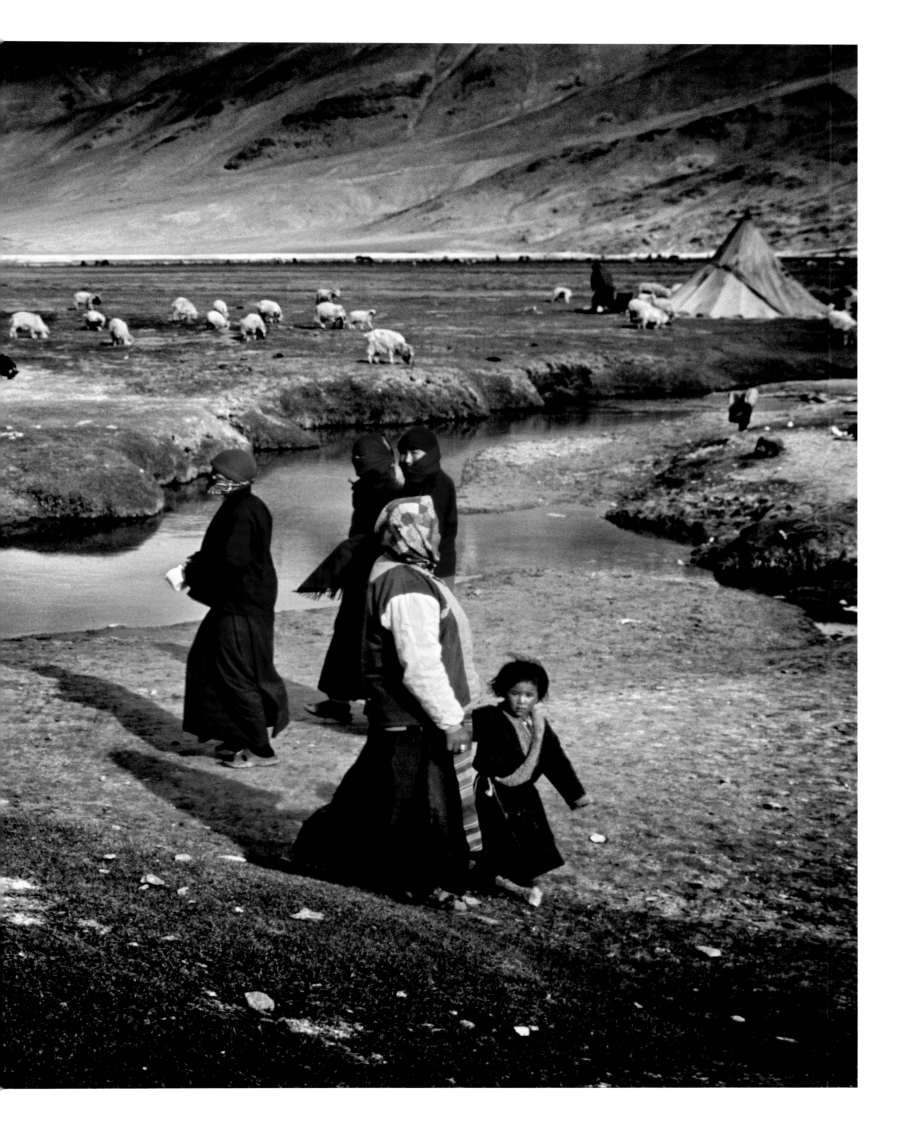

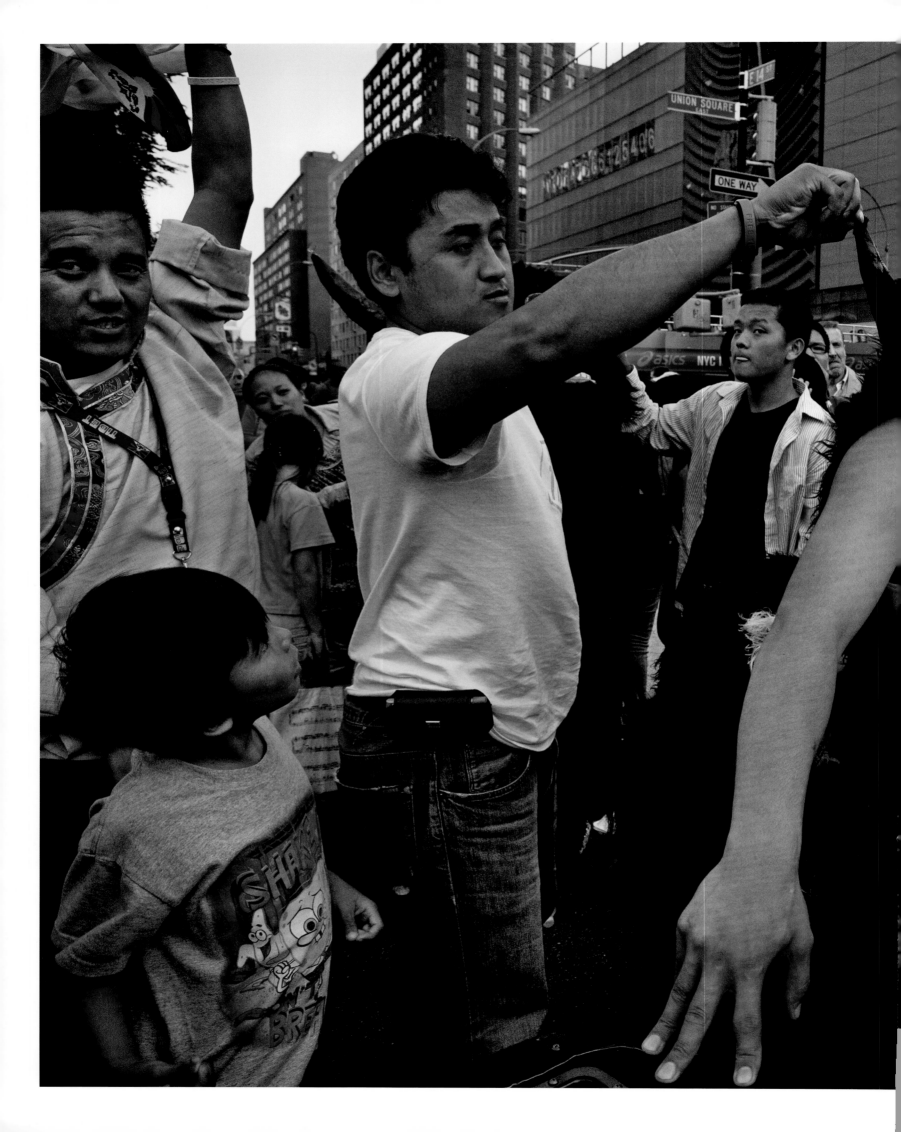

NEW YORK. U.S.A. - A Tibetan performing artist at Union Square carries a mask during an event celebrating the awarding of a Congressional Gold Medal to the Dalai Lama. The medal is one of the highest honours awarded by the U.S. government.

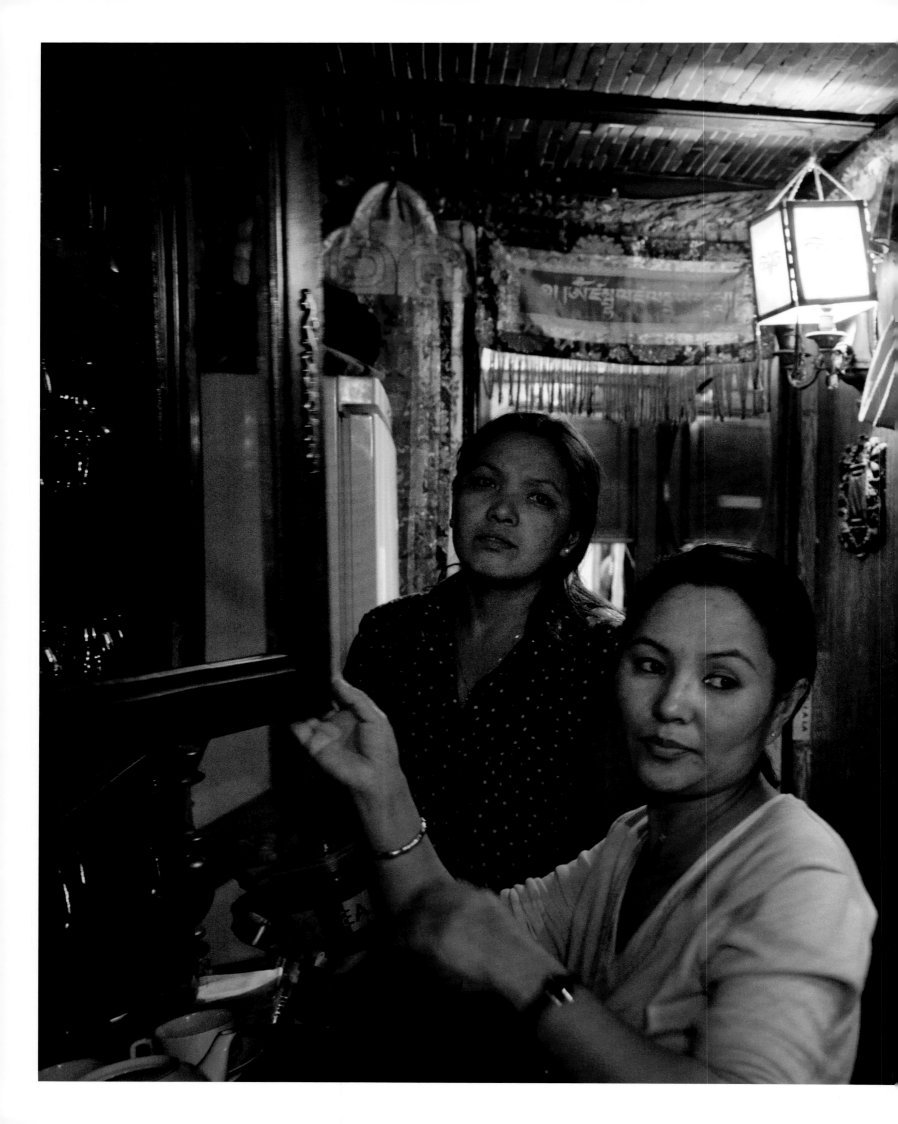

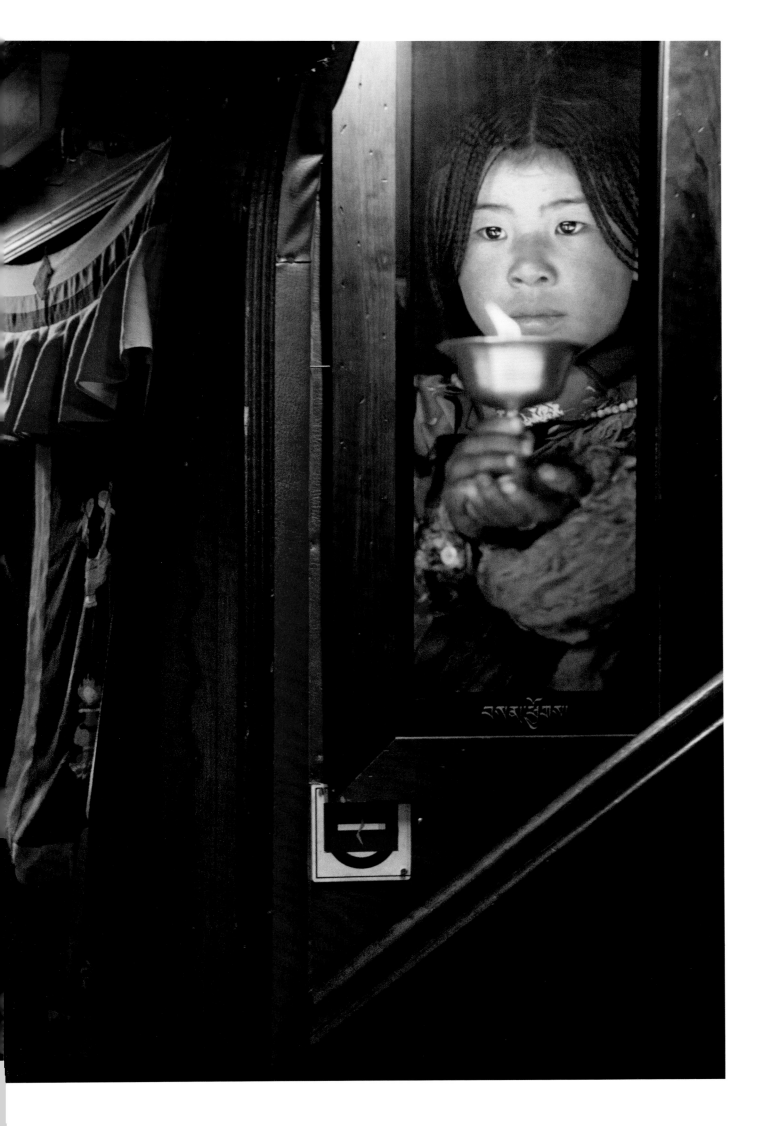

PARIS, FRANCE - Yangchen Lhamo, who came from India in 2001, at work with her colleague at Gang Seng, a specialty Tibetan restaurant. The Tibetan owner Tenzin, originally from Kham, took refuge in France and now runs the popular restaurant. Recent Tibetan arrivals are often employed, as a way to help them resettle.

BODH GAYA, BIHAR, INDIA - A Tibetan woman with her two children during a candlelit vigil to mourn and honour Tibetans who have carried out self-immolation in protest at the Chinese occupation.

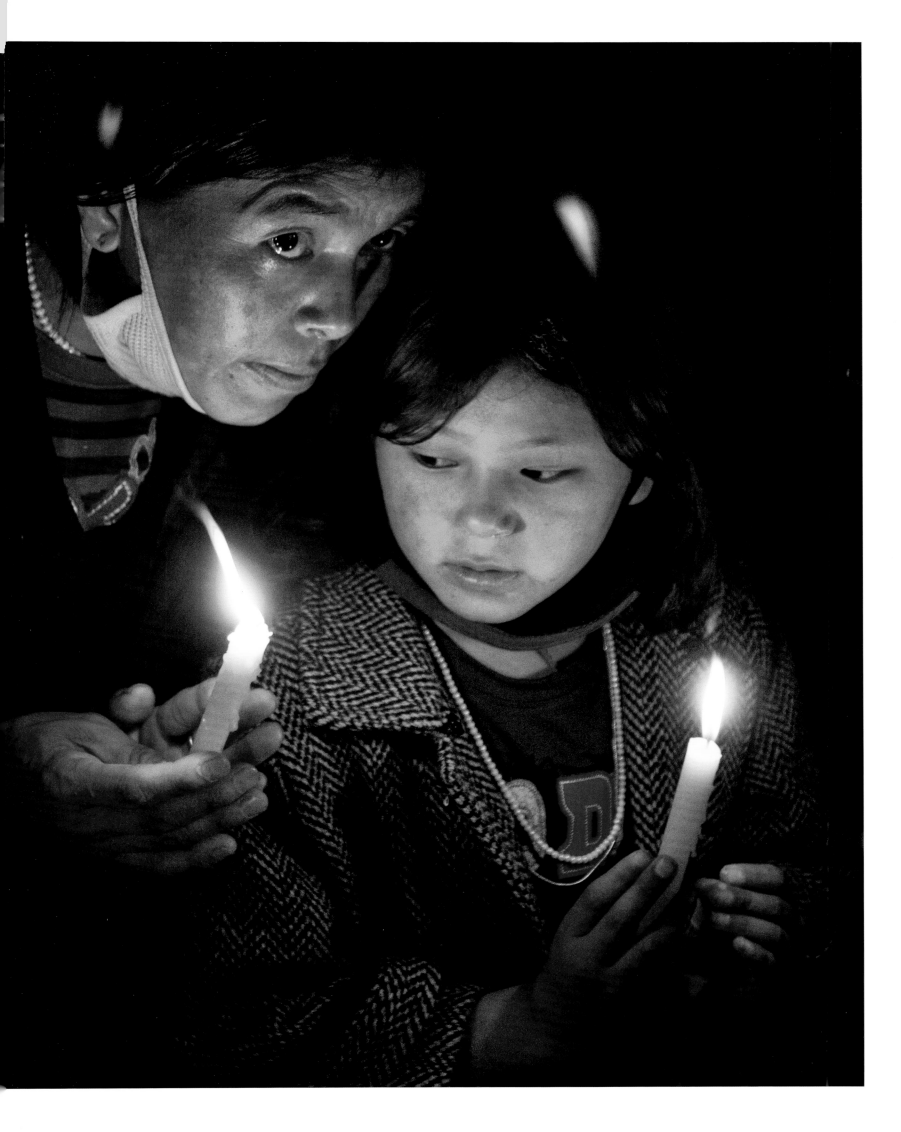

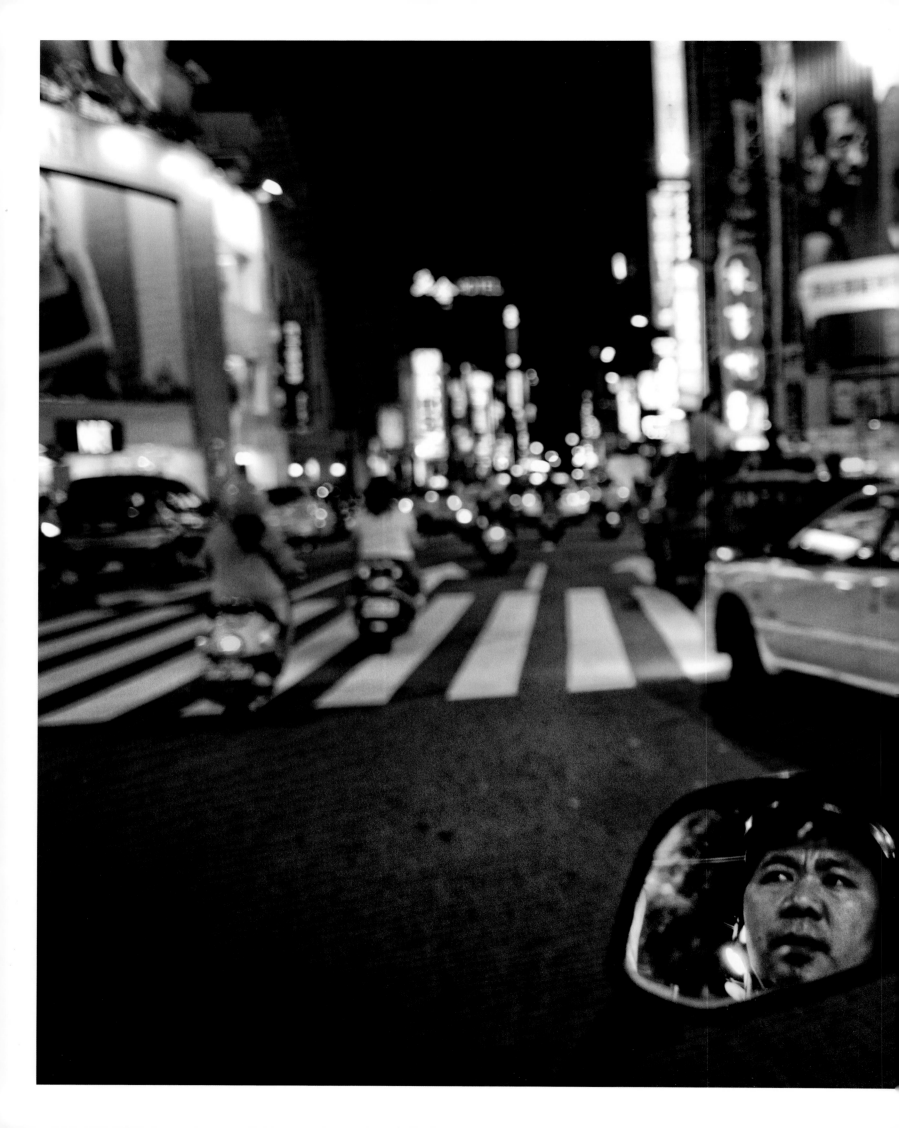

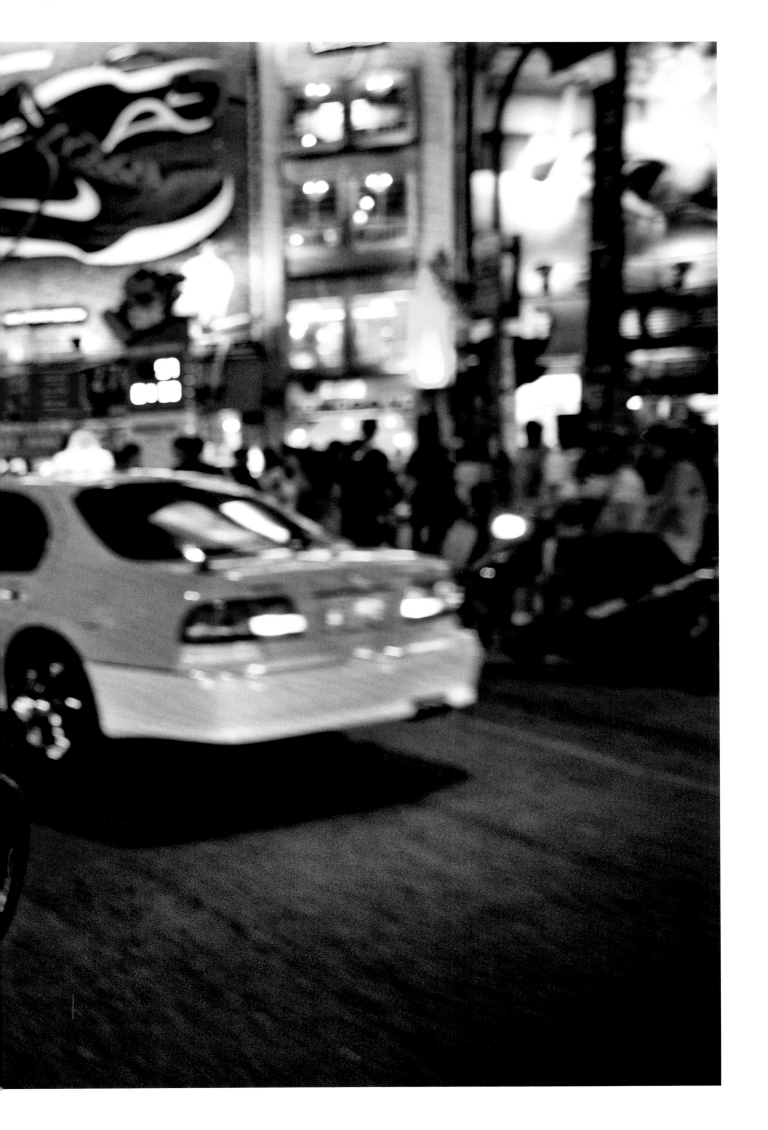

TAIPEI, TAIWAN - Samten Dorjee, an exiled Tibetan, rides his motorbike through Taipei's busy streets. Born in India, Samten has been in Taiwan for over a decade.

The strongest memory
of my escape journey
was the moment that
I stood on top of a
mountain on the border
of Tibet and Nepal. On
the Tibetan side, the snow
mountains stretched
endlessly and steeply
and seemed to be
joined together. While
on the Nepalese side

The strongest memory of my escape journey was the moment that I stood on top of a mountain on the border of Tibet and Nepal. On the Tibetan side, the snow mountains stretched endlessly and the sky and earth seemed to be joined together, whilst on the Nepalese side,

the earth seemed to be descending. I looked towards Tibet and prayed. I don't remember what I prayed for, but I do know one thing that crossed my mind – whether I would ever be able to return to this magnificent land.

Tenzin Losel, Dharamsala, India

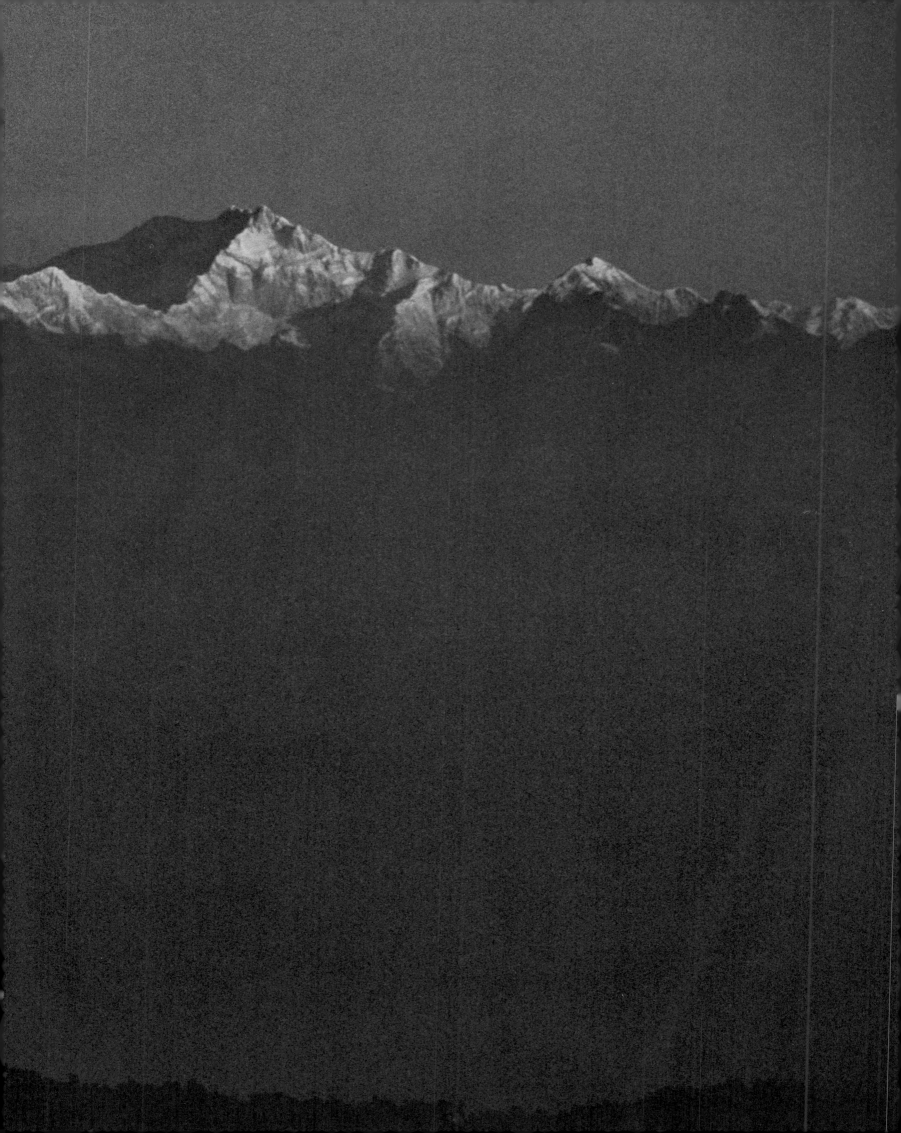

First published in the United Kingdom in 2016 by

Dewi Lewis Publishing
8 Broomfield Road, Heaton Moor
Stockport SK4 4ND, England
www.dewilewis.com

© 2016
for the photographs: Albertina d'Urso
for the texts: The Dalai Lama, Dr. Lobsang Sangay,
Albertina d'Urso and the contributors
for this edition: Dewi Lewis Publishing

ISBN: 978-1-907893-96-4

Design & layout:
Teun van der Heijden, Heijdens Karwei, Amsterdam

Print:
EBS, Verona, Italy

This book was made possible by:

During my first trip to Tibet in 2000, I could see how Tibetan culture and religion were repressed. I came back with a deep sense of sadness and disappointment – it seemed that something had been lost forever. But a few years later, I met a Tibetan family in India who assured me that if I visited their settlement, I would find what I was looking for and so I followed them to Bylakuppe, a refugee camp in Southern India. There I began to understand how these refugees were able to maintain their culture.

For the last 10 years I have documented Tibetan refugees in several areas of India (Himachal Pradesh, Karnataka, Sikkim, Darjeeling, Ladakh, Bodhgaya), as well as in Nepal, Taiwan, USA, UK, France, Switzerland, Italy, Belgium, Holland and Canada. My focus has been on their daily activities in the new countries in which they now live and on the deep intimacy which exists in their private lives through the continued practice and honouring of their Tibetan beliefs.

My goal is to visually unite these Tibetans in exile, who are now displaced all around the world. They have their own official language, their own medicine, symbols, calendar, and, above all, their spiritual leader, the Dalai Lama. Yet they are living in limbo, in a unique de facto state, with a Prime Minister and a government that no country in the world recognises.

I would like to thank all the Tibetans who, throughout my travels, have never hesitated to be photographed, to tell their stories, to introduce me to their homes, their families and their friends – always with great enthusiasm. Their wish is that their people and their culture will not disappear, but will become known and appreciated by as many people as possible. I hope that this book will bring them closer to all of you.